CLASSIC RESTAURANTS

OF

Coastal Virginia

CLASSIC RESTAURANTS

OF

Coastal Virginia

PATRICK EVANS-HYLTON

AMERICAN PALATE

Published by American Palate
A Division of The History Press
Charleston, SC
www.historypress.com

Copyright © 2019 by Patrick Evans-Hylton
All rights reserved

First published 2019

Manufactured in the United States

ISBN 9781467140171

Library of Congress Control Number: 2019935349

Contents

Acknowledgements

When I was attending culinary school at the (now closed) Norfolk campus of Johnson & Wales University, I was immediately struck by how rich this corner of Virginia was with foods and foodways. I began to study the people, places and things that flavored Coastal Virginia and took notes along the way. Many of those endeavors have led me to this book.

Along my journey, there have been many friends who have been my champions, but I am lucky to have two best friends who have supported me unequivocally. The first was my late husband, Wayne Hylton, with whom I shared more than a quarter century with until his passing in 2016. The other is my current partner, Douglas Stisher, with whom I have been with a shorter time but with whom I feel as rich as I did with Wayne. I want to acknowledge both for their help in so many ways.

Also, a big thank-you to my editor at The History Press, Kate Jenkins, for her friendship, guidance and support though this process. Assisting, too, have been Troy Valos and his staff with the Sargeant Memorial Collection at the Slover Library in Norfolk. My deepest gratitude goes to them. Thank you, too, to Al Chewning, Sammy Edwards and the Edwards family of Edwards Virginia Smokehouse and Brady Viccellio of Steinhilber's Restaurant.

Introduction

Tell me what you eat and I will tell you what you are.
—Jean Anthelme Brillat-Savarin (1755–1826), French gastronome

Although Coastal Virginia is a relatively new term to describe Virginia's low country, this isn't a new region. The wording of the area isn't the only thing that is hard to define, either. Geographically speaking, this ancient region covers more land than that of the states of Delaware and Rhode Island combined.

Coastal Virginia covers a swatch of land and sea along the Atlantic coast from Maryland south to North Carolina, and inward, across the mighty Chesapeake Bay deep into its tributaries and the surrounding rich soil. Among the areas here are the Eastern Shore, Middle Peninsula, Peninsula, Southside and Western Tidewater. Included are cities such as Hampton, Newport News, Norfolk, Portsmouth, Suffolk, Virginia Beach and Williamsburg. A number of counties are included, too, like Isle of Wight, James City and York.

So to pinpoint a particular style of food here, like you can in Charleston, South Carolina, New Orleans, New York City or San Francisco, is difficult. In this region, salt water and brackish water are home to an amazing array of sea life, and the earth is sandy and loamy and perfect for growing many edible treasures. Those dynamics come together to craft a unique Coastal Cuisine—some of it old, some of it new. It's centered on seafood, but isn't exclusive to that.

Sometimes it's the use of signature produce, like sweet potatoes. Sometimes it's a preparation method, like dredging in cornmeal and cooking in a cast-iron skillet. It's a rich, historic, multifaceted way of cooking.

But one thing remains the same, regardless of time or place: the main hallmarks are fresh, seasonal, simply prepared ingredients that create a sense of place and a sense of palate. When folks ate in Virginia, whether the indigenous people before the arrival of the English settlers in 1607 or the same settlers for a period thereafter, the food was prepared at home and eaten at home. It would be some time before the fledgling colony had need for a tavern.

As the first enduring English colony in North America grew, needs grew too. Longer distances between settlements meant the need to stop for the night. And while lodging was the primary purpose of these taverns, food—typically served communally from a fixed menu and at a fixed time—was offered. Later still, many of these taverns became meetinghouses to exchange news and information, as well as talk politics. Many of the country's Founding Fathers met in such ordinaries in Williamsburg and elsewhere, discussing the need for independence from England.

A revolution of another sort—the French Revolution—assisted in the formation of what we think of today as a modern restaurant. By the late eighteenth century, the concept found its way to America, and by 1820, the first true restaurant in Virginia opened in Norfolk. Along the way, a specific regional cuisine was born, making this area truly the birthplace of American cuisine. It started with an amalgamation of native and English cooking. The cooking was further fused with influences from Africa and the Caribbean. Later still, as the country grew and embraced immigrants, the style added additional nuances.

This regional cuisine incorporated indigenous ingredients, including grains such as corn and fruits such as strawberries. It also featured seafood: the blue crab, oysters and fish such as rockfish and sturgeon. Methods of preparation borrowed heavily from Virginia's population—both free and slave. It wasn't just food, either. Corn was distilled to create a spirited drink akin to modern moonshine. Distilled corn, aged in barrels, gave birth to bourbon. And rum was imported from the Caribbean and crafted from the molasses runoff from the sugar production there. Beer was crafted and flavored with local ingredients, such as pine pitch, in the absence of hops. Wine was at first made with native grapes like scuppernong, then Norton after it was discovered in Richmond in the early nineteenth century. Later, still, when *vinifera* grapes took root, Virginia began to come into its own with wine production.

INTRODUCTION

In the beginning, all America was Virginia.
—William Byrd II (1674–1744), Virginian author, planter and statesman

Virginia grew as America grew, and many of the things that America celebrated or mourned were the same that Virginia did too. The Civil War. The Industrial Revolution. Both World Wars. Prohibition. The Great Depression. Segregation. Baby Boomers. The Summer of Love. And more. Those events had not only an effect on the commonwealth but also on the way the commonwealth ate.

The Civil War and both World War I and II brought food shortages and rationing. Prohibition ran many bars and restaurants out of business, as did the Great Depression. Segregation kept many Virginians from dining at the restaurants of their choice or forced them to go to the back door and take food to go. In this book we look at these events, and others, that have shaped dining in the Old Dominion. Grab a napkin—this is going to be a tasty read.

1
Eats + Drinks-ionary

HERE ARE SOME TERMS to use as a primer for information in the book.

beer. Beer was a common beverage in eighteenth-century Virginia. It was the everyday drink for most people, principally for enjoyment but also for health reasons. Water was often contaminated, and a weak beer, safe for drinking since the water was boiled in the process, was crafted for everyday consumption. Beer with a higher alcohol content was also brewed. Historical Virginia beers have included:

> *porter*. George Washington loved his porter, but only if it was brewed in America. A cousin to stouts, the dark-hued porter was historically brewed with the same recipe, but brewers drew off more water in making a stout, making stouts stronger. Porters have bold flavors, commonly chocolate and/or coffee. The term *porter*, generally accepted as dubbed by the hardworking London laborers of the same name, has been used interchangeably with *stout* even today.

> *pale ale*. A favorite beer of Thomas Jefferson, pale ale is an amber-colored quaff that has a good balance of hop and malt flavor. It is a good waypoint between light lagers and strong stouts.

clam. One of the region's culinary calling cards, clams are categorized in four sizes: Little Neck, the smallest, with seven to ten clams per pound; Cherry Stone, the next larger, with six to ten clams per pound; Top Neck, sometimes called Count Neck, the next larger, with approximately four clams per pound; and Chowders, sometimes called quahogs, the largest, with two to three clams per pound.

corn. Captain John Smith noted corn was the main crop of the Native Americans; indeed, corn was at least half of the food they consumed. Colonists ate corn fresh, in stews and other dishes and ground into flour and meal to make corn cakes, corn dumplings and other offerings. Most parts of the plant were also used to feed livestock, including blades and husks. Corn was easy to grow and easy to harvest. Corn could be easily stored, too, on the cob, shelled or ground.

crab. The blue crab is one of the region's culinary calling cards. Crabs have been part of Coastal Virginia's cuisine scene for centuries, first with the Native Americans, then with the English settlers. Here is information to know:

> *back fin crabmeat.* Smaller than jumbo lump, these chunks of white meat from the back fin cavity are often used in crab cakes, sautéed crab, salads and garnishes.
>
> *claw meat.* This dark, rich meat has a stronger flavor that is more suitable for soups, stews and crab cakes than for salads.
>
> *crab boil.* A boiling hot pot of water, usually with spices added and sometimes with the addition of vinegar or beer, in which or over which

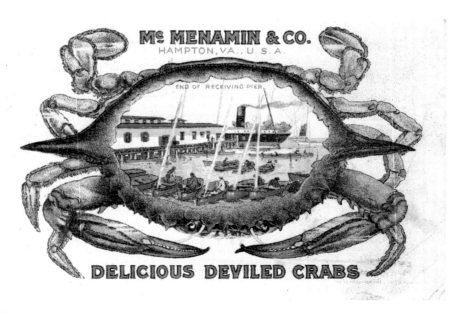

McMenamin & Co. "Delicious Deviled Crabs" advertising card, circa 1900. *Author's collection.*

hard crabs are cooked. If steamed or cooked over the boiling water, the crab itself is seasoned, often with Old Bay®.

gender. Males are called jimmies, and females are referred to as sooks. Sooks often carry roe, or eggs, that are traditionally used to flavor she crab soup.

jumbo lump crabmeat. These large nuggets of meat from the body cavity are good for sautéed crab, crab cakes, salads and garnishes.

soft-shell crabs. A seasonal delicacy here, soft-shell crabs are eaten whole—shell and all—after having molting in the late spring and early summer months.

special grade crabmeat. These small bits of white meat from the body cavity give flavor to baked dishes and recipes with sauces.

fish. The Virginia seafood industry is one of the oldest industries in the United States, the third-largest seafood producer in the nation and the largest on the Atlantic coast. In 1612, Captain John Smith recorded in his diary: "Of fish we were best acquainted with sturgeon, grampus, porpoise, seals, stingrays whose tails are very dangerous, brits, mullets, white salmon [rockfish], eels, lampreys, catfish, shad, perch of three sorts, crabs, shrimps, crevises, oysters, cockles, and mussels." Fresh catch is one of Virginia's culinary calling cards. Favored fish today include:

flounder. This fish is also called summer flounder or fluke in Virginia. The quaint fishing village of Wachapreague, located on the Eastern Shore, is called the Flounder Capital of the World due to the excellent fishing of the lean, white-fleshed delicate fish there. A noted restaurant in Wachapreague is the ISLAND HOUSE.

rockfish. Also known as striped bass, this is a mild, white, flaky meat fish that has been a favorite since colonial times; a 1639 statute to protect the fish was one of the first conservation acts.

ham. Virginia has been famous for country hams since the late 1700s when Bermuda native MALLORY TODD (1742–1817) set up shop in Smithfield offering the product. The history of the meat prepared by individuals for home use predates Todd; Todd was the first to sell the hams commercially. The salty, cured taste of a Virginia country ham is immediately recognizable and highly sought after. It is said that Queen Victoria loved Virginia ham so much that she had six sent over to England once a week during her reign. It is one of the region's culinary calling cards. Here is information to know:

city ham. This is the most common variety of ham, the majority of which are wet-cured, also known as brine-cured, where the product has been

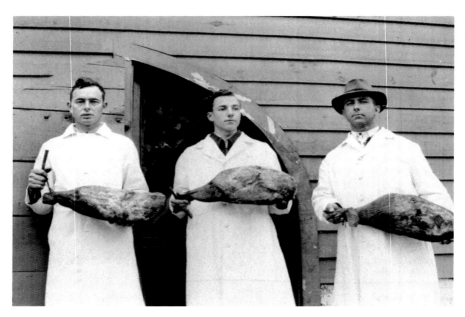

Country hams at Edwards Virginia Smokehouse, circa 1945. *Edwards Virginia Smokehouse.*

soaked in or injected with water and other brining ingredients, such as a salt, sugar, spices and seasonings. City hams are moister and have a milder flavor/texture than country ham.

country ham. This is a ham dry-cured at least seventy days, then smoked over fragrant hardwoods and aged a minimum of six months. In Virginia, it is sometimes called Virginia ham or (generically) Smithfield ham, although Smithfield ham has evolved to a broad brand name for hams produced by Smithfield Foods.

sugar-cured. a ham that usually includes cane and/or beet sugar in sufficient quantities to flavor and/or affect the finished product. Similarly, there is honey-cured ham.

Hayman potatoes. First cultivated in South America, the potato has been in Virginia for centuries; the state is a major producer, with the concentration of both Irish potatoes and sweet potatoes being on the Eastern Shore. While it is the traditional sweet potato that you find most often, the heirloom Hayman is truly something special. Limited in quantities, it is a bit smaller than a traditional sweet potato and has an almost white flesh that turns a pale green-yellow when cooked. The flavor is a bit more delicate than its orange cousins, with a bit of a sweet herbal note.

Potatoes ready for shipment, Cape Charles, circa 1900. *Author's collection.*

meal service. Although today we largely make selections from a menu and pick what we wish to enjoy at breakfast, lunch or dinner, that type of meal service hasn't always been the norm. Here is some information to know:

 à la carte. Translated from the French, à la carte means "according to the menu" and refers to a menu where diners are presented with a host of choices per course, with each choice priced individually. This type of meal service is the opposite of table d'hôte service.

 American Plan. Used almost exclusively in inns until the late nineteenth to early twentieth centuries, the cost of lodging included meals prepared by inn staff and served at the inn, usually in a dining room. Some resorts still use this plan today.

 table d'hôte. Translated from the French, table d'hôte means "host's table" and refers to a set menu where diners are presented with few choices per course. The meal is set at a fixed price; table d'hôte is often referred to as *prix fixe*.

oysters. If there was a contender for the food most historically tied to Virginia, it would be the oyster. In fact, Virginia has been widely known by oyster lovers near and far for having offerings unparalleled elsewhere. There is no place that offers the oyster experience like the Commonwealth or offers the vast array of oysters not just from the Lynnhaven Bay but

Oyster tonging, circa 1900. *Author's collection.*

indeed from all eight distinct oyster growing regions. They are one of the region's culinary calling cards. Here is information to know:

bayside. In the case of Virginia, these are oysters that are grown along the Chesapeake Bay, in particular the side of the Eastern Shore, and are not as salty as seasides due to the bay not having salinity levels as high.

cup. This is the bowl-shaped part of the oyster shell (the other valve is typically flat), which is used for presenting an oyster on the half shell (which includes the liquor) or in a Rockefeller preparation

half shell. This refers to an oyster that is presented for consumption shucked and resting in one half of its shell, usually the cupped side and typically in its own liquor. Oysters on the half shell are usually presented on a lipped tray filled with ice or rock salt with accouterments.

liquor. In this context, liquor refers to the briny liquid that surrounds the meat of the oyster within its shell.

seaside. In the case of Virginia, these are oysters grown on the Atlantic Ocean side of the Eastern Shore, making them saltier due to the high salinity of the sea water.

peanut. One of the region's culinary calling cards, here is information to know:

goober. A generic name for the peanut from an African word for peanuts, *nguba*. Other colloquialisms, historic and/or current, for peanuts include goober pea.

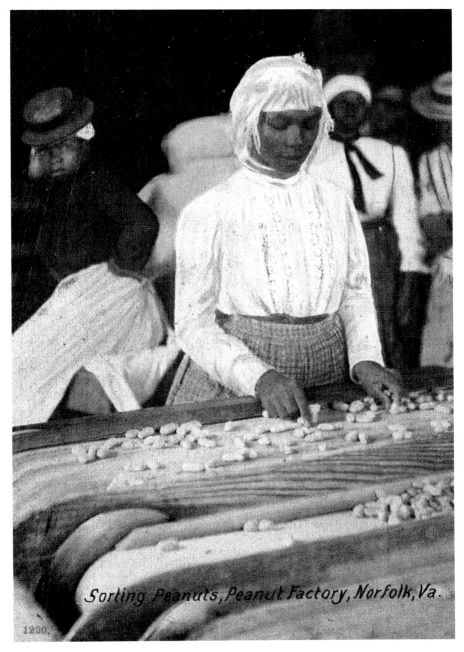

Sorting peanuts, peanut factory, Norfolk, Virginia, circa 1900. *Author's collection.*

Virginia type. A large, buttery kernel peanut good for eating-out-of-hand as in gourmet snack mixes, or prepared into peanut butter and other dishes. It is grown in the Peanut Belt, which stretches across Coastal Virginia and into eastern North Carolina, and, sometimes, in other southern states. Other types of peanuts include Spanish and Valencia.

places to eat. True restaurants did not emerge in Virginia until the beginning of the nineteenth century. Throughout time, the name of places to eat or drink have changed and evolved, along with what was offered. Here is information to know.

coffee house (also *coffeehouse*). Coffeehouses came onto the scene in the seventeenth century, offering a bit more than a typical tavern. Much like at a tavern, folks gathered to discuss happenings and exchange information, but offerings included (drinkable) chocolate, coffee and tea in addition to ale and spirits.

eating house. A term one starts to see in the late eighteenth century and into the nineteenth century to describe a place to grab a bite and most likely a libation. It might be prix fixe (set menu, set price and often set time of service) or à la carte (an offering of food at the diner's pleasure, and often offered upon demand). The term was often seen during the period when restaurant service was being introduced, but that word was new and unknown to some.

inn. The name *inn* began springing up in the late seventeenth century to indicate that lodging was available, providing a distinction from a tavern, which might offer some overnight accommodations, but increasingly meant a place for eats and drinks only. Inns usually did offer food too, not only to guests but also to the public at large.

ordinary. One of the early terms for taverns, generally interchangeable. By late in the seventeenth century and early eighteenth century, many began favoring the name *tavern* over ordinary.

public house (shortened to *pub*). A beer house, much like a tavern—in which the name is often interchanged—focused on the servings of alcoholic beverages, largely ale but often spirits and wine. Food is also served at pubs.

restaurant. The first true restaurants began emerging in France in the mid- to late eighteenth century. The concept of diners going into an eating house at the time of their choosing, sitting at either a communal (which was often seen in taverns) or private table and selecting from a menu a variety of dishes, was revolutionary. The term *restaurant* comes from the root that also means restore, or restorative. Early restaurants featured

broths, soups and other such dishes that focused on restoring the health and well-being of their clients.

tavern. A term that grew in favor in the late seventeenth century to describe a place to grab a bite to eat and a drink. Many taverns would accommodate overnight guests, too, but increasingly the word *inn* was used to differentiate between a waypoint for eats and drinks and lodging.

strawberries. Of all the New World food finds, we don't often consider the strawberry. But that delightful little red fruit, so abundant and fresh in the spring, was one of the first edibles that greeted the first colonists. George Percy wrote in 1607, "Going a little further we came into a plat of ground full of fine and beautifull Strawberries, foure times bigger and better than ours in England."

Picking strawberries in Norfolk, circa 1900. *Author's collection.*

wine. Virginia is a large wine producing state and has a history of winemaking to some degree for more than four hundred years. There are numerous wineries in Coastal Virginia, including CHATHAM VINEYARDS on the Eastern Shore and MERMAID WINERY in Norfolk. The COLONIAL WINE TRAIL showcases several wineries on the Peninsula up to Richmond, including JAMES RIVER CELLARS and WILLIAMSBURG WINERY. The CHESAPEAKE BAY

Wine Trail features a number of wineries on the Middle Peninsula and Northern Neck, such as Ingleside Vineyards and the Dog and Oyster.

scuppernong. The large, round, thick-skinned green/bronze scuppernong grape, a variety of the muscadine, is common in the American South. It is most likely the grape that greeted Jamestown settlers. Largely eaten out-of-hand, it is a different classification than the varietal of grapes used in traditional winemaking. As such, the flavor profile is different. Wines made with scuppernong grapes are typically sweet and often have a foxy aroma and taste. It was the predominant grape used by Garrett & Company in Norfolk in the late nineteenth and early twentieth centuries, in addition to such cultivars as Concord and Niagara.

viognier. Of all the wine varietals grown in Virginia today, viognier has been designated the official wine grape of the state. According to the Virginia Wine Marketing Office, viognier, a white wine grape, gives off strong and appealing perfumes of fresh flowers and fruit. That doesn't mean it's a sweet wine; viognier is usually dry or slightly off-dry.

Birthplace of American Cuisine

It was a cold December day in 1606 when three ships pushed away from docks in Blackwall, an area in east London. They made their way eastward down the Thames River, turned southwest into the English Channel and sailed toward the new colony of Virginia into history.

Aboard the *Susan Constant*, *Godspeed* and *Discovery*, under the command of Captain Christopher Newport, were 144 men and boys. For four months, on vessels about the size of a modern-day commuter jet, they made their way past the Canary Islands, just off the coast of Africa, and into the West Indies. They ate rations and were allowed a gallon of beer per person, per day.

In the Caribbean, stops were made along the way: Martinique, Dominica, Guadalupe, St. Croix and Puerto Rico among them. It would be the beginning of a long history between the Caribbean and Virginia and a lasting influence on the foods and foodways in the Old Dominion. After picking up supplies, the ships headed north, well off the coast of Florida, and toward the Chesapeake Bay. The Chesapeake Bay wasn't a new discovery; it had been part of Spanish—and later English and Dutch—exploration along this stretch of the Atlantic coast for almost one hundred years already. In 1570, the short-lived Ajacan Mission, established by Spanish Jesuits, set up an outpost most likely near present-day Yorktown.

The English tried to settle in the region, establishing the Roanoke Colony in the present-day Outer Banks of North Carolina in 1584. Known as the Lost Colony, the settlers vanished by 1587 without a trace.

Jamestown settlers, Jamestown Exposition postcard, 1907. *Author's collection.*

So it had to be with a mix of excitement and trepidation when Newport's ships spotted the capes that form the opening leading to the Chesapeake Bay. They anchored just off shore of what is now Cape Henry in the current city of Virginia Beach on April 26, 1607.

Surf lapped on the sandy shore and the air filled with the scent of fresh salt as they made their way from the three ships to land. A cross was planted in honor of England; the event is now known as the "First Landing." The London Company's commercial enterprise would lead to the establishment of the first permanent English settlement. The next day, April 27, as a group of men began construction of a shallop (small boat) to explore, another group set out on foot, "eight miles up into the land," wrote diarist George Percy. Their exploration was important for another reason: it became the seed for the birthplace of American cuisine.

> *We came to a place where they* [Native Americans] *had made a great fire, and had been newly roasting Oysters. When they perceived our coming, they fled away to the mountains* [large sand dunes], *and left many of the Oysters in the fire. We eat some of the Oysters, which were very large and delicate in taste.*
>
> —*George Percy (1580–1627), colonist and future governor*

Although at this point the oysters were eaten as is, it is good to note that this is the first time the settlers of what would become Virginia ate a native, cooked product. Another important fact: this area was most likely around the present-day Lynnhaven Bay, which has been noted for the size and quality of its oysters for centuries. The same oysters that Percy and his fellow explorers ate during that outing more than four hundred years ago—and the manner in which they were prepared—are exactly the same today.

The next day, April 28, Percy noted more exploration, and more discoveries: "We went further into the Bay, and saw a plain plot of ground where we went on Land….Upon this plot of ground we got good store of Mussels and Oysters, which lay on the ground as thick as stones." He continued, "Going a little further we came into a little plat of ground full of fine and beautifull Strawberries, foure times bigger and better then ours in England."

Newport did not intend to set firm roots at Cape Henry; the area was too open and vulnerable to attacks, especially from the Spanish. The ships also needed a natural harbor for protection. Shortly thereafter, the group made its way into the Chesapeake Bay and up the James River (originally Powhatan, after the Native American ruler in the region, renamed by the Englishmen). The colonists explored for weeks before settling on Jamestown Island on May 14; George Percy noted the men celebrated with beer. The English loved their beer, and it was an everyday drink, not only because they believed the water to be unsafe but also out of enjoyment.

Unfortunately, the London Company neglected to send a brewer along—one of the first problems the fledgling colony faced. There was frustration as they waited for additional beer to come from England. Sir Francis Wyatt, the first governor, placed an ad in a London newspaper calling for two brewers to come set up their craft. Crops of barley were planted in anticipation of their arrival.

Jamestown Island was a good location for defense and shelter, but the area around it was marshy, allowing for disease-carrying mosquitos. That same stagnant water was not fit to drink, and the ground provided little space to farm. The colonists were not properly prepared for self-sufficiency, not only because of the shortcomings of where they had settled but also because many of them lacked farming, hunting and other labor skills. The goal of the London Company was for this expedition to be a moneymaking enterprise; the colonists hoped to have time to search for valuable goods to ship back to England.

To that point, they had planned to establish trade with the Native Americans for food, but trading with the local tribes was problematic. They had also anticipated regular supplies from England, but it took considerable

time for ships to arrive. And despite often disastrous events, including the "Starving Time" (coined by Percy as "this starveinge Tyme") in the harsh winter of 1609–10, when 80 percent of the colonists died (and, some, lacking food, resorted to cannibalism, as evidenced by a butchered skull and shinbone in an excavated James Fort cellar), the effort didn't die. Virginia received much-needed relief when, in 1612, it was discovered that tobacco not only grew in the sandy, loamy soil, but also thrived. Tobacco became an important cash crop because of high demand in England. Relations with Native Americans remained tenuous but improved.

NATIVE AMERICANS

Native Americans lived in Virginia for thousands of years before the first colonists arrived, and for quite some time, they had been domesticating various crops, among them beans, corn and squash. They were attuned to the seasons, and they knew how to effectively fish, gather and hunt. The James River had abundant fish, among them the large, prehistoric-looking sturgeon. Blue crabs danced in tidal pools, and oysters anchored themselves to rocks. In the woods, bears and deer roamed, and wild turkeys strutted about. The natives had all the skills and resources that the English lacked.

Settler and writer (and later secretary of the colony) William Strachey wrote in 1609,

> *About their howses they have commonly square plotts of cleered grownd, which serve them for gardens, some one hundred, some two hundred foote square, wherein they sowe their tobacco, pumpons* [pumpkins], *and a fruit like unto a musk million....They plant also the field apple, the maracock, a wyld fruit like a kind of pomegranette, which increaseth infinitelye, and ripens in August, contynuing untill the end of October, when all the other fruicts be gathered.*

Strachey noted the Native Americans did not breed livestock but trapped fish, turkeys and squirrels; "to mend their dyett, some disperse themselves in small companeys, and live upon such beasts as they can kyll with their bows and arrows, upon crabbs, oysters, land-tortoyses, strawberryes, mulberries, and such like." He also observed the planting of corn in May and the gathering of acorns, chestnuts, grains and (black) walnuts. For

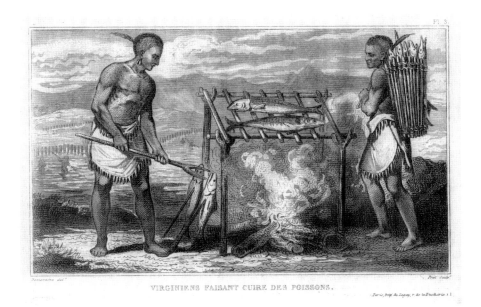

The roasting technique of tribes native to Virginia. *Theodor de Bry, engraver, and John White, artist, Library of Congress.*

authenticity, original spellings and punctuations from historic writings have been preserved throughout this book.

Trade with the natives did improve, and they taught the colonists important skills as well. The colony grew, too, with indentured servants first, and later slaves, who increased agriculture, fishing and hunting production. Also, with women coming to the colony, their additional labor assisted in feeding the colony. Eventually, the settlers not only had enough food for sustainability but also extra for bartering and selling. Of note: by 1700, slavery had outpaced indentured servitude.

The merging of traditional English foods and foodways with those of Native Americans established a fusion that became the first true American regional cuisine in what would become English-speaking America.

CARIBBEAN CONNECTIONS

Another component that added to the establishment of early Virginia cuisine (of which many components are still present) was the region's strong

connection with the Caribbean. In 1492, Christopher Columbus laid claim to the Caribbean in the name of Spain, but as Spanish influence began to decline, other European empires were able to establish a foothold, including the British, Dutch and French. The English colonized Bermuda (considered part of Virginia then) in 1612 and islands forming the British West Indies beginning in 1623. Barbados had particularly strong ties with Virginia; the island was colonized in 1627. In 1655, Jamaica was taken from the Spanish by the British.

The Caribbean was a waypoint for many voyages from England on the way to Virginia; ships were laden with goods from both places and, often, slaves from Africa. Eventually, a triangular trade between these points was established, importing and exporting commodities along the way.

Often, if a ship stopped at one of the Portuguese Atlantic islands, such as Canary or Madeira, the fortified drinks named after their place of distillation would often be part of the manifest. Madeira was, in particular, a favorite of George Washington's. Nelly, his step-granddaughter, noted that he would drink three glasses after dinner.

In trade between the Caribbean and Virginia, the commodities were often molasses, rum, slaves (from the Caribbean) and sugar. Molasses and sugar had a number of uses, but foremost among those was the making of rum, particularly when rum crafted in the Caribbean was not purchased. Sugar cane had been brought to Jamestown in 1619, but it did not grow; in the tropics, it took off like weeds. The importation of sugar from the British colonies in the Caribbean helped cut down the dependence on other sources under control of other nations. Sugar and molasses are, of course, used in edibles, but sugar is necessary for the production of rum, in which the cane is crushed and juice is extracted. One process in taking the sugar cane juice to rum is by turning the raw sugar into molasses; it is this method by which most rum is distilled.

Colonial Americans often picked rum as their drink of choice, although beer, brandies (made with any available fruit), ciders made from apples and pears, other spirts and wine (imported and made domestically from native grapes) were also enjoyed. But the importance of rum—and thus the connection to the Caribbean—cannot be emphasized enough. According to A. Smith Bowman Distillery, which today crafts George Bowman Rum (a dark rum hand-bottled in Fredericksburg, Virginia), it is estimated that an average colonist quaffed three imperial gallons of rum annually. That's a staggering 308 shots—per person—in addition to other alcoholic beverages consumed. It's not surprising, then, that Governor Wyatt

established Temperance Day on March 5, 1623, in addition to imposing fines for public intoxication.

Of note: the Sugar Act of 1764 was levied on the colonies as a tariff on molasses and sugar (and other shipped goods) from countries other than Great Britain, notably France and Spain's interests in the West Indies. It was done to increase revenue to pay down British debt but hit during a time of economic depression. The Sugar Act is cited as one of the factors that led to unrest in America leading up to the Revolutionary War. Also, cost and irregular availability of rum began to turn the nation more toward whiskey drinking, which could be made easily enough with corn and rye.

While rum crafted in the Caribbean was preferred, it was often cheaper and more available to get the spirit domestically distilled, hence the need for molasses and sugar. According to the Colonial Williamsburg Foundation, by 1770, there were more than 140 rum distilleries making about 4.8 million gallons annually across the colonies. An advertisement in the March 2, 1802 *Norfolk Herald* announced the opening of a new rum crafter, GOSPORT DISTILLERY. Gosport is an area in Portsmouth. The ad read:

> *Manufacture of Rum, from Molasses; and the quantity already produced is deemed by Judges superior to that imported from the Northern States. The inhabitants of Norfolk are earnestly invited to a trial of its quality, and if they find it superior, or even equal to that which is imported, they respectfully solicit their patronage. It is now for sale at the store of Arch. Campbell, No. 112, Main-street, opposite Bank-street. William Atkinson & Co.*

But there would be other interests coming from the Caribbean, too: barbecue. On the islands, natives had been roasting meat over a grill set above a fire no doubt long before Columbus first observed them in 1492. A corruption of a Caribbean word became *barbecoa*, first noted in Spain in 1526. With the Spanish explorers' release of pigs on the islands, pork was readily available (as noted by George Percy in 1607). Part of the barbecue equation is the piquant vinegar- and pepper-based sauce. Manifests of ships arriving in Norfolk from the late seventeenth century forward show that this region was the Trader Joe's of the period. Residents had the benefit of sugar, coffee and spices—including peppers and peppercorns—regularly arriving from the Caribbean at the wharves downtown.

A Harmanson & Harvey advertisement in the (Norfolk) *Virginia Gazette* from June 7, 1774, shows shipments coming in from "West India," including

alfo (millet) flour, coffee, muscovado sugar (a sugar that includes molasses, similar to brown sugar), pimento (allspice) and ship bread (a hard, salt-less cracker).

Another Caribbean connection is JOHN REDWOOD, also known as John Pierce or John Perse. In 1693, he received the grant for lot number 47 on Main Street as Norfolk was being laid out as a town. He operated what was most likely the first tavern here, REDWOOD'S ORDINARY, until 1708. He operated a Redwood's Ordinary in Williamsburg, too, where he also was a gaoler for the colony and a caretaker for the capitol. Later, the Williamsburg inn was known as BLUE BELL TAVERN. Redwood was born in Barbados on February 5, 1661. His father, also John Redwood, was from Bristol, England. Redwood's family may have been involved in the sugar trade in the Caribbean.

1619: A PIVOTAL YEAR

The year 1619 was pivotal for Virginia as "20, and odd Negroes," according to colony secretary John Rolfe, arrived in August at Point Comfort, which is located in what is now the city of Hampton. It was the first time slaves had been introduced in English-speaking America. The slaves were taken in a raid by English privateer vessels, the *Treasurer* and the *White Lion*, against a Portuguese ship en route to Mexico. In 1616, the *Treasurer* had transported Pocahontas from Virginia to England. The exact origin of the slaves is disputed, whether African or Caribbean, or perhaps both. The Portuguese ship had left west-central Africa and stopped in the Caribbean before being boarded by the English.

It was the *White Lion* that brought those first slaves to Virginia, and the captain sold them in exchange for "victualle (food) [whereof he was in great need as he pretended] at the best and easyest rate they could," writes Rolfe. A few days later, the *Treasurer* pulled into port, bringing additional slaves.

In March 1620, when Virginia's first census was taken, the population included 892 Europeans. Also included were "[o]thers not Christians in the Service of the English," including 4 Native Americans and 32 Africans, 15 male and 17 female. Over time, slaves arrived in the New World from other parts of Africa as well, all of them bringing with them their own distinct ideas of food and how to cook it. And it wasn't just ideas, but actual foods

and dishes created with those foods, too, whether indigenous or incorporated with others. Some slaves were allowed to plant small gardens, which they used to supplement the food given to them, tending to the plots when the plantation's workday was done.

In his 1732 journal noting a visit to Virginia, Englishman William Hugh Grove recorded: "They also allow them (slaves) to plant little Plants for potatoes or Indian pease (an African legume) and Cimnells (patty pan squash), which they do on Sundays or night, for they work from Sunrising to setting." Slaves planted other items too, and these began finding their way in the gardens of the slaves' owners. Some slaves would also keep poultry and other livestock, consuming some, but also occasionally selling some for spending money. One of the foods that made the journey with the slaves was the black-eyed pea, probably cultivated in Virginia as early as the 1600s, but not widely consumed until the late 1700s. Around this time, George Washington began planting the peas at his Mount Vernon home.

Okra—also known as gumbo then—was most likely brought over in the early eighteenth century, and it was often used as a thickening ingredient in soups and stews. By the late eighteenth century, Thomas Jefferson was planting it in his gardens at his Monticello estate, and dining on ocra (okra) soup, attributed to his daughter, Martha Randolph, which some historians see as the beginning of present-day dish gumbo.

In true Virginia cuisine style of combining influenced foods and foodways, the soup blended Native American vegetables like squash with the African okra and others. It also takes the West African tradition of cooking for an extended time in a pot and serving the soup/stew over rice, a grain also brought over by slaves.

Governor Sir William Berkeley tried to establish rice cultivation in seventeenth-century Virginia, but without great success, certainly not as viable a cash crop as in colonies to the south. Peanuts (sometimes referenced as groundnuts) made a circuitous route from South America to Virginia via Africa but, like some other ingredients, weren't popularized until much later. As peanuts were often seen as a food for livestock or slaves, the white population didn't pay much attention to the goobers (which is most likely derived from the African word *nguba*) until the late eighteenth century; Thomas Jefferson recorded that he was growing sixty-five peanut hills in 1794, and a little over half a century later, the portable protein was popularized by Civil War soldiers desperate for food.

Watermelons were also introduced by slaves. Robert Beverley, historian, planter and politician, wrote in his 1705 *History and Present State of Virginia*

that "[w]ater-melons…are excellently good, and very pleasant to the Taste, as also to the Eye; having the Rind of a lively green Colour, streak'd and water'd, the Meat of a Carnation, and the Seed black, and shinning, while it lies in the melon."

In addition to ingredients, foodways were also introduced, including the use of undesirable cuts of meats and vegetables, such as ash cakes or hoecakes, candied yams, chitterlings, fatback, ham hocks, boiled or stewed greens and pigs' feet. Some of Virginia's most iconic dishes stem from the introduction of slaves, and their contributions, combined with the British, Native American and Caribbean influences, form the basis of English-speaking America's first true cuisine.

WOMEN

Jamestown was first established as an outpost for a commercial enterprise in a land where there were many unknown variables. The colonists were all male until two women arrived in October 1608: Mistress Forrest, wife of Thomas Forrest, and her maid, Anne Burras. And although women would arrive infrequently throughout the next decade, a true effort to bring women to Virginia didn't occur until 1619, when ninety single women were sent by the Virginia Company as potential wives for male colonists. Anne Burras had married John Laydon, who was a laborer and among the original settlers, by the end of 1608.

No doubt life was a hardship in the early years of Virginia, with constant threat of attack and disease—not to mention starvation. Many resources readily available in England were not in Virginia, and the wait could be months before a supply ship arrived. The mortality rate in the colony was alarming. So why would women sign up to live in such an environment? For many, they saw opportunities in the colony that they did not have back home.

During this time, life was also hard in England. Unemployment and poverty abounded, according to the Colonial Williamsburg Foundation. Increasingly, there were fewer opportunities for women, and although there were many unknown variables in the New World, many of the responsibilities a woman would have as an indentured servant or wife there would be the same had she not made the journey. In a smaller house or in the country, many women both in England and Virginia helped in the fields. In larger

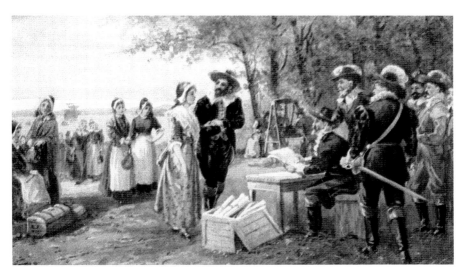

Women arrive in Virginia, Jamestown Exposition postcard, 1907. *Author's collection.*

homes, the work would include household chores such as cleaning, cooking and washing. Sometimes women had to do both.

Although two alehouses had been built in Jamestown, the daily consumption of beer was sustained by home brewing—another role that fell largely to women, although the trade of brewing leaned toward men. This was consistent with practices in England, where the majority of ale crafted for domestic use was brewed by women; it was seen as a household duty.

In regards to marriage, the ratio of male to female was much greater in Virginia than in England, especially in the first years of women coming to the colony, which increased women's chances of finding husbands. By 1625, the ratio was still three-and-a-half men for every woman. Women who married benefited from British law, ensuring them a good-sized portion of their husband's estate should he pass, giving them some financial assurances. Single women, including widows, also enjoyed the privilege of buying and selling property as well as conducting business, something a married woman was not permitted to do. Nonetheless, widows often remarried—sometimes multiple times if widowed more than once.

This patriarchal outlook was well established in Britain and, as such, wasn't a new concept to women in the New World. Even the division of gender roles among Native Americans was observed by the English. George Percy wrote, "I saw Bread made by their women, which do all their drudgery. The men take their pleasure in hunting and their wars."

There were women who bucked the system—including Grace Sherwood, born as Grace White around 1660, most likely in the area around Pungo community in Princess Anne County, which is today known as Virginia Beach. Around 1680, she married James Sherwood, a farmer in the area who received a large tract of land from his father-in-law, John White. According to tradition, Grace was outspoken and strong-willed, which drew the attention and suspicion of her neighbors. In 1698, some of those neighbors—John and Jane Gisburne and Anthony and Elizabeth Barnes—accused Grace of witchcraft. After the passing of her husband in 1701 (Grace never remarried), she was again accused—and this time formally charged—with witchcraft in January 1706. Today, she is known as the Witch of Pungo.

On July 10, 1706, she was subjected to ducking, or being tied and dunked in water with the supposition that if she drowned, she was innocent, and if she floated, she was guilty. Grace floated. The event took place on the Lynnhaven River; today, the avenue crossing Virginia Beach at that point is called Witchduck Road. Grace was imprisoned for a length of time, but she had returned to her farm along the banks of Muddy Creek by 1714 and lived there until her death in 1740. Governor Tim Kaine gave her an informal pardon in 2006.

One piece of interesting food-centric lore about Grace: she was allegedly a healer and midwife and a user of herbs in those crafts. To that point, Grace is said to have brought the Mediterranean herb rosemary to America. One story takes it a step further, saying that she floated across the Atlantic and back in a hollowed-out eggshell in a single night to retrieve the herb. Interestingly enough, there may be some element of truth in the story, as it has been common practice to transport plant cuttings in eggshells. A statue in honor of Grace, located in front of Sentara Independence (formerly Sentara Bayside Hospital), near the site of the ducking, has her holding a basket of rosemary.

Later, an influential woman in the realm of eats and drinks was Mary Randolph, born in 1762 in Chesterfield County and, orphaned, raised by her distant cousins, Thomas Jefferson's parents. She grew up learning domestic skills and, in 1807, opened a boardinghouse in Richmond, operating it until she moved to Washington in 1819. Her contribution to Virginia's rich culinary scene came in 1824 when she drew on her experiences from the kitchen and penned *The Virginia House-Wife*, a 225-page book with almost five hundred recipes. It is recognized as the first regional American cookbook.

The Virginia House-Wife epitomized what had become Virginia cuisine: recipes using Virginia products for dishes not only influenced by Great Britain but also France—Americans had a strong affinity for the French following their assistance in the Revolutionary War—Africa, the Caribbean and Native Americans. Culinary luminary James Beard said Randolph was "a far-seeing culinary genius" in a 1982 interview in the *Richmond News Leader*. In a 2014 essay for *National Geographic*, star chef José Andrés said Randolph was an influence on his career.

The Virginia House-Wife has been reprinted numerous times, with commentary and recipes adapted to more modern palates. One such reprint was by the University of South Carolina Press in 1984. In it, American culinary historian Karen Hess wrote, "Mrs. Randolph left her own imprint on these Virginia recipes," noting the blending of influences of "Indian, African Black, and Creole." She noted that Randolph's work "has been transformed in various ways to respond to local produce and talents. In short, an authentic American cuisine."

COLONY GROWTH

With the arrival of new settlers, including women, and the introduction of slave labor, the colony began to grow outside the realm of Jamestown. By 1638, an area called Middle Plantation had been established about twelve miles away. Focus was given to this centrally located settlement, especially after the 1676 Bacon's Rebellion uprising when Governor William Berkeley temporarily moved the seat of government there while the statehouse at Jamestown, which had been burnt and destroyed during the insurrection, was rebuilt. Following the establishment of the College of William & Mary in 1693 and another burning—this time accidental—of the statehouse in 1698, the capital was permanently moved from Jamestown to Middle Plantation, which was laid out formally as a town and renamed Williamsburg after King William III of England. It remained the capital of Virginia until 1780, when the seat of government moved to Richmond.

It was also during this growth period that food was being used to define class and social standings. The grand Governor's Palace projected elegance and a British authority. There was a staff of slaves and servants to prepare and serve meals, including trained European "principal cooks." The finest kitchen equipment and serving pieces were employed, and an invitation to

dine there firmly showed one's place in the colony. Although not as opulent as the Governor's Palace, homes of the Virginia gentry also showed status through food. At this level, skilled slave cooks could still put out an impressive meal with a number of courses, including sweets. According to the Colonial Williamsburg Foundation, Lydia Broadnax was one such cook who gained a reputation for her culinary prowess preparing food for the Wythe family. After years of service, she was granted freedom.

In the middling class, less variety or quantity of food would have been enjoyed, although they would have entertained from time to time and enjoyed richer dishes occasionally. Most of the cooking would be done by women in the household, although the Colonial Williamsburg Foundation says upper-middle-class families may have had slave cooks in their employ. While many folks have varying images of colonial Virginia from the ruling classes—well-appointed dining rooms with a groaning sideboard filled with roast meats and decadent desserts—the fact is, most folks in the colony didn't live that way.

The lower classes lived simply due to their poverty. The focal point of the living quarters, the fireplace, doubled as a source of heat for the home and cooking quarters, whereas some had a separate kitchen space. Resting on or above the hearth, the mistress of the house would prepare simple meals, often in one pot due to the lack of other kitchen equipment. According to the Colonial Williamsburg Foundation, a typical meal would be hominy (coarsely ground corn), perhaps flavored with salt-cured pork and vegetables.

With the establishment of a larger town, and ever-growing colony, there became an ever-increasing need for gathering places to eat and drink and for food and lodging for travelers.

ORDINARIES, TAVERNS AND INNS

Taverns, initially known as ordinaries, began popping up in colonial Virginia by the mid- to late seventeenth century. These mimicked, in many ways, the same ordinaries and taverns that had been in England. Some were barebones and basic, while others were more elaborate and expansive. The quality of food greatly varied; some taverns were noted for excellent fare, while others served up dishes that were barely edible.

Taverns provided several functions: in more rural areas, on a journey between Norfolk and Williamsburg, a traveler might stop to spend the night,

get something to eat and drink and catch up on the local happenings. There might be some locals, too, but to a much lesser degree than in towns due to population density. In towns, taverns provided accommodations for travelers as well as locals who stop by for a tipple or two and to exchange ideas, information and news. By default, many taverns became clubhouses for those who frequented them. Later, it would be that exchange of ideas and information in taverns in which the seeds of disenchantment with Mother England would be sown, leading up to the Revolutionary War.

Many times, taverns were established next to courthouses, where folks would come from all over to conduct business. After a growth period, Virginia was divided in 1634 into eight shires, which began a division along the lines of what we now know as counties. The original eight shires were Accomack, Charles City, Charles River, Elizabeth City, Henrico, James City, Warrosquyoake and Warwick River. As the colony's population grew, the shires expanded too, not only within the division of the original eight shires, but with the formation of others as well, within and beyond the Coastal Virginia region. For travelers in a stagecoach rather than alone on horseback, the passage price often included food at stops at inns and/or taverns.

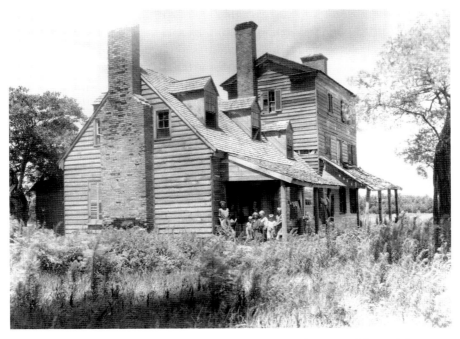

Old Bird's Nest Tavern, Marionville vicinity, Eastern Shore, circa 1935. *Library of Congress.*

The formation of these ordinaries, taverns and inns (the name *inn* began coming into fashion with larger facilities that had a specific offering of lodging) was instrumental in establishing a sense of community in Virginia—many restaurants fill that role today. One of the main differences between these ordinaries, taverns and inns, however, is that folks dined from a fixed menu of the tavern keeper's choosing and at a fixed time, also set by the proprietor. Meal service was often family-style, where a large platter or pot of food was set in the middle of a table and passed around for folks to serve themselves.

The menu at an ordinary, tavern or inn largely depended on what was available to the establishment owner, and that's why there are few indications of what was eaten, other than descriptions by guests who took note in diaries or journals. What menu there was, if it was even written out, typically was a list of what was being prepared that day. Often the meat was chicken or pork, but in Coastal Virginia, it could also be augmented with seafood—clams, crabs, fin fish or oysters. Because of lack of refrigeration, except in the coldest of months, the food was either fresh or preserved in some way—brined, cured, pickled, potted, salted or the like. Hot dishes would have been boiled, baked or fried or served cold/at room temperature, especially in the case of preserved foods.

Breakfast was often the largest meal of the day, often supplemented with eggs, with lunch and supper served midafternoon and early evening respectively, frequently being lighter. Following along the lines of a British diet, pasties, pies (savory and sweet) and puddings were often served. Alcohol was served with meals, but varying laws prohibited or strongly discouraged public drunkenness or drinking on Sunday. Somewhat related to dram shop laws today, the tavern keeper would sometimes be held responsible for serving too much alcohol to a guest. The drinks were often ales or other styles of beer the tavern keepers crafted themselves; hard ciders crafted from what fruit was available were common too. Wine was popular, and early cocktails comprised rum by the drink or in punches or wine turned into sangrias or sangarees.

Information about colonial-era taverns is spotty at best; what is known largely comes from advertisements, court records (legal actions, licensing) and diaries. Notable ordinaries, taverns and inns in Coastal Virginia include:

REDWOOD'S ORDINARY. Perhaps the first tavern keeper in Norfolk when the town was first established in 1693, Redwood, whose family had, most likely, been in the molasses/rum/sugar business in Barbados (where he was born on February 5, 1661), received a grant for Lot 47, on Main Street, almost directly north from what is today the Dominion Tower

Daphne Room, Raleigh Tavern, Williamsburg, circa 1935. *Library of Congress.*

in downtown Norfolk. Here Redwood established Redwood's Ordinary. When the capital of Virginia relocated from Jamestown to Williamsburg (previously known as Middle Plantation), Redwood opened a tavern there too, under the same name, and also became the jailer (spelled *gaoler* at the time) and caretaker of the newly built capitol building there. It seems the Williamsburg location of Redwood's Ordinary closed shop in 1708, and in 1719, Lot 47 in Norfolk also sold.

Although Redwood's menu would change often, depending on what he purchased from the nearby Market Square in Norfolk, located along the shores of the Elizabeth River or caught in the creeks that ran through town, his general offerings of drinks were known. At the time, the prices of beverages were regulated by the county court. According to Norfolk County records, patrons would have enjoyed:

Rum, priced at 6 shillings per gallon
Punch, "if made good," at 16 pence per quart
Cider, 12 pence per gallon
Small beer (a lower alcohol brew), 7-1/2 pence per gallon
Madeira, 22-1/2 pence per quart
Milk Punch, 7-1/2 pence per quart
Claret, 3 shillings, 3-1/2 pence per quart
Meals per priced at 3-3/4 pence.

Another notable early Coastal Virginia tavern was the PLEASURE HOUSE TAVERN. Not much information about the tavern is available, although it would have been located near the Chesapeake Bay in the late seventeenth and/or early eighteenth century in what is today Virginia Beach. The legacy of the tavern—which is believed to have been owned and operated by one of the region's pioneers, Adam Thoroughood—lives on today with the naming of the north–south corridor called Pleasure House Road. Although the name sounds salacious, it was named for the good times enjoying a drink, playing a game and visiting with others—and not as a brothel. Local historian George Tucker noted that an early map from the 1700s pinned the location "near the present south end of the Chesapeake Bay Bridge-Tunnel." The map may have been a 1781 plat titled *Plan of Princess Anne and Norfolk Counties* drafted for Benedict Arnold during the Revolutionary War.

The tavern also played a patriotic role during the War of 1812; a lookout post atop the building provided soldiers a vantage point when watching for the British entering the nearby waterway. A letter in 1812 to Governor James Barbour described Pleasure House Tavern: "It is a suitable lounge for Gamblers, tipplers, & those gentry of pleasure." A notice in the May 21, 1785 edition of the *Virginia Gazette and Weekly Advertiser* noted that the CARAVAN & PHILLIPS COFFEE-HOUSE in Portsmouth was a "large brick house by the river side" where all vessels were visible and offered the "genteelest treatment, as good servants are provided."

Many taverns would open and close during the first two or so centuries of history in Coastal Virginia, and their legacy continues in Colonial Williamsburg. The colonial capital has gone to great lengths to reconstruct several taverns (along with other buildings), which are open today to visitors. Want a taste of history? Here are some places to visit:

CHOWNING'S TAVERN is open for meal service with period-inspired dishes. Josiah Chowning operated the tavern on the Court House Green as an alehouse, as announced in the *Virginia Gazette* on October 10, 1766. Two years later, it changed hands; new owner William Elliot promised "all Gentlemen…good accommodation for themselves, servants, and horses, and the best entertainment."

CHRISTIANA CAMPBELL TAVERN is open for meal service with period-inspired dishes. Campbell kept her tavern from 1755 through the next ten years or so, to provide income for herself and her daughters following her husband's death. Among her notable patrons were Thomas Jefferson and George Washington, who, tradition says, favored seafood here.

KING'S ARMS TAVERN is open for meal service with period-inspired dishes. Jane Vobe, who promised "good eating" in a place "where the best people resorted," opened the original King's Arms Tavern in 1772.

King's Arms Tavern, Williamsburg, circa 1965. *Author's collection.*

R. CHARLTON'S COFFEEHOUSE is open for tours with samples of period-inspired (drinking) chocolate and coffee. Opened in the early 1760s by Richard Charlton, the coffeehouse operated for a decade, serving the likes of George Washington and Thomas Jefferson. Near to the capitol, it was a center of activity.

RALEIGH TAVERN operates as a museum and is open for tours. This was one of the largest taverns in colonial Virginia, and the Apollo Room, a large banquet hall within, saw many famous Patriots pass through, including Patrick Henry. Above the mantel was the Latin phrase *Hilaritas sapientiae et bonae vitae proles*, or "Jollity is the offspring of wisdom and good living."

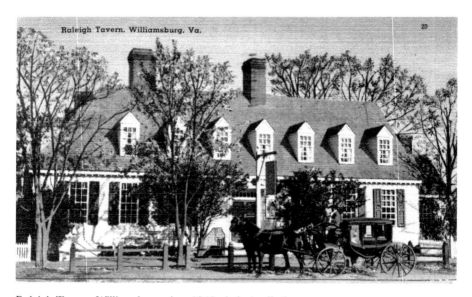

Raleigh Tavern, Williamsburg, circa 1940. *Author's collection.*

SHIELDS TAVERN is open for meal service with period-inspired dishes. Originally Marot's Ordinary, owned by John Marot, the property passed to his daughter, Anne, following his death and became Shields Tavern in 1705 after she married James Shields.

Also in Coastal Virginia, the SMITHFIELD INN, once known as Syke's Inn, first opened in 1752 and hosted such notables as George Washington. The inn is still open, operating as a bed-and-breakfast with meal service that includes upscale southern-inspired menus, including amazing biscuits stuffed with Virginia-style country ham. Taverns in this realm began to

decline by the early to mid-nineteenth century, replaced by various other forms of eating, drinking and lodging services such as restaurants, bars and inns/hotels. By the late nineteenth century and into the twentieth, the term *tavern* was often used interchangeably with bar.

FIRST TRUE RESTAURANTS EMERGE

Dining out is such a part of our lives that it is hard to imagine a time without restaurants. And although ordinaries, taverns and inns served eats and drinks during the colonial period, they were not restaurants in the sense that one dines from a menu of options, at a time of one's choosing. The French Revolution, in the latter part of the eighteenth century, not only changed the political and social landscape of that country but also had a far-reaching global impact. This cultural shift included laying the groundwork for the first true restaurants to emerge.

The democratization taking place during that time, and the climate leading up to the revolution, came when strict guilds, which had been granted dominion by the king to control who could produce certain foods for sale, were relaxed. With the guilds in place, a cook who roasted meats, for example, would not also be allowed to prepare any other food in any other manner.

With the monopoly on food service no longer in place, equal opportunities emerged not just for cooks—who were looking for gainful employment after the dissolution of aristocratic houses—but for middle-class diners, too. A new market of food service with meals prepared by anyone with the desire and skills to prepare them was open to a new market of customers. From this came a *carte*, or "menu." A diner could sit down, make a selection from any number of offerings and have it prepared to order. Diners would pay the same prices for the same portion sizes. Food would be presented to diners on individual plates, rather than a communal platter or pot being passed around.

The basis of the name *restaurant* comes from the words *restore* and *restoratives*, given that enriching bouillons, broths, consommés and soups are meant to restore one's strength. Not surprisingly, as the concept spread outside France, restaurants were set up first in towns where there was a larger audience for this new way of dining. Jean Baptiste Gilbert Payplat, a French expatriate and former cook for the archbishop of Bordeaux, opened

his restaurant, Julien's Restorator, in Boston in 1794; it is considered one of the first restaurants in America.

According to David S. Shields, a noted food historian and the Carolina Distinguished Professor at the University of South Carolina:

> *While numbers of institutions offered meals and hospitality at the beginning of the 19th century, no one placed quite the premium on the food. Taverns and inns were all about the beverages. Coffeehouses were about stimulants as well as alcohol. Hotel saloons aspired to a certain splendor in repast, but the menu was table d'hote rather than à la carte, the hallmark of the restaurant.*

Shields has also received the highly respected Ruth Fertel Keeper of the Flame Award from the Southern Foodways Alliance.

In Virginia, the first true restaurant was DANIEL SCHELLING'S RESTORATIVE, according to Shields. Schelling advertised the opening of his restaurant in the September 4, 1820 edition of the *Norfolk American Beacon*. It was located in "the fire proof house belonging to Mr. Arthur Taylor, the third door above the Post Office." The restaurant offered "superior coffee, early in the morning," as well as soup prepared "every day, by eleven o'clock" in the morning, as well as "beef steaks, oysters, or other relishes" at any time until ten o'clock in the evening. No other tidbits about Schelling have been found, although, according to Shields, he may be the same Daniel Schelling who died in New York City in 1825 at age fifty-five. "Whatever the case, he should be recognized as the first restaurateur in the Old Dominion," said Shields.

3

Turn of the Twentieth Century

Beginning in the 1870s, around the time the Reconstruction years of the Civil War were coming to an end, a lot was happening in America, including Coastal Virginia. The nation was expanding, and opportunities stretched from coast to coast, linked by the transcontinental railroad. And not every young person went west. Some, such as Chinese laborers from the West Coast—California in particular—migrated east across the country, bringing with them their heritage and lifestyle, including their foods and foodways. The nation also geared up with the expansion of industrialization, which did make a small group of folks very wealthy but also distributed money across the increasing workforce, meaning more disposable income for entertaining, including indulging eats and drinks. That might mean a day at a seaside resort or a night out on the town.

It was the time of the Gilded Age, the Gay Nineties, technical advances such as the first powered flight by the Wright Brothers in Kitty Hawk, North Carolina, in 1903 and huge ocean liners like the *Titanic*. But it also was a time when the temperance movement, which advocated abstinence from alcohol, was starting to reach its pinnacle. It would succeed in Virginia in 1916 (after severely hindering the ability to enjoy a drink with the passage of the Mann Act in 1903) before the rest of the nation went dry following the ratification of the Eighteenth Amendment in 1919, ushering in Prohibition.

LET'S DO LUNCH

Industrialization increased the American workforce, prompting exponential growth in the number of lunchrooms and dairy lunches in the late nineteenth and early twentieth centuries. Workers needed a place to go outside of the factory or office to get a bite in case they had not packed lunch from home. Also, lunchrooms and tearooms grew in favor with women who were not in the workforce as a way to get out of the home and socialize. The term *dairy lunch* is a bit confusing; when the phrase came into fashion, businesses emphasized "wholesome" dairy products, such as milk or cheese. Part of this was due to a public awareness of eateries that did not practice proper sanitation or whose offerings were otherwise suspect.

Some of these misgivings gave rise to the Pure Food and Drug Act of 1906, the beginning of consumer protection laws to prohibit foods (and drugs) that did not meet a level of standards or were mislabeled. Later, the term *dairy lunch* evolved to be almost synonymous with lunchroom in general. By the mid-twentieth century, lunchrooms (and lunch counters at pharmacies and tearooms in department stores) were alive and well, but the phrase *dairy lunch* was falling out of favor.

One of the first mentions of a dairy lunch was in an advertisement on December 22, 1894, that showcases a menu of French drip coffee, tea, (hot) chocolate, pure milk, sandwiches and a cut of pie priced at five cents each at the VIRGINIA DAIRY LUNCH at 99 Main Street in downtown Norfolk. Another ad, from January 3, 1895, promotes the concept of a wholesome meal: "In purity there is health, is the motto of the Virginia Dairy Lunch. Patronize it. Open all night. 99 Main Street near Commerce street." Folks must have patronized it; by February, a second location at Market Square was in operation.

The same year, MAC'S DAIRY LUNCH ROOMS (owned by R.W. MacDonald), which had two locations in downtown Norfolk, was serving "pure, fresh milk" at five cents a glass but offered another choice: buttermilk. They promoted ice cream, "tables for ladies" and "the only good coffee in the city." On October 21, 1895, Mac's expanded, as reported in the *Virginian-Pilot*: "Something long needed in this city has been opened at 142 Church street, and it is no less than a ladies' lunch room by Mac, well known dairy lunch room. The place is handsomely fitted up and beautified profusely with flowers and ferns…a cordial invitation to the ladies to inspect the coffee, [hot] chocolate and other good things provided for them."

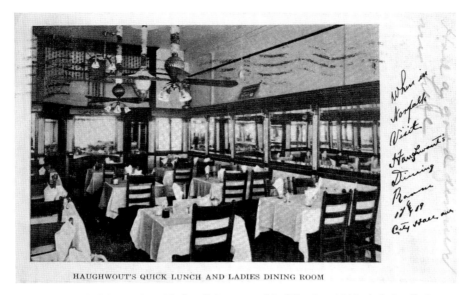

HAUGHWOUT'S QUICK LUNCH AND LADIES DINING ROOM

Haughwout's Quick Lunch and ladies dining room, Norfolk, circa 1910. *Author's collection.*

An interesting case against a MacDonald dairy lunch came up in the *Virginian-Pilot* in June 1906:

> *The Virginia club has brought unlawful detainer proceedings against McDonald and Co., renters of a little store under the club* [in downtown Norfolk]. *The club men have lately been annoyed by the odors of cooking which float in through the big club windows on hot nights. The Virginia club claims that the store was rented with the agreement that there was to be no cooking done in it. The fried-egg sandwich craze broke up the contract.*

In Portsmouth, a new dairy lunch opened, as the newspaper reported on October 23, 1895: "Mr. Lewis Morton has opened up a first-class dairy lunch at the corner of Crawford and High streets and is putting up a dandy article in the way of 'quick snacks.' The Bijou eating house has the bull's eye of public favor." Four days later, the paper gushed about another Portsmouth eatery: "Mr. F.D. White assumed charge of the Portsmouth Dairy Lunch, located at 418 Crawford street, near High, yesterday morning. He will be pleased to see his many friends who will find a first-class lunch at all hours. Mr. White is an experienced 'chef' and from the writer's trial, will please any who may become his patrons." It seemed that male patrons were what

SUFFOLK DAIRY LUNCH, in Suffolk, was calling for in its August 24, 1904 ad: "For the Business Man. The Man who comes to Town. The Man about Town—And all other men…Everything a Nickel Each."

A giant headline in the March 29, 1907 *Virginian-Pilot* newspaper announced "N.Y. Caterers Invade Norfolk," saying that the WHY DAIRY LUNCH COMPANY, a "famous New York restaurant company," was setting up shop at the southeast corner of Main and Commerce Streets. The paper reported, "Five thousand or more dollars will be spent in fitting the interior of the corner store, and the upper floors will be utilized for sleeping purposes, it is said. A feature of the new restaurant will be exclusive white help, including the waitresses, who will be brought from New York, where the firm has a number of eating houses."

DRINK, DON'T DRINK
Prohibition

Virginians were a drinking lot—from beer to spirits like rum and whiskey to wine—during much of the colony's first three hundred years. In 1916, on the cusp of Prohibition, the *Virginian-Pilot* acknowledged, "Virginia…had been a friend to liquor since John Smith and his followers established the first permanent settlement at Jamestown Island in 1607." Over the years, there were occasional laws to curb public drunkenness and also pushes for temperance, some beginning in the late eighteenth century as alcohol production proliferated and booze was cheaper. Folks noted an increase in alcoholism and the social issues that follow it. By 1800, a temperance association had formed in Virginia; it formally railed against the production and sale of intoxicating beverages.

Toward the end of the nineteenth century, the movement had a stronghold in Virginia and across the nation. In 1901, the Virginia Anti-Saloon League was founded at a meeting in Richmond, and the June 7, 1902 *Virginian-Pilot* reported, "The Anti-Saloon League of Virginia is preparing to establish temperance saloons in various portions of the state. They will consist of reading-rooms, parlors and soft-drink counters. Several have already been established, and there has been a decrease in drunkenness in those localities."

Four years before the national ban on alcohol sales, Virginia went dry on November 1, 1916, with the Mapp Law, thanks to the efforts of the Woman's

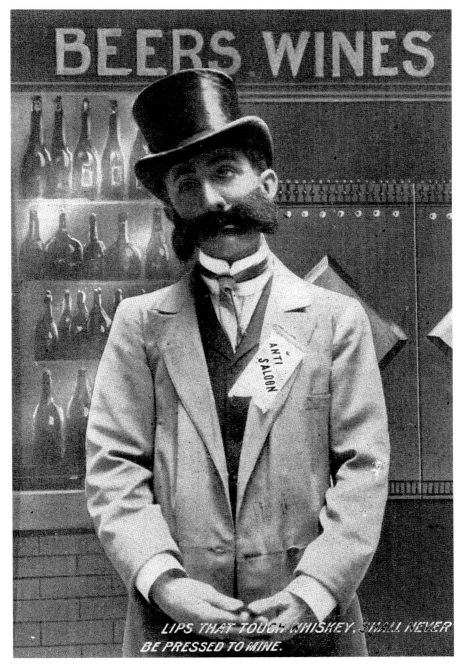

Anti-Saloon League propaganda postcard, circa 1900. *Author's collection.*

Christian Temperance Union and the Anti-Saloon League. Laws like the 1903 Mapp Law and 1908 Byrd Law set many industry-killing restrictions in place. This affected a wide group of Virginians: most bar and saloon owners, brewers, distillers and winemakers were forced out of business if they were not able to adapt to another line of business. It also affected restaurant owners, who had to forfeit alcohol on their menus. The Mapp Law was strict, defining "ardent spirits" as "alcohol, brandy, whiskey, rum, gin, wine, porter, ale, beer, all malt liquors, absinthe, and all compounds or mixtures of any of them."

Of course, there were ways to get a drink if you wanted one. Some folks turned to making small batches of alcohol in their homes, and others had larger-scale operations. (Consider Virginia's long history with moonshine.) In homes and in the back of businesses, speakeasies, serving spirits on the sly, popped up. Many roads in Coastal Virginia were rural and much of the coastline desolate, making transportation, especially at night, difficult for authorities to prevent smuggling.

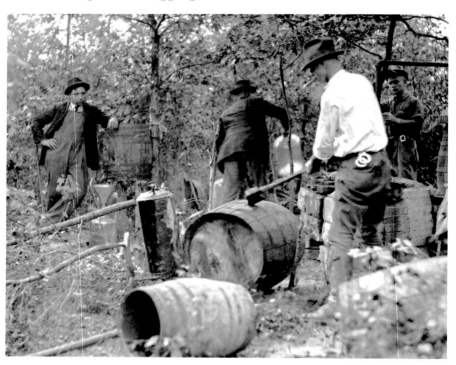

Law enforcement officers destroying moonshine still in Virginia Beach, circa 1925. *Library of Congress.*

On the last legal day of alcohol possession in Virginia—October 31, 1916—the *Virginian-Pilot* wrote, "At midnight tonight the guillotine will fall upon the head of Old Man John B. Tanglefoot, a resident of Virginia since 1607....[T]he boisterous revelry in some of Norfolk's clubs and saloons will be in marked contrast with joyous thanksgiving in many homes and in the churches." Because of the anticipated antics as folks had one—or more—last legal drinks, Norfolk's mayor issued orders not allowing certain Halloween activities in areas where bars were concentrated "on Main, Granby, or Church streets." But the paper also reported that some saloons were already closed, "depleted of their stocks" in a run by customers leading up to the final date. They noted that in Portsmouth, "[o]ne of the bars at County and Crawford streets was dark last night for a tiny electric globe that cast its faint rays over a desolate scene of empty shelves, abandoned glasses, and general disorder."

A legacy of Prohibition still remains in Virginia today: the Department of Alcoholic Beverage Control (ABC), established on March 7, 1934. This state agency regulates all aspects of alcohol sales in the state, even running all the retail liquor stores across Virginia, although beer and wine can be sold in shops such as convenience stores and supermarkets. The liquor sales extend to Virginia's restaurants too: spirits must be purchased through the ABC. The agency also restricts the amount of alcohol a restaurant can serve based on a formula of how much its overall sales include food and regulates the wording in advertisements, such as forbidding phrases like "Happy Hour" to describe drink specials. Until 1968, Virginia restaurants were prohibited from selling drinks, and for a time after that, customers couldn't stand or walk while holding an alcoholic beverage.

Breweries

From the very beginning, beer was a beverage that Virginians drank for both enjoyment and from necessity, since it was safer (through boiling the water and with the addition of hops) than drinking water itself. There were alehouses that popped up at Jamestown, but with the lack of commercial brewers at the time, for much of the seventeenth century, beer was made at home. That changed as the colony grew and with the advent of true towns around the end of that century.

By the nineteenth century, a shift had occurred with the upswing of breweries as we think of them now: places that manufacture on a larger

scale beer for sale to the public and/or restaurants/saloons. One of the most notable local beer bottlers of the time was CONSUMER BREWING CO., which began operations on the Lesner's Park property (purchased for $16,500) at Church Street and Washington Avenue in 1896. In September of that year, the brewery announced: "Ready for Delivery, Elk Beer. Pure, Fresh, Home Brewed," with a large stag as the mascot. The *Virginian-Pilot* reported on September 5 of that year, "The Consumers Brewing Company in Huntersville has placed its beer on the market and it is pronounced very fine by those who have tried it. This large home enterprise should receive the liberal patronage of Norfolk citizens. Call for Elk beer when thirsty." A September 11, 1896, ready reference guide named Consumers Brewing Co. and PABST BREWING CO. as brewers in the city.

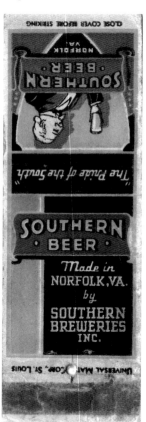

Southern Beer, "The Pride of the South," brewed in Norfolk, circa 1925. *Author's collection.*

In addition to Pabst, still a big name in brewing, ANHEUSER-BUSCH opened up operations in 1896 too. The July 23 *Virginian-Pilot* reported, "Persons passing along City Hall avenue of late notched a large pearl-colored building. It is the new ice and bottling house of the Anheuser-Busch Brewing Association of St. Louis. The ice house is in the front part of the building and the bottling department in the centre. Yesterday the first beer was delivered. About one year ago this beer was first introduced here." Some ads from Anheuser-Busch during this time promised quite a bit from the King of Beers, including, "All doctors prescribe the Anheuser-Busch Beer for invalids and delicate females"; "The greatest luxury at watering places is the Anheuser-Busch beer"; "The temperance people indorse the Anheuser-Busch beer as nourishing and non-intoxicating"; and "Delicate persons and nursing mothers should drink the Anheuser-Busch beer." Ads also noted: "The Anheuser-Busch Beer is now the attraction at Ocean View, Virginia Beach and Old Point Comfort," and "All leading saloons at Norfolk draw the Anheuser-Busch beer. Ask for it."

Four years later, the 1900 Norfolk, Portsmouth and Berkley city directory listed—in addition to Consumers Brewing and Anheuser-Busch—BAY VIEW BREWERY, CHRISTIAN HEURICH BREWING

Co., L. Hoster Brewing Co., Old Dominion Brewing Co. and Robert Portner Brewing Co. These would all go by the wayside with the implementation of Prohibition, but others would open or reopen following the seventeen-year dry period, including Consumers Brewing, which operated under the name Southern Breweries from 1934 until 1942.

In Newport News, four breweries were operating around the turn of the twentieth century: Leo Schulz Brewing, Haven View Brewery, W.H. Davis & Co. and Old Dominion Brewing and Ice Co. An interesting beer tie to Virginia Beach: although Coors beer was not sold east of the Mississippi River until 1981, the brewery's founder and namesake, Adolph Coors, age eighty-two, came to the Cavalier Hotel in Virginia Beach in April 1929 to restore his health following a period of illness. It wasn't uncommon during that period for folks in poor health to seek out fresh salt air. He was a guest until the early morning of June 5, 1929, when, for unknown reasons, he climbed out of a sixth-floor window and fell—or leaped—to his death. Was it an accident or suicide or perhaps murder? It is still a mystery.

Garrett Winery, Virginia Dare Wine

Wine was being imported to the new colony of Virginia, but it was often expensive to bring it from its European places of origin. The solution was to craft wine here, and not just for settlers, but also to ship back to England. In 1609, wild native grapes were gathered, pressed and fermented, making about twenty gallons in the process. It didn't work; one colonist described the taste as foxy and the fragrance as that of a wet dog. Things didn't improve over time to make a true table wine; there was success with fermenting fruits such as apples and peaches into brandy, cider and wine, but it wasn't quite the ticket. Although crafted with—largely—scuppernong and other non-vinifera grapes (the grape used in traditional wines), one regional winery found great success.

Paul Garrett was born about 125 miles southwest of Norfolk in 1863. He began a seven-year apprenticeship at age fourteen under his uncle Charles Garrett in the family wine business. Following the death of his uncle, he started his own winery called Garrett & Company. It began Paul Garrett's lifelong love affair with American wine. But the temperance movement was on the rise, and prohibition loomed in North Carolina, Garrett's base of operations. Garrett decided to move his winery to Norfolk in 1903, building a five-story winery at the site of a former marine hospital (which became

his residence) at the foot of Chestnut Street in the Berkeley section, just across the Elizabeth River from downtown. The impressive brick building was capped off with "the largest clock on earth," by which folks arriving on the ferry traversing the river would set their watches. A vineyard was planted along Pearl Street, augmenting grapes from vineyards in North Carolina. There is no other Coastal Virginia winery listed in city directories or mentioned in newspaper articles or advertisements during this period, although there may have been some operating on a much smaller scale, as some ads for liquor stores do reference the sale of "native wines."

A September 24, 1903 report in the *Virginian-Pilot* explains that the facility pressed scuppernong grapes through crushers, sending the juice into fermenters; the first juice drawn "is the choicest stock, from which two fine wines—champagne and scuppernong—are made." The article also notes that "[t]he Berkley plant has a storage capacity of two million gallons in its cellars." Garrett's Special Champagne, a méthode champenoise crafted from scuppernong, received the grand prize for sparkling wines—over offerings from California and France—at the Louisiana Purchase Exposition of 1904 (informally known as the St. Louis World's Fair). Of note, it was at the same exhibition where Abe Doumar popularized the ice cream cone; Doumar's is a Norfolk landmark.

Prohibition again came calling on Paul Garrett; Virginia enacted laws to take the state dry on Halloween 1916. The *Virginian-Pilot* reported on July 2, 1916: "The disastrous effects of prohibition upon the large manufacturers of wines and cordials, beers and ardent spirits" occurred when the winery shipped 4,300 cases of wine in the process of moving the plant to New York, which was not facing becoming dry, at least immediately. The newspaper called it the largest shipment of wine ever made in America before that time. "When the prohibition law goes into effect here, on the first of November, the Berkley plant will move to a unit in the Bush Terminals, New York, where he has arranged for facilities."

Prohibition followed Garrett to New York, and it went into effect nationwide four years later. Like so many others in the alcohol production business—large and small—he tried what he could to keep things afloat. Soft drinks were added to his line, including a grape soda. A de-alcoholized "wine" under his signature Virginia Dare label was released, which allowed consumers to add their own spirits, if they wished. A grape syrup called Vine-Glo made the process even easier, which made crafting wine at home with the product a relatively simple task. Wine was also made for sacramental purposes, which was an exception made in the Prohibition law.

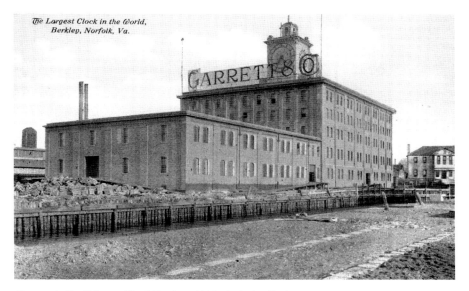

The Largest Clock in the World,
Berkley, Norfolk, Va.

Garrett & Co. Winery, Norfolk, circa 1910. *Author's collection.*

Unlike many other brewers, distillers and winemakers, Garrett was able to ride out the dry spell until the Eighteenth Amendment was repealed on December 5, 1933. The company changed hands and locations over time. Today, the Family Coppola (which produces other wines, including under the name Francis Ford Coppola Winery) in Geyersville, Sonoma County, California, produces a Virginia Dare brand (using original artwork as inspirations for the labels) that includes a Chardonnay, Pinot Noir, red blends and a hard apple cider.

Despite Prohibition, a newspaper reported, "Mr. Garrett seemed very optimistic in regards to the future of the large wineries." In a letter to the *New York Times* in December 1935, Garrett (who was dubbed the "Dean of Wine Makers" in an article in *Fortune* magazine the prior year) asked, "How many have drunk the noble claret of Virginia?…The Old Dominion is indeed the mother of wine-growing in America." When the Garrett Winery closed operations, the Imperial Tobacco Company moved into the building. On June 30, 1919, the building was destroyed by a fire of unknown origin, with two firemen dead and two hurt in the blaze. Garrett died on March 18, 1940.

Soft Drinks

There had been sweetened carbonated beverages before Coca-Cola came onto the scene in 1886, but once folks started tasting the concoction from Atlanta pharmacist John Pemberton, taste buds soon changed around the world. That was especially true in Coastal Virginia when, in the May 27, 1887 *Virginia-Pilot*—on the front page no less—an ad appeared that read: "Coca Cola! The Pleasant Exhilarant. Refreshing and Invigorating Popular Soda Fountain Drink containing the tonic properties of the famous Kolanuts, and Pemberton's French Wine Coca Which destroys the taste for alcoholic stimulants."

That last statement is important, as soft drinks were not only refreshing on their own, but, increasingly with the call for prohibition of alcoholic beverages, also seen as wholesome alternatives. To that point, soft drinks were finding their way into traditional drinking establishments, too. A Coca-Cola ad in 1905 announced that "the most refreshing drink in the world" was "at all saloons, groceries, cafes and stands" and sold at five cents a bottle.

Through the next few decades, several homegrown soft drink companies sprang up. One such soda was GIN-GERA, a ginger ale–type concoction bottled in Norfolk beginning in 1912. By 1914, the company had grown so that it expanded into a 10,000-square-foot home that President F.B. Howard said would be the most up-to-date manufacturing establishment of its kind in the country. Norfolk even sponsored a Gin-Gera Day on July 17 for the public to tour the north Granby Street facility and sample the drink. The *Virginian-Pilot* reported that the soda was "a Norfolk creation, having originated in this city and was first sold over the counters here" and that, now bottled and sold all over the country, "the labels carry the fact that Norfolk is the home town." Ads said the soft drink was "healthful" and "refreshing" and "It gingers you up," accompanied by images of Gin-Gera's mascot, a rather Grateful Dead–looking dancing bear.

Not far away, at the corner of Church and Twenty-Sixth Streets, LEMON-KOLA was selling a Sprite-type carbonated beverage, opening its Norfolk distribution center in 1916. The *Virginian-Pilot* reported on April 17 that "in addition to being a splendid invigorator and thirst quencher, is a health drink especially fine for children and delicate systems, being made of lemons and other healthy ingredients, which makes it a home drink and one all may take without the least fear of consequences." A large painted notice on the side of the building reassured a public often skeptical of the purity of foods of the time: "It's Sanitary in Bottles." Among the more than two

Nisco was a soft drink
bottled in Norfolk, circa
1910. *Author's collection.*

dozen places it was sold were Diggs Pharmacy, D. Pender's lunch counter, both on Granby Street; Krauss Confectionary at the Colonial Theater and Holland Confectionery on Botetourt Street; and at the lunch counter at F.W. Woolworth Co. on Main Street.

Also in 1916, Nisco cola came onto the scene from the Consolidated Bottling Works in downtown Norfolk. The unusual name came as the result of a contest; Hunter Price of Norfolk and R. Howard of Newsoms, Virginia, won twenty dollars in gold as the first prize for selecting the moniker. Others won two dozen cases of the soda (which sold for ninety cents a case) for folks who came up with the next-best suggestions. Those suggestions included Bon Ton, Creamokola, Dixie Cola, Knoxall, Norkola, Pep, S.O.S., Sunny South and Queen Cola.

With the onset of Prohibition, other soft drink bottlers came onto the scene too, completely out of necessity. Breweries—mostly—had a lot of capital involved in their production lines, and they came out with sodas and

fruit juices to keep the factories running. But overall, it was Coca-Cola and Pepsi-Cola (and a handful of other large regional or national brands) that had staying power; the other soft drink bottlers did not, and their memory is relegated to the occasional find of a dusty, empty bottle in an antique store.

OYSTERS' GOLDEN ERA

Oysters had enjoyed a good, long run as a favorite eat for Virginians by the start of the nineteenth century. During the early 1800s, a new era for the oyster was ushered in, its first Golden Age.

In 1885, a poem underscored the love affair, waxing poetic about the oyster: "We try him as they fry him/And even as they pie him/We're partial to him luscious in a roast/We boil him, and we broil him/We vinegar-and-oil him/And, oh! he is delicious stewed with toast."

On March 30, 1837, the future emperor of France, Prince Charles Louis Napoleon Bonaparte, arrived in Norfolk, staying at FRENCH'S HOTEL at the corner of Main and Church Streets. Known as a gourmet, he sought out Lynnhaven oysters, heading on an excursion to Witchduck Point in what is today Virginia Beach. He noted that he relished them for their pure taste.

On December 18, 1865, MEARS & BARCRAFT RESTAURANT AND BAR ROOM, located at the corner of Market Square and Union Street in downtown Norfolk, advertised that "the bar is furnished with the best Liquors and Segars" and "meals at all hours," including "game and meats of all kind." Also on the menu: Lynnhaven oysters, specifically promoted by the source of the sought-after bivalves.

"Oysters for the People" proclaimed H.O. Pearson at his FERRY DAIRY LUNCH ROOM in Portsmouth. An October 18, 1899 advertisement announced, "I have just added to my Lunch Room a raw box, where the choicest oysters can be had in any style."

A 1906 advertisement for the HOTEL CHAMBERLIN in Hampton promoted oysters and other seafood by promising, "You will soon see why The Chamberlin cuisine is famous....You will delight in all those sea products for which Tidewater, Virginia is famous...oysters, terrapin, crabs and fish are fresh from nearby waters and are not refrigerated when served a la Chamberlin."

On November 19, 1909, President William Howard Taft, in town for the second annual convention of the Atlantic Deeper Waterways Commission, visited O'KEEFE'S CASINO at Cape Henry. There he dined on, among other

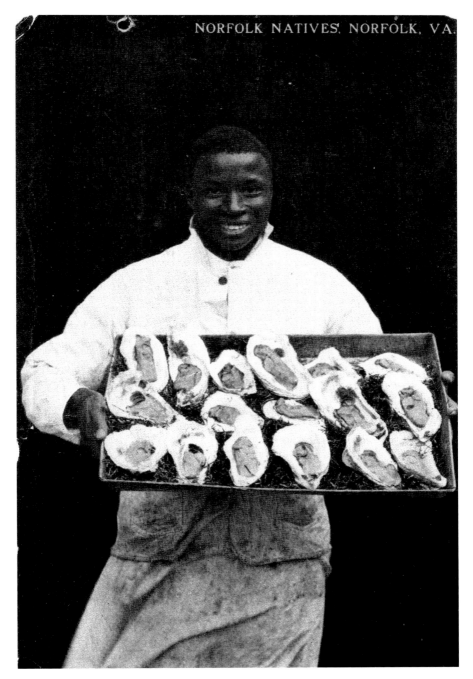

Norfolk natives, waiter with Lynnhaven oysters, circa 1910. *Author's collection.*

dishes, Virginia ham, Princess Anne turkey and Lynnhaven oysters—raw and roasted—reportedly more than ten dozen total. He started his after-dinner speech by addressing the crowd, "Gentlemen, I'm so full of oysters, I should be as dumb as one."

An entire section of a March 17, 1911 menu from Chef PHILIP ROOS at the MONTICELLO HOTEL in downtown Norfolk was devoted to oysters and clams, with these offerings:

> *Lynnhaven Oysters (1/2 doz.), .25*
> *Steamed Oysters, .60; in Shell, .75*
> *Roast Oysters, .75; Broiled, .75; with Celery Sauce, 1.00*
> *Lynnhaven Fry, (7), .50; Fried in Butter, .60*
> *Special Steamed Oysters, a la Diable, 1.00*
> *Lynnhaven Stew, .50*
> *Oyster Cocktail, .35*
> *and more.*

The discovery of a new oyster reef, in addition to improved harvesting techniques, provided a new supply, as well as a better way to get them to market. Oyster houses began popping up across Coastal Virginia, filled with shuckers packing the flesh to be sent off to consumers. JAMES SANDS DARLING was one of the big names in bivalves around this time. Darling had come to Hampton before the Civil War and operated a lumber business, transitioning into the fishing industry. By 1882, the company had turned to oysters and became known as the largest producer of oysters in the world. During summers, Darling would employ some four hundred shuckers, many of them African American.

By the early twentieth century, Darling's company was shipping out fifty thousand gallons of shucked oysters and thirty thousand bushels of unshucked oysters from Hampton. An iconic four-story stack of oyster shells loomed over the downtown Hampton landscape for more than a half century.

But Darling's and others' success led to conflict; From about 1865 to about 1959, the Oyster Wars took place, a conflict that included oyster pirates and (sometimes bloody) disputes between oystermen in Virginia and Maryland against one another over water harvesting rights in the Chesapeake Bay.

By the early 1900s, the oyster was on decline. In the 1800s, billions had been harvested from the Chesapeake Bay without much thought to sustainability. Beds had been decimated with dredging and mining. And with

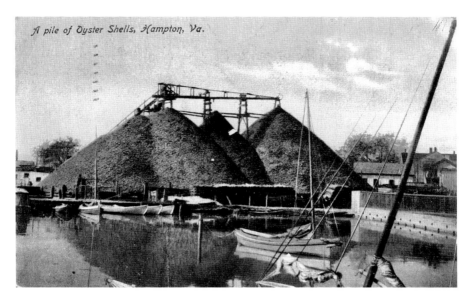

A pile of oyster shells, Hampton, circa 1910. *Author's collection.*

the onset of the Industrial Revolution, pollutants and runoff from chemicals and fertilizers used in increased agricultural production sluiced into the Chesapeake Bay. In the mid-twentieth century, it became dangerous to eat Lynnhaven oysters; it wouldn't be until 2007 before they were once again commercially harvested. But with good stewardship from the state and from watermen, the bivalves have rebounded, and it appears we are entering a second Golden Era of the oyster.

MR. PENDER COMES TO NORFOLK

In the fall of 1899, DAVID PENDER, born and raised in Tarboro, North Carolina, moved to Norfolk and set up the Virginia Grocery Company at 57 Brewer Street with one clerk and one delivery wagon. The company went on to be one of the largest grocery store chains in America by the mid-twentieth century. Pender changed the name of his concern to D. PENDER GROCERY COMPANY (sometimes called DP STORES or simply PENDER'S) and moved to the corner of Washington Street and Monticello Avenue in a brand-new building. By December 1910, a second D. Pender's had opened, also in

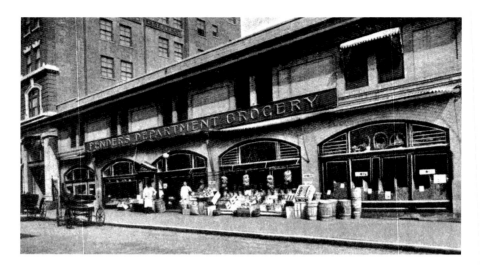

Above: Pender's Department Grocery, Washington Street, Norfolk, circa 1920. *Author's collection.*

Left: D. Pender Grocery Company later became Big Star and Colonial Stores, circa 1945. *Author's collection.*

Norfolk, at the corner of York and Botetourt Streets. It would be the first of many locations; at the chain's peak, when operating as COLONIAL STORES (then based in Atlanta), there were more than five hundred supermarkets in Virginia and ten other states. After a name change to BIG STAR, the company declined in the 1980s, and by the end of that decade, stores were sold off to the likes of A&P, Food Town (Food Lion), Harris Teeter and Piggly Wiggly. Like Colonial, A&P stores have closed shop, but today, Coastal Virginia has several grocers, including Food Lion, Harris Teeter and Piggly Wiggly.

One of the most interesting aspects of Pender's is that it was a well-appointed department grocery—something that is typically taken for granted now but was truly unique at the turn of the twentieth century. Within the store, specific departments included tea and coffee (the coffee was blended and roasted in-house); oysters (for the Washington Street store, one man was solely devoted to shucking Lynnhaven oysters all day); milk, cheese, butter and eggs; dressed fruits and vegetables; and candies. An extensive meat department offered cuts of beef and pork, game, dressed poultry (including Princess Anne turkey) and smoked meats. Large warehouses and storage plants were nearby. A separate bakery operated day and night providing bread (making one thousand loaves at once), wedding cakes, fruit cakes and other items.

There was more to shopping at Pender's than grabbing groceries. A 1905 advertisement announced a lunch counter within the Washington Street store: "Dairy Lunch, a clean dainty place to get a bite to eat and something cooling to drink. Sandwiches, pies, cakes, pastries and tea, coffee and milk always fresh and delicious. Right next to bakery department."

A TASTE OF THE EAST

Many of the first Chinese to immigrate to America did so in the nineteenth century, the majority of them arriving on the West Coast. Some came at the height of the gold rush as laborers, later others worked on the transcontinental railroad. Some began moving eastward, perhaps as their work had dried up or they were simply looking for a better life. Some fled prejudicial laws. The late historian George Tucker was born not long after the turn of the twentieth century and asserted in a *Virginian-Pilot* column: "There were probably no Chinese in Norfolk before 1885." He noted that a city directory of that year listed two laundries.

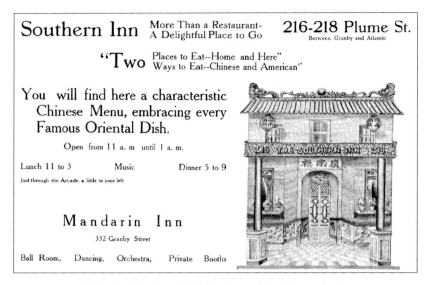

Advertisement for Mandarin Inn, Norfolk, circa 1920. *Author's collection.*

But the community grew quickly enough that by the turn of the nineteenth century there was a small Chinatown near downtown Norfolk in the areas of East Main and Church Streets. Tucker recalled walking through the area as a teenager, and he found "[t]antalizing odors emanated from their dark, small-windowed shops, where brightly packaged teas, straw-covered jars of preserved ginger and kumquats, dried fish, Chinese melons, exotic vegetables and porcelains were displayed."

In the February 15, 1899 *Virginian-Pilot*, the first Chinese restaurant in the city was announced:

> *That Norfolk is getting up to date in more ways than one is demonstrated most every day. Her progress is reaching all nationalities, too, for now it is said a regular Oriental Chinese restaurant is to be started on East Main Street in a few days where "chop suey," "yocama"* [probably yock-a-mein], *"bird's nest soup," "shark's fins" and all other "toothsome" Celestial* [Chinese] *dishes will be served in true Waldorf-Astoria style. Up North the Chinese restaurant is a great American institution...*

The demand for Chinese food, particularly chop suey, grew tremendously in a short amount of time. Many "American" restaurants offered the

dish on their menus, too, with Virginia specialties side by side with that of the Far East. Some promoted in ads that their Chinese dishes were made with fresh, wholesome and local meats and vegetables. In 1918, the ORIENTAL CHINESE & AMERICAN RESTAURANT opened; Tucker called it an elegant eatery "up two flights of marble stairs overlooking College Place and Granby Street. Lighted with tasseled red lacquer Chinese lanterns and furnished with black wood tables inlaid with mother-of-pearl, the Oriental's menu ran the gamut from chop suey to the most elaborate Cantonese cookery."

This would begin another realm of influence in the cuisine of Coastal Virginia, following that of Native Americans, the English, Caribbean, African and, to a smaller extent, French, following the adaptation of the restaurant style from that country. Today, a large Filipino population, especially in Virginia Beach, flavors the region with the rich cuisine of the Philippines.

OPULENCE IN HOTEL, CLUB AND STEAMBOAT DINING

The Gilded Age meant opulent hotels, all of which had lavish dining rooms to not only serve guests staying at the establishments but to entertain locals as well. They were often the best restaurants in town, whereas many of the freestanding eateries of the time were more casual or had a larger focus on adult beverages with simpler food offerings.

The Hygiea and the Chamberlin

Folks had been stopping at the extreme tip of the Peninsula, at what is today Hampton, since the beginning of the Virginia colony when Captain Christopher Newport's ship *Susan Constant* anchored near there on April 28, 1607. This is the area where the *White Lion* unloaded the first African slaves in the New World in August 1619. In 1823, following lessons learned during the War of 1812, Fort Monroe (named after President James Monroe) was garrisoned to help protect the region from attack by sea. The fort was instrumental during several events during the Civil War. Today, the fort is decommissioned and is known as Fort Monroe National Monument. Nearby,

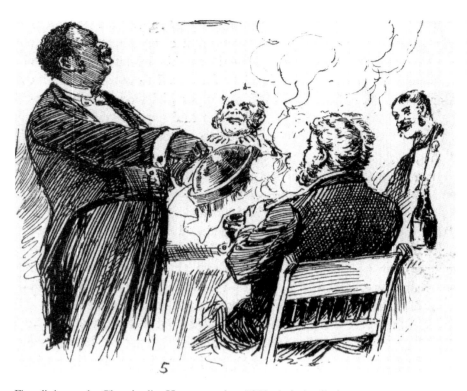

Fine dining at the Chamberlin, Hampton, circa 1890. *Author's collection.*

the town of Mill Creek was established in 1609. Growing since the early nineteenth century in year-round population and also as a resort town, the town became Phoebus in 1900, named after prominent citizen HARRISON PHOEBUS, a later owner of the HYGEIA HOTEL.

The Hygeia was one of two grande dame hotels constructed during the nineteenth century at Old Point Comfort; the other was the CHAMBERLIN. There will be more about these hotels and their food offerings in chapter 5, "Beach Eats."

Hotel Warwick

The stretch between Hampton and Williamsburg in Elizabeth Cittie, and later Warwick River Shire and Warwick County, was sparsely populated and filled mostly with farmland from the time of English settlement

until the late nineteenth century. It was then that Collis P. Huntington, who had gained fame and wealth as one of the first builders of the transcontinental railroad, came to Newport News Point to complete a rail link for the Chesapeake and Ohio Railway to a deep-water port to the Fall Line of the James River around Richmond. The sleepy village sprang into life, and at the center of it was the HOTEL WARWICK, built by Huntington's Old Dominion Land Company. The building was much more than a hotel, however: it held Newport News's first bank, newspaper, post office and more. The federal customs office was here, as was the county's municipal government offices. Huntington later went on to establish Newport News Shipbuilding and Drydock Company.

The hotel was beautiful; historian and columnist Parke Rousse described it as a "memorable Victorian" four-story building capped with cupolas and a "large, palm-filled lobby, a florid dining room, [and] a big banquet hall" on Twenty-Fourth Street and West Avenue. It opened on April 11, 1883, with a banquet for all the prominent Peninsula men and their wives, according to John R. Swinerton, the first manager of the Hotel Warwick. "It was kept up to a high standard….It has as good a chef as could be found, and the best that the New York markets could supply was none too good for the Warwick," said Swinerton. The hotel became the center for all major social events. Management from the nearby shipyard often took lunch there.

There also were separate gentlemen's and ladies' lounges, where one could retire with a glass of whiskey for the men or a cup of tea for the women. The gentlemen's lounge had dark wood accents and thick columns from floor to ceiling. Oversized leather chairs were scattered throughout the room. A bright, open feel was in the ladies' lounge, filled with elegant wicker furniture. By the 1920s, the Hotel Warwick's popularity had begun to wane. The original building was destroyed in a fire and replaced with a seven-story brick structure in 1928 that was the first skyscraper in Newport News.

Monticello Hotel

The MONTICELLO HOTEL was a perfect example of a grand hotel during the Gilded Age. First opened on City Hall Avenue between Monticello Avenue and Granby Street on September 27, 1898, the first structure burned on New Years Day in 1918; a second, less opulent, but nonetheless grand hotel was

built on the same spot in 1919. The second Monticello Hotel was imploded on January 25, 1976, to make way for the James E. Carter Federal Building as part of an urban renewal movement.

An ad in the 1920 *Hotel Red Book and Directory* noted that "Tidewater Virginia's famous and Norfolk's finest hotel" covered an "entire city block and constructed along improved lines. Spacious halls and corridors issuing an abundance of air and light and supplied throughout with the highest type of furniture of equipment." It also asserted, "The Monticello is famous for its cuisine."

Some of that cuisine was served up in the elegant fifth-floor café of the six-story hotel. "You know that you get the best edibles cooked in the best manner by the best chefs in Town. The MONTICELLO HOTEL CAFE is in a class by itself. Fifth Floor. Overlooking the Harbor," read a June 1909 advertisement. Dishes in the main dining room on a May 21, 1900 menu included relishes like mixed pickles, olives and chow chow; chicken croquettes in tomato sauce; prime ribs of beef au jus; cold meats like smoked tongue and pâté de foie à la gelée; sides of mashed potatoes, lima beans and browned sweet potatoes; and lemon sherbet, rhubarb pie and cheese and crackers to end a meal.

Countless folks from many walks of life enjoyed the Monticello Hotel during its long tenure, including the likes of Buffalo Bill Cody, Will Rogers, Gary Cooper, General Douglas MacArthur and Samuel L. Clemens, better known as Mark Twain. Twain visited Norfolk in the spring of 1909 as the guest of Henry Huttleston Rogers, his close friend and financial adviser. The dinner that Twain, Rogers and 226 others (who paid twenty dollars per plate) enjoyed was swanky to say the least. Historian George Tucker described the April 3 meal from a found menu in one of his newspaper columns: "Beginning with hors d'oeuvres, the dinner got under way with Cove oysters on the half shell. Then came a puree of mushrooms with Brauneberger to wash it down." Next on the menu was individual planked shad and shad roe, garnished with diced cucumbers followed by the first entrée, braised guinea hens with fried hominy served with Pommery Nature 1900. "And as if that wasn't enough," Tucker mused, "the waiters cleared the plates again, and served a second entree of terrapin and baked potatoes that was followed with an endive salad and hearty helpings of Camembert and Bar le Duc cheeses with toasterettes on the side." Dessert featured strawberry frappe and fancy cakes accompanied with a choice of three liqueurs—Benedictine, Russian Bear Kümmel and Chartreux.

Monticello Hotel, Norfolk, circa 1900. *Library of Congress.*

Monticello Hotel, Café Del Opera, Norfolk, circa 1900. *Author's collection.*

Lobby and dining room, Monticello Hotel, Norfolk, circa 1910. *Author's collection.*

Tucker recalled, from a firsthand account, a visit to the grandly appointed mahogany bar in the Monticello as a child. He made the visit with his father in 1915:

> *The place was such a splendid combination of marble columns, beveled mirrors, potted palms and gilt-framed oil painting of voluptuous nudes it never occurred to me to question why my father's drinks were served in a small shot glass while my ginger ale came in a bottle. But childhood is not an age of speculation, and even though my nose told me my father's libation was different than mine, I brushed that detail aside and concentrated on the luscious painted damsels instead.*

The hotel also included a ballroom, the Starlight Room.

Hotel Neddo

Before RICHARD NEDDO built his namesake hotel, he came to Norfolk in 1900 and built a reputation as a chef and restaurateur. The *Virginian-Pilot* reported on December 2 of that year,

> *The opening of Neddo's restaurant in the Columbia building on Granby street will occur on Thursday, December 6th. Neddo is a caterer* [a period phrase synonymous for chef] *of long and successful experience. He is a practical man in his business. Being a chef of the first grade himself, he knows all the fine points of the culinary department, and is going to use his knowledge in seeing that his patrons get only the best of service.*

It went on to say that "ladies and gentlemen can come and partake of the delicacies of the season and be served quickly....[T]he restaurant will be elegantly furnished, and cleanliness and neatness will be always a leading feature." The article noted that Neddo had been in the hotel and restaurant business for more than twenty years, including ten years in Chattanooga, Tennessee. The restaurant opened on December 10, 1900.

The restaurant had a program where regular diners could pay by the week ($6.50) or month ($25.00) and also offered the Merchants' Lunch for busy men, served between 11:00 a.m. and 3:00 p.m., with meals priced at $0.25. "Then too, the ladies who are down town shopping will find Neddo's the very place to get a dainty meal without having to wait." Other meal programs

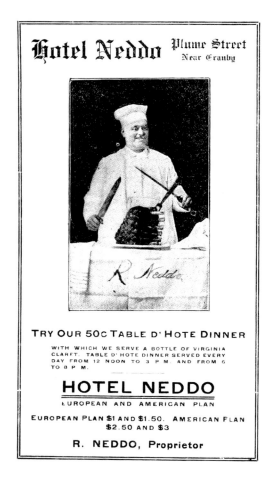

Hotel Neddo, R. Neddo, proprietor, circa 1905. *Author's collection.*

and services included regular dinner served daily and priced at $0.50. A Meal Book, which sold for $5.00, was also an option and "entitles the owner to order any dishes from the bill of fare to the amount of six dollars." Although an exact menu wasn't named, the promise for an unforgettable meal was made:

The cuisine will be of the finest. All that an epicure can desire will be elegantly served. Game of all kinds and every delicacy will be prepared by people well experienced in their respective lines. The kitchen will be in charge of a chef, who comes from New York, with excellent credentials as to his ability, and most improved utensils. There is a large range, a charcoal broiler, steam tables, and everything, in fact, which is needed to make the kitchen one of the best fittest in the south.

It was also noted that the restaurant would cater outside events, like receptions, teas, weddings and other social occasions.

The HOTEL NEDDO opened on Plume Street near Granby in January 1903 to rave reviews in the *Virginian-Pilot*, including details about the culinary prowess of the chef/hotelier: "Neddo has built up a wide reputation and made himself famous as a caterer, and the opening of his new hotel will be heralded with delight by his hundreds of old patrons who have been waiting patiently since he was burned out at the time of the bit Atlantic hotel fire, last year, for him to reopen." It described the facilities: "[T]he dining room, which is 66x33 feet, is…furnished in quartered oak, and has a seating capacity for 150 people…as is the gentlemen's cafe, adjoining. In addition there are three private dining-rooms upstairs." And again, it emphasized Neddo's kitchen credentials: "Neddo prides himself on his culinary department, and well he may, for this department is certainly worthy of special mention for if there ever was a model kitchen Neddo surely has one in every respect. His cooking utensils are all solid copper and everything in this department, as throughout his place, is the best that can be had."

Princess Anne Hotel and the Cavalier

The town of Virginia Beach, located within Princess Anne County, was a small community largely isolated due to several factors, including land distance from Norfolk. In the late nineteenth century, where the busy Oceanfront is today, resort development began, augmented by rail service from Norfolk and, in 1922, Virginia Beach Boulevard, a concrete roadway cutting a straight line through farmland and pine forests. Hotels and cottages were built, including BARCLAY COTTAGE in 1895. Built as a clubhouse for a golf course that never came to fruition, it became a residential home. In 1916, Lillian St. Claire Barclay moved in and began accepting guests in 1917. Today it is operated as a bed-and-breakfast, the only original cottage from the period.

Two of the grande dame hotels constructed at the Virginia Beach Oceanfront in the late nineteenth and early twentieth centuries were the PRINCESS ANNE HOTEL and the CAVALIER. There will be more about these hotels and their food offerings in chapter 5, "Beach Eats."

Enclosed dining terraces, Cavalier Hotel, Virginia Beach, circa 1930. *Author's collection.*

Enclosed dining terraces, Cavalier Hotel, Virginia Beach, 2018. *Robert Benson Photography for the Cavalier.*

Other Hotels

There were three ATLANTIC HOTELS, the first opening on July 14, 1859, on West Main Street between Gray and Bank Streets. A second, new Atlantic Hotel operated from 1868 until January 31, 1902, a few blocks west at Main and Granby Streets, when it was destroyed by a devastating fire that also burned down other structures, including the Columbia Building, which housed Richard Neddo's restaurant, as well as the Virginia Club. Inside the second Atlantic, the PARISIAN CAFE served a variety of meals, including an afternoon tea from 4:00 to 6:00 p.m. and specials on evenings when a performance occurred at local theaters. The third, and final, incarnation of the Atlantic Hotel opened the following year and was torn down in the early 1970s. One interesting culinary history bite, in a casual-dining realm, was the CHILDS' RESTAURANT on the ground floor. Founded in New York in 1889, this was one of the first national dining chains; by 1925 there were 107 eateries in twenty-nine cities, including Norfolk. The chain waned in the 1950s, selling most of its remaining locations in the early '60s before fading into restaurant history shortly after that. The memory of the Atlantic Hotel location was honored in a newspaper column by historian George Tucker:

There was Childs'—the white-tile-walled cafe on the ground floor of the old Atlantic Hotel on lower Granby Street. Spotlessly clean and cooled with

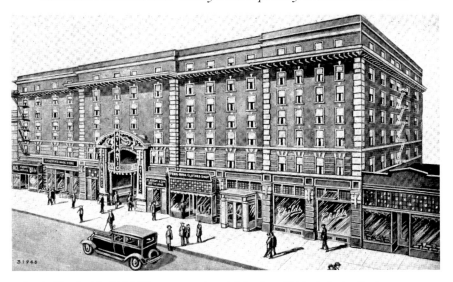

Atlantic Hotel with Childs' Restaurant sign visible, circa 1915. *Author's collection.*

lazily rotating overhead electric fans, the place was famous for creamed chicken served over buttery waffles. Another specialty was lace-edged pancakes turned out by an exhibitionist chef on a hot plate near one of the front windows. Among Childs' longtime employees was a taciturn waitress jocularly known as "Happy," who seemingly never smiled. Because Childs' around-the-clock operation attracted Norfolk's youthful night owls of the Flapper Era, the police kept a watchful eye on the place from midnight on.

Other preeminent hotels of the time were the HOTEL FAIRFAX, the LORRAINE HOTEL and PINE BEACH HOTEL.

Two other notes: the VIRGINIA CLUB, established in June 1873, still meets today. Historian George Tucker called it "Norfolk's oldest male coterie." Today, the members-only club says it encourages diversity. The next month, July 1873, the *Virginian-Pilot* reported that the club had leased the U.S. Custom House (completed in 1858), saying it was "elegantly and tastefully" established and "divided into rooms to suit the wants of the club," including "the refreshment room, neatly fitted up and supplied bountifully with the good things of this life." There have been several locations since, mostly in downtown Norfolk, including, in 1902, next door to the Atlantic Hotel when a fire there destroyed both buildings. For a while, the club met

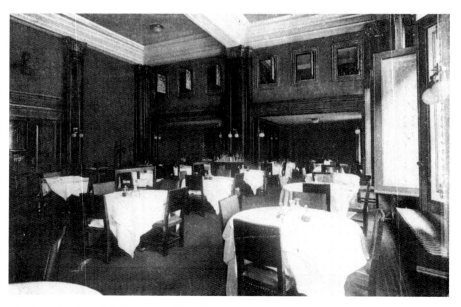

The Lorraine Hotel dining room, Norfolk, circa 1907. *Author's collection.*

at the Lorraine Hotel. The current building, a renovated historical bank building, is at 101 Granby Street. A weekday luncheon (catered by the adjacent Norfolk Tap Room, which is open to the public) featured dishes such as crab bisque, a club sandwich featuring Virginia ham, a barbecue plate and fried green tomatoes—all Coastal Virginia staples.

Steamboat service along the Chesapeake Bay, such as cruises between Norfolk and Baltimore, were in their halcyon days around the turn of the twentieth century. The Old Bay Line, formerly known as the Baltimore Steam Packet Company, ran from 1840 to 1962 between the two cities by the bay. Travel on steamboats was efficient, particularly when going by land was arduous and time-consuming and air travel was either nonexistent (the first airline served Norfolk in 1926) or very expensive. In his book *Steam Packets on the Chesapeake*, author Alexander Crosby Brown described eats at sea:

> *The Old Bay Line, long famous for its meals, was offering its celebrated $1.00 à la carte dinner. This feat began with Mobjack Bay oysters and included such delicacies of the season as diamondback terrapin, canvasback duck, quail, Norfolk spot, turkey, beefsteak, and all of the best of seafood and game which could be obtained in the epicurean paradise surrounding the waters of the Chesapeake.*

An interesting side: The name of Old Bay® seafood seasoning, that distinctive blend of herbs and spices in an iconic yellow, blue and red tin (over the original choice of "Delicious Brand Shrimp and Crab Seasoning"), was inspired by the Old Bay Line.

Another of the companies plying the waters was the Norfolk & Washington Steamboat Company, which began operating in 1891 and lasted for some six decades, ending in 1957. It operated overnight service on a route that left Norfolk and stopped at Old Point Comfort, site of the Chamberlin Hotel, and Alexandria before arriving in Washington. The boat had two dining areas; one was the less formal John Smith Grill, which an early brochure described as, "unique and interesting. Splendid service and courteous attention to all who dine has given this room a delightful atmosphere." A more formal dining room, located aft below the ladies' saloon, was opened mornings at 6:00 a.m. and evenings at 6:30 p.m. at Washington and at 5:45 p.m. at Norfolk for meals served à la carte. The brochure noted, "The dining-room cuisine is faultless; special dishes prepared by the chef are unequalled. Sea food and fresh vegetables make up a large part of the menu; cleanliness in the culinary department is of paramount importance."

ONYX OPULENCE

It was called "a palace in Norfolk" and "a scene of rare brilliancy" in the headlines of the April 28, 1895 *Virginian-Pilot*. JOSEPH SEELINGER'S ONYX BAR pulled in many folks through its doors, including a sitting president. "On the south side of [East] Main street [at 221 Main, near Church Street], just two doors east of the Purcell House, one comes upon a smooth granolithic sidewalk and his attention is at once drawn to the massive granite structure in Roman architecture, which towers above in majestic solidity and seemingly in defiance of the wear of time," recorded the newspaper. The entrance, one of solid mahogany with plate-glass panels, was illuminated with "electric lights and imitations candles, which are lighted with gas." Past the vestibule and "stepping inside the cafe you are as one transmitted to some foreign and ancient city, which to you seems as a dream. You think surely there can be nothing like this in Norfolk. You imagine yourself in one of the ancient temples." Inside was a mosaic floor, with a half-million tile pieces, an embossed steel ceiling with skylight, electric ceiling fans and chandeliers made of crystal and burnished bronze, beveled glass mirrors on the walls and "the grand and massive bar fixture, which is of solid mahogany, pure Mexican onyx, and French plate mirrors. The wood work is magnificent. The panels and moldings are profusely carved by hand and the columns are all polished Mexican onyx. There is no question as to this being the finest fixture of its kind in America. Between this fixture and the lunch counter, which is identically the same, is a beautiful refrigerator." There were private rooms as well as a billiard hall. "There is no word more appropriate in a description of this temple of mechanical art than grand, as it is truly a grand and imposing triumph of skilled labor and artistic taste," the report concluded. Others felt the same way, and the bar was the place to see and be seen. Not everyone was a fan, however; prohibitionist Carrie Nation entered the bar, which she deemed "wicked," and threw a hatchet, shattering the barroom mirror, according to the *Virginian-Pilot*. When asked by a reporter about Nation's saloon-smashing crusade across the country, President Grover Cleveland said, "That is a social question upon which I am not qualified to speak," reported the March 13, 1902 *Richmond Times*.

In fact, Cleveland was a fan of the Onyx and usually spent a few days as a guest of Seelinger's where he ran the White House from the "old back room," as he described it, and slept in a room upstairs.

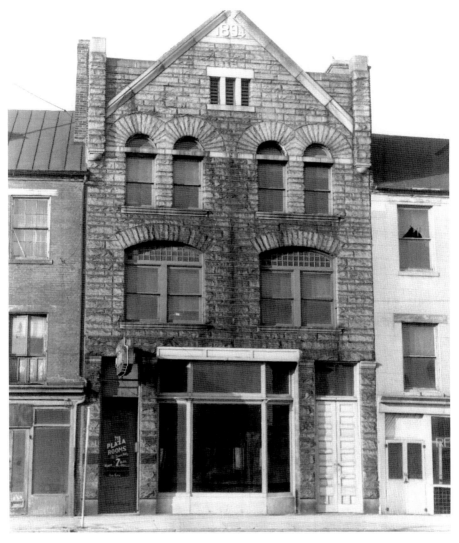

Exterior of the Onyx, circa 1961. *Isabella and Carroll Walker Photograph Collection, Sargeant Memorial Collection, Norfolk Public Library.*

Cleveland was an avid waterfowl hunter, and Seelinger was president of the Back Bay Gunning Club in Princess Anne County (now Virginia Beach) and led Cleveland on duck hunting excursions. It was on one of these trips that Cleveland and Seelinger got into some hot water and went hunting when there was no game warden presently in the county;

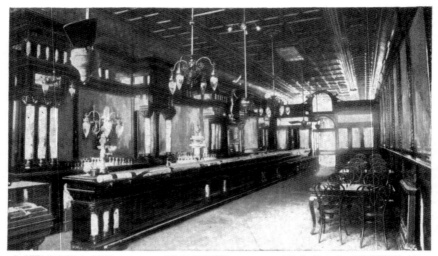

J. SEELINGER & SON "THE ONYX" 713 E. Main St., NORFOLK, VA.

Interior of the Onyx, postcard, circa 1900. *Author's collection.*

according to a 1903 account in the *New York Times*, an arrest warrant was requested. The warrant was refused by Judge Benjamin Des White, who sat on the bench presiding over what is now Norfolk, Portsmouth and Virginia Beach.

In the "Little White House" back room, according to a recollection by *Virginian-Pilot* reporter Harry P. Moore made in 1952, the president liked to enjoy cocktails of "whisky and ginger ale, or perhaps a concoction of his favorite whisky, mint, a slice of pineapple, and a piece of orange"—a mint julep—of which he said, "Unless the mint tickles your nose, it is not a real mint julep." Moore says the Onyx was known nationally not just for its drinks but for its eats, too. Often on the menu were duck and other waterfowl hunted in Back Bay. The Onyx "became widely known throughout the city by fastidious diners with whom cost was not a factor. In the gay days of Norfolk [it] was the center of fashionable gatherings, especially around the holiday season," said Seelinger's obituary. Joseph Seelinger's brothers also got in the business, with brother Anthony running his own saloon and brother Henry operating H. Seelinger's Stag Hotel and Ladies' and Gentleman's Cafe and Restaurant at 39 City Hall Avenue. Another brother, Steven, opened Steve Seelinger's Cafe at 10 Bank Street. Like others, the bars closed with the advent of Prohibition

at midnight on October 31, 1916. Seelinger died at his residence at 318 Mowbray Arch in Norfolk in 1939, and the Onyx changed hands, splitting into a hotel on the upper story and the SHANGRI LA OYSTER BAR on the ground floor. The building was demolished in February 1961 due to urban renewal efforts along the East Main Street area of the city.

4

You Say You Want a Revolution

Wars and Other Military Influence

Virginia has had a military presence since its earliest days, with a militia established in 1607. Virginians have been involved in informal conflicts from the Anglo-Powhatan War of 1623 to the present-day War on Terror. The beginning of the modern U.S. Navy arguably had a start here when an armada of sixteen battleships, called the Great White Fleet due to the vessels' stark-white paint job, launched its worldwide tour to show naval prowess from Hampton Roads Harbor on December 16, 1907. A decade later, in 1917, Naval Operating Base (NOB) Norfolk opened on the site of the 1907 Jamestown Exposition; it would grow to become the world's largest naval base. Other bases dot the area, as well as NATO's Allied Command Transformation, based in Norfolk. All of these bases build an international community and send out and bring back troops around the world. They return with a desire for dishes they tried abroad.

Battles in three major wars have been fought here—the Revolutionary War, the War of 1812 and the Civil War. In the case of the American Revolution, it was taverns—predecessors of modern restaurants—that provided spirits and space to cook up a fight with the British. The British came back for a second round during the War of 1812, which included raiding towns and blockading the mouth of the Chesapeake Bay—preventing imports, including food, from coming into port. During much of the Civil War, larger towns like Norfolk, Suffolk and Williamsburg were occupied by Union forces, which allowed for imported items from the North but presented other issues too. Regardless, during this time, advertisements and notices in the

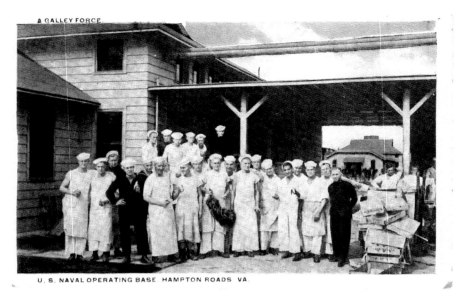

A galley force, U.S. Naval Operating Base, Hampton Roads, circa 1920. *Author's collection.*

Lineup for chow, U.S. Naval Operating Base, Hampton Roads, circa 1920. *Author's collection.*

few still-printing newspapers show that some hotels, restaurants and saloons remained open and merchants still sold goods, including eats and drinks. Apparently, during the war years, a city or business directory, which would have chronicled exact names or numbers, was not published.

Virginians have gone to fight wars abroad, such as the Spanish-American War, World Wars I and II, the Korean War, the Vietnam War and the Gulf War. But perhaps the most direct impact on how the nation—and the state—eats came after troops returned from overseas upon the conclusion of the two world wars. Suddenly, restaurants in Coastal Virginia served up dishes like pizza and other Italian offerings or Polynesian pu pu platters in response to the new interest.

REVOLUTIONARY WAR

Taverns are where the seeds of liberty, leading up to the American Revolution, were sown over a good cup of coffee or a bracing libation. One of those was the RALEIGH TAVERN in Williamsburg. In Lyon Gardiner Tyler's book *Williamsburg, the Old Colonial Capital*, the Raleigh Tavern, built around 1717, is described as "a large wooden building, which occupied lot 54 on the north side of Duke of Gloucester Street, between Botetourt Street and the capital. It was two stories in height, lit by eight dormer windows. A leaden bust of Sir Walter Raleigh stood in a niche over the front door." It was a place to sit and feast, play dice or enjoy a drink, including arrack punch. Arrack would have been an import to the colony from the Caribbean—another example of the strong ties between the two geographic regions. Spelled *arak* sometimes, it is an ancient distilled alcoholic drink traditionally from the tropics. The *New York Times* noted that it "was a kind of rum imported from the East Indies. Its main use was for mixing with water, sugar, or fruit juices in making punch."

The main room of the tavern was the APOLLO ROOM, which Tyler described as being "well lit, having a deep fireplace, on each side of which a door opened, with carved wainscoting beneath the windows and above the mantelpiece." The tavern was not, however, just a place to break bread, but also to break the hold of England. In 1769, members of the House of Burgesses protested the Townshend Acts, saying England had no right to tax citizens without their consent. This met with the disfavor of Governor Lord Botetourt, who dissolved the assembly; burgesses then met at the Raleigh

Engraving of the Apollo Room interior by American historian Benson Lossing, circa 1850. *Author's collection.*

Tavern and adopted the nonimportation "association," a boycott of certain goods from British merchants.

In 1773, lawmakers including Patrick Henry and Thomas Jefferson met here to create a committee to communicate, including the sharing of documents and other information, with legislatures of other colonies—one of the first steps of unification. Botetourt dissolved the House of Burgesses again in 1774 after members protested the closing of the Port of Boston in light of the Boston Tea Party. The assembly again went to the Raleigh Tavern and formed another association against the importation of certain British goods. Colonial statesman Peyton Randolph was feted at the Raleigh upon his return to Williamsburg from Philadelphia in 1775 after serving as speaker of the Continental Congress, a meeting of delegates from twelve of the original thirteen colonies that began the framework of the new nation.

The American Revolution, which began in 1775, effectively ended on October 19, 1781, with the surrender of British general Charles Cornwallis at Yorktown. The full end of the war would come on September 3, 1783, with the Treaty of Paris. Williamsburg celebrated the treaty at the courthouse, with the party moving to the Raleigh. Later, when the Marquis de Lafayette, the French aristocrat and military officer who fought with the Americans, returned to the United States in 1824, a banquet was given in his honor at Raleigh Tavern. Author Lyon Gardiner Tyler said, "[W]ith the advent

of the Revolution, it grew suddenly popular as a meeting place of the patriots.…[T]his room [the Apollo] witnessed probably more scenes of brilliant festivity and political excitement than any other single apartment in North America." Raleigh Tavern was destroyed by fire in 1859 and rebuilt in 1932.

Raleigh Tavern wasn't the only ordinary that had America's founders at its tables eating, drinking and planning a revolution. CHRISTIANA CAMPBELL (1723–1792), the daughter of a tavern owner, became a widow in 1752 and, a few years later, opened her namesake CHRISTIANA CAMPBELL'S TAVERN as a way to support herself and her two daughters, Molly and Ebe. According to the Colonial Williamsburg Foundation, it was a large and popular tavern, and with a location close to the capitol, many of Virginia's leaders met here, including George Washington, who favored the establishment. "She provided rooms and food for people who traveled to Williamsburg to conduct business with government officials.…When the General Assembly was in session, Campbell hosted members of the House of Burgesses, including Thomas Jefferson and George Washington."

It's noted in Washington's diary that within a two-month span, he dined there ten times. In 1769, the future first president wrote in his diary on December 1: "Dined at Mrs. Campbells with the Speaker, Treasurer & other Company," showing how both political and social life intertwined in taverns. Washington favored Campbell's seafood offerings. A December 2 entry notes, "Mrs. Washington & children, myself, Colo. Basset, Mrs. Basset & Betcy Bassett all Eat Oysters at Mrs. Campbells abt. One oclock." On December 13, a ball hosted by members of the House of Burgesses was given at the capitol building, which was illuminated for the holidays, and Washington recorded, "Dined at Mrs. Campbells and went to the Ball at the Capitol." The Colonial Williamsburg Foundation notes that the general mentions occasionally eating in "the Club" at the tavern, which is supposed to be a private room. A handwritten receipt, signed by Campbell, shows he paid off his bill of seven pounds, seven shillings and six pence on April 8, 1772. The tavern closed around 1782, when business across Williamsburg dropped off after the capital moved to Richmond. The building was destroyed by fire around 1859 and rebuilt in 1956.

Another place for eats and drinks that was part of the budding liberty movement in Williamsburg was R. CHARLTON'S COFFEEHOUSE, owned by RICHARD CHARLTON. Coffeehouses had risen in popularity in England in the mid-sixteenth century, and the venues for caffeine and conversation carried over to the New World. Like Christiana Campbell's Tavern, this

building was also close to the capitol building and served cups of coffee from the West Indies, drinking chocolate from the Caribbean and tea from England to guests, as well as food. Among the dishes, according to the Colonial Williamsburg Foundation, were fish, shellfish, all kinds of meat and game, including peacock. Alcoholic beverages would have been offered, such as beer, spirits and wine. Many of the guests included politicians. Seven fireplaces leading from a single chimney in the middle of the building warmed the various rooms and private parlors throughout. A kitchen in the basement took in goods and prepared the fare, taking it upstairs to the main part of the structure. The thirty-five-square-foot coffeehouse had a large porch that ran along the front.

It was on that porch where coffee and conflict merged in 1756 when an agent sent as stamp distributor for Virginia and Maryland, in regards of the Stamp Act, arrived from England. The reviled George Mercer was promptly chased down Duke of Gloucester Street by an angry mob of protesters. Mercer ran up on the porch of R. Charlton's Coffeehouse seeking protection, and Governor Francis Fauquier came to his rescue. Sort of. The governor, according to the Colonial Williamsburg Foundation, said he was accosted by the colonist at "the Coffeehouse, in the porch of which I had seated myself with many of the council."

An interesting note on the serving of chocolate during colonial times: while chocolate was eaten, it was a rival for coffee in drink, although it was not crafted with the milk and sugar used in modern recipes. The army even provided a ration of chocolate to soldiers. Following the Boston Tea Party, Thomas Jefferson predicted that chocolate would become America's favorite drink, even surpassing tea and coffee. Chocolate blocks were coarse and gritty and, like today's dark chocolates, a bit bitter from the levels of cocoa. Refinement of chocolate would come in the next century. Forrest and Deborah Mars, of the Mars candy company fame, donated funds and resources for the reconstruction of the building. Mars has an American Heritage line of chocolate sold at Colonial Williamsburg to give a taste of the sweet stuff as the Founding Fathers would have enjoyed it. The original coffeehouse fell by the wayside and was replaced in the nineteenth century with a Victorian home. That home was moved, and the coffeehouse was rebuilt in 2009 on the foundation of the original Charlton's; it was the first reconstruction in the historic area in some fifty years.

CIVIL WAR

Just a little over a month after Confederates fired on Union troops at Fort Sumter outside Charleston, South Carolina, on April 12, 1861, Virginia seceded from the United States and became embroiled in the Civil War. Because of its strategic location at the mouth of the Chesapeake Bay, which leads up to the Potomac River and Washington, D.C., Coastal Virginia became of vital importance to the Union. On the cusp of conflict, the Norfolk and Portsmouth city and business directory showed slightly more than two dozen restaurants and saloons. The year following the war, that number almost doubled to more than three-and-a-half dozen restaurants and saloons listed in the 1866 city and business directory for Norfolk and Portsmouth. An advertisement for OXFORD HALL RESTAURANT, at 4 Oxford Hall on High Street in Portsmouth, promised, "The most choice edibles of the season served, in elegant style, by experienced caterers, and the best of ales, wines, and liquors always on hand. Prices extremely moderate." Owner WILLIAM LINN asked for folks to "[r]emember and patronize a first-class Restaurant, and enjoy a good meal, served up on the American plan."

The city of Hampton, located right outside Fort Monroe (which was under Union control the entire war), was occupied by northern forces on June 3, 1861. Confederates burned the city—torching five-hundred-plus structures—instead of allowing the Union to use their homes and other buildings. In 1862, the Battle of Hampton Roads, often called the Battle of the Ironclads or the Battle of the *Monitor* and *Merrimack*, took place on March 8 and 9. The *Merrimack*, sometimes spelled *Merrimac*, was called the *Virginia* by the Confederates. The conflict has an interesting food footnote: Charles Martin wrote about what he saw in the 1903 book *The Romance of the Civil War*: "March 8th is bright and sunny when she [the *Merrimack*] steams down the Elizabeth River to carry out the first part of her programme. And all Norfolk and Portsmouth ride and run to the banks of the James to have a picnic, and assist at a naval battle and victory."

Over the next two years after Hampton's occupation, 1862 and 1863, almost the entire area came under Union control. Because of the occupation by Union troops, Coastal Virginia did not experience the blockades and food shortages felt in other Southern regions. "Before the war, the South had imported a significant portion of food from outside the region, including much of its pork, beef, wheat, potatoes, cheese, and butter," noted Helen Zoe Veit in her book *Food in the Civil War Era: The South*. "The Union blockade of Southern ports reduced imports of food and other materials to a trickle,

Civil War soldier with crates of hardtack. *Library of Congress.*

and the blockade only tightened as time went by." But in Coastal Virginia, goods were coming in from Northern markets. However, under Union rule, some businesses were allowed to operate, and some weren't. Some businesses could afford to operate, and some couldn't. And travel and other freedoms were also restricted. There were few newspapers in the region chronicling which restaurants were open and what they were serving as recorded in advertisements—and those that were had a Union slant. For example, in May 1862, the *New York Times* reported one newspaper, the *Norfolk Day Book*, "was allowed to continue its issue by Gen. Viele, after the occupation of Norfolk, on condition that it should be respectful in its tone." But the paper was later suppressed.

One business casualty of the Civil War in Coastal Virginia was the original HYGEIA HOTEL. The resort was built in 1822 at Old Point Comfort,

next to Fort Monroe, for construction workers' and engineers' housing. It later expanded to a resort, attracting thousands drawn to the allure of the water views and luxurious accommodations and amenities. Named after the Greek goddess of health, the hotel, which included lavish dining and banquet rooms, was owned in part by Caleb C. Willard of the noted—and still operating—WILLARD HOTEL in Washington, D.C. Guests at the Hygeia included President John Tyler. Edgar Allan Poe held his last public reading of his poetry on the veranda on September 17, 1849. Many of the guests arrived by steamships at the hotel's dock; the Baltimore Steam Packet Company operated daily service beginning in 1840. But by 1862, Union leaders were afraid the hotel could be used by Southern spies and other sympathizers to undermine war efforts at the fort next door. An order for the Hygeia's demolition was ordered in 1862, and it was carried out beginning on December 1, 1863.

One of the lasting food legacies of the Civil War is the mainstreaming of the peanut. Although not widely cultivated, there were peanuts to be found across Virginia and the rest of the South. In a time when other foodstuffs were scarce, this portable protein supplemented the diets of Confederate soldiers, Union soldiers and the general population. This helped elevate the status of the peanut both in the South and in the North when soldiers

Freshly dug peanuts drying on shocks in the field. *Author's collection.*

returned home. Goobers were originally viewed as food for slaves, poor whites and livestock. Peanuts were not only eaten raw and out of hand but also boiled, roasted, ground into a paste, made into a coffee substitute and other preparations. The oil was also used in many applications, including a substitute for lard in cooking. This helped set the stage for peanuts popping up by the end of the nineteenth century, sold by street vendors at baseball games, at circuses and elsewhere. The legume was even memorialized in a Civil War song, sung from a soldier's perspective, "Eating Goober Peas," which opens with these verses:

> *Sitting by the roadside on a summer's day,*
> *Chatting with my mess-mates, passing time away*
> *Laying in the shadows underneath the trees,*
> *Goodness how delicious eating goober peas*

WORLD WAR I AND WORLD WAR II

The world was still a large place in the late nineteenth and early twentieth centuries, with travel to faraway places reliant largely on rail or ship, since the automobile and airplane were both in their infancies. And the cost of travel, even in third class, was expensive. According to the book *The Titanic for Dummies*, transatlantic passage on the ill-fated ship in 1912 would have cost in today's dollars approximately between $350 and $900 for a bunk in a small cabin with five others and no private bathroom. Also, work hours, whether in a business in a town like Norfolk or on a farm in rural Princess Anne County, would have been long and typically not required much, if any, travel—even across the state. So when the First and Second World Wars came along, for many in Coastal Virginia, indeed across the nation, it was the first time they had left the United States. Not that going off to fight was a vacation, but the troops encountered local eats and drinks in theaters across the globe. Issues back at home included food shortages and rationing as well as soaring costs, which affected grocers and restaurateurs alike.

America's engagement in World War I began in April 1917; the war ended on November 11, 1918. In Newport News, Washington Street was alive, especially with such proximity to the shipyards. Nachmans department store and Woolworth's served up soda fountain specialties at their lunch

Dinner à la carte at shipyard, Newport News, showing a number of lunch trucks feeding workers, circa 1915. *Author's collection.*

counters. Executives and naval officers dined at the WARWICK HOTEL dining room. The sweet tooth was sated at ROY CHARLES' CONFECTIONERY.

The day following the December 7, 1941 attack on the naval base at Pearl Harbor in Hawaii by the Japanese, America was pulled into World War II; the conflict ended on September 2, 1945. Perhaps one of the biggest differences in the two conflicts was the scale in which Coastal Virginia geared up prior to World War II. Well before the Japanese attack, the region was in buildup mode. For two years, the area was flooded with military and civilian workers, bringing an economic boost, including to bars and restaurants.

But for some, the war effort was harmful. Especially along the shorelines, businesses shut down during blackout periods to protect the region from German U-boats just a few miles out. At times, folks stood at such places as the SURF CLUB at the Virginia Beach Oceanfront—normally a place for dining, dancing and drinking—and watched ships explode with massive displays of fire and smoke when they hit German mines. Some buildings were actually confiscated for the war effort and temporarily occupied by the military. Among these was the CAVALIER HOTEL, near the Surf Club. The upscale hotel was used as a radar training school through the war, shutting down not just the lodging but also the noted restaurants POCAHONTAS ROOM and HUNT ROOM.

Rationing

Many items became scarce during the war; Americans were asked to sacrifice everyday items normally taken for granted, from gasoline to nylon. Rationed foodstuffs included butter, liquor, meat, shortening/lard, sugar and vegetables. There were limits on alcohol and even travel. Many things were hard to come by in Coastal Virginia—bananas virtually disappeared. Coffee deliveries were cut by 25 percent. Restaurants limited the amount of sugar one could put in coffee to one spoonful per cup. There was even a shortage of Coca-Cola. The government set up the Office of Price Administration (OPA) to regulate the rationed products and issue books of stamps to "purchase" products in short supply. When the stamps were gone, you did without until the next month, unless you purchased them on the black market. Norfolk butcher C.J. JOHNSON fretted over the meat shortage for retail and restaurant customers, going so far as to post a sign out front:

Application for war ration book, 1943. *Author's collection.*

"Business Is Dead, Not Enough Meat to Keep It Alive." In the last quarter of 1942, some 30 percent of slaughterhouse production was cut, leading households and restaurateurs to look for alternatives. A spokesperson for the food industry said Norfolk had only 30 percent of the beef and pork it needed. Even so, what was already scarce was also rationed. Cooking grease and lard were recycled and reused.

Victory Gardens

To help supplement rations, victory gardens (sometimes called war gardens) were planted during both World War I and World War II. During the first conflict, President Woodrow Wilson said of such efforts at home, "Food will win the war." During the second war, Norfolk's Victory Garden Committee estimated that thirty thousand gardens were planted there in 1943 and that home gardens increased the vegetable supply in the area by 50 percent. Schools were encouraged to grow food for their own lunchrooms, and the city provided the soil and fertilizer for the effort. Homes and businesses—including restaurants—planted victory gardens in empty lots, on rooftops and in backyards to stave off the wartime food shortage. Some produce was eaten right away; some was canned for later use. To educate people on the proper ways to preserve food, the Norfolk Civilian Defense's Nutrition Committee held "Foods for Victory" cooking classes and taught canning.

International Influence

Virginians certainly did not live in a bubble in regards to international foods prior to involvements in the global conflicts. French influence was obvious in finer-dining restaurants, and since the late nineteenth century, Chinese eateries were on the rise. There were folks living in the region from abroad who no doubt served dishes of comfort from their homelands, but largely in their homes. But returning troops demanding the flavors they discovered while fighting in World War I and World War II began to influence what was served on tables in restaurants, and that influence is still felt to this day.

There are some interesting culinary footnotes from this time, such as the civilian interaction with friendly German prisoners of war held at Camp Ashby in the Thalia area of what is today Virginia Beach. The POWs

supped with area families and worked on farms in Princess Anne County. No doubt some good German food was enjoyed, but this didn't have a large impact on the eats and drinks of Coastal Virginia. What did was American troops returning from Atlantic and Pacific theaters and bringing a taste for Italian and Polynesian cuisines, specifically.

Spaghetti and other Italian dishes weren't unknown to folks in Coastal Virginia in the first half of the twentieth century, but unless you were of Italian descent, you probably didn't eat it, and if you did, you may have appropriated it differently than, say, a classic dish of spaghetti in meat sauce or even spaghetti aglio et olio. A 1917 *Virginian-Pilot* article noted that "[a] little border of well-cooked spaghetti or macaroni makes an attractive edging to a stew, for instance," instead of expensive ingredients like the "big restaurants" did to save money. "Some of the hotels and restaurants use much macaroni as a garnish." Spaghetti was also offered as a starch alternative in a separate 1917 article due to "when potatoes took their flying soar in price." An unusual offering of "Celery Consomme with Spaghetti" was served with options of fried fish, mutton or roast wild goose in a fifty-cent Sunday dinner at the MAJESTIC CAFE inside the NEDDO HOTEL in downtown Norfolk. In a March 1920 ad for WHITE HOUSE CAFE, located at 452 Granby Street in Norfolk, "Spaghetti au Gratin" is listed as a vegetable (along with mashed potatoes, candied yams and butter beans) for the café's one-dollar dinner, which had entrée options of chicken, fish or lamb.

There are few mentions of Italian food or Italian restaurants during the first few decades of the twentieth century, but an interesting article from February 27, 1920, noted that FRANK SENICK, owner of an unnamed Italian restaurant in Norfolk, was arrested for using a still at the eatery to craft spirits from "plain 'whiskey' to 'cognac brandy'" in obvious violation of Prohibition. The Italian options were increasing just prior to the outbreak of World War II, with MOLLURA'S ITALIAN RESTAURANT advertising in June 1940, "Italian as Italy Itself. We are proud of the part we take in Norfolk and for a real Italian dinner visit Mollura's." The address was 122 Granby Street. Also in 1940, L. SNYDER, a downtown Norfolk department store, advertised a Monday lunch special: "Italian spaghetti with meat balls, tomato sauce, grated cheese, coffee, or tea," priced at twenty-four cents.

During and after World War II, Italian food enjoyed mainstream acceptance. Many Old-World eateries were popping up across Coastal Virginia, including those from ORLANDO and CATERINA LOIERCIO, who came to Norfolk from New York City in 1942. They opened ITALIAN KITCHEN near Selden Arcade downtown and NAPOLI in Norfolk's Ghent. The

Loiercios then came to the city's Riverview neighborhood in 1946, opening VENEZIANO. Homemade gnocchi became a staple; pizza was always popular. Other notable menu items were eggplant parmesan, "Veal Cutlet Valdosta" and tiramisu. Carafes of chianti flowed. Also notable was the welcoming ambiance, from warm greetings at the hostess stand to faux marble statuary, red-checkered tablecloths and sweeping oil murals of a long-ago Venice. The artwork was painted by Irving H. Wolshin, who became a set painter in Hollywood for Fox Studios. Just off a streetcar line and near a bustling movie theater, the eatery was a hit. Later, the name would change to the VENICE. Generations of families and friends broke bread there for nearly seventy years before it closed on August 25, 2013. As of this writing, the building houses CHARLIE'S AMERICAN CAFÉ. The same year Veneziano opened, GIOVANNI RUGGIERO and EUGENIO SANTUEEL established the SPAGHETTI HOUSE at 163 North Main Street in downtown Suffolk.

DOMINICK CIOLA was a Coastal Virginia native with an appreciation for the food of his Italian heritage. In 1949, after a stint in the army during World War II, he and his wife, ALICE, ventured to Virginia Beach and opened their namesake eatery, CIOLA'S RESTAURANT, which would be a staple for many in the region until 2003. Like many other Italian restaurants of the mid-twentieth century, it had the required checked tablecloths, paintings of the Old World, flickering candles on each table and songs of love and loss playing in the background. It also had authentic dishes, each made from scratch under the direction of Dom, known as "Master Chef," himself. Specialties included Veal Marsala and Seafood Garibaldi, linguine with white or red clam sauce and topped with calamari, mussels, clams and shrimp. There also was Steak Margarita, a filet mignon with Ciola's special sauce. ISLE OF CAPRI delighted at the Virginia Beach Oceanfront and still does.

Many troops served in the Pacific theater and got a taste of food and life while there. The 1947 journey of *Kon-Tiki* and James Michener's book *Tales of the South Pacific* (1948) reinforced the romance of the Polynesian culture. This was further fueled the next year when Rodgers and Hammerstein's musical *South Pacific* opened on Broadway, based on Michener's work. Some sailors and soldiers brought back exotic souvenirs and tales of adventure. The stage was set to set the restaurant table with pu pu platters and Tiki mugs filled with fruity, boozy drinks. One noted eatery was BLUE HAWAII, which offered an everyday getaway or celebration for a special occasion in the JANAF shopping center in Norfolk. The room was accented with dark wood, palm fronds, floral and tropical prints and twangy South Pacific music. One of the signature dishes was the pu pu platter, a large, sharable

offering of small meat and seafood bites and dipping sauces such as sweet and sour, arranged around a flaming mock volcano in the middle. Also on the pyrotechnical side, small hibachi grills were brought table side for grilling meat and seafood. Other dishes included Hawaiian Pepper Steak and Shrimp Tempura, large, fantailed shrimp battered in a light batter and quickly fried, sealing the sweet shellfish in a crispy, golden coating. The house salad, with a piquant peanut dressing, was also notable. Perhaps the most Tiki of all Tiki drinks, the Mai Tai, was offered. Based on a Tahitian word for "good," the drink typically consists of a number of rums, Curaçao, orgeat syrup and lime juice. Other popular Tiki libations are the Blue Hawaii cocktail, a brilliant blue-hued drink classically made with rum, Curaçao, pineapple juice and sour mix, and the Sundowner cocktail, a golden beverage based on fresh-squeezed lemon and orange juice traditionally with the addition of Galliano and sometimes other spirits like cognac and Cointreau.

East Main Street

Another legacy of the troop build-up during World War II was the number of bars that proliferated to quench the thirst of sailors and soldiers on liberty. There were several red-light districts that popped up across Coastal Virginia, but one of the largest, most infamous and long-lasting was East Main Street and Church Street (which intersected) in Norfolk. Beer halls, burlesque shows and tattoo parlors were milder elements that tugged at some of the enlisted to let go and have some fun. There were some darker elements, too, including brawls, gambling and prostitution. The story of Elvira Taylor, one of the nation's most famous "Allotment Annies," combines a little of all that. Taylor married six sailors and was on the seventh when she was arrested after two of her "husbands" fought at a bar after showing each other the picture of their "wife." Taylor was in it for their navy pay and potential life insurance.

And while business was booming for the bars, other businesses were feeling the squeeze. FRANK and MARCELLO CANTANESE, who owned ROME ITALIAN RESTAURANT at 213 East Main Street, approached the Alcohol Beverage Control (ABC) Board in July 1946 to dissuade new bar applicants, saying the vicinity didn't need more "beer joints." Navy authorities began forbidding patronage of the area on certain days and at certain times and began patrolling, along with police, looking for violations.

Interior of an East Main Street watering hole, downtown Norfolk, circa 1945. *Author's collection.*

The area sprang up shortly after Prohibition ended and alcohol was legal again. Storefronts in this area of town, later called "The Strip," were plentiful after a previous real estate exodus, and they filled up with taverns with names like ANCHOR, KRAZY KAT, RED ROOSTER, SHAMROCK and STAR. Those, and other bars, in turn filled up with folks looking for a night out, and many of those were men in uniform either with their girls or looking for one. The Strip was bawdy and loud, illuminated by pulsating neon signs promising one good time after the other. A quick hot dog, hamburger or other greasy eat could be had before heading into a bar, which was thick with smoke and loud from competing conservations and blaring jukeboxes. Beer flowed from taps almost continually throughout the night. It came to an end, unceremoniously, in 1961 when bulldozers from the Norfolk Redevelopment and Housing Authority leveled everything in a wide swath of that area of town in urban renewal efforts.

5
Beach Eats

Coastal Virginia is, as the name implies, a coastal region with hundreds of miles of shoreline along the Atlantic Ocean, Chesapeake Bay and their tributaries, including the Elizabeth, James and York Rivers. In 1607, when the first colonists arrived from England, this area was pristine and undeveloped. But people are drawn to water. Sometimes it is for commerce; sometimes it is for pleasure. The popularity of seaside resorts rose throughout the nineteenth century, fueled by several factors, among them the accessibility of the shore, first via steamships and later railroad; the belief in taking salt air as a treatment for the mind, body and soul; to seek a cool breeze from the summer heat; and a retreat from urban life. Cape May, New Jersey, is recognized as America's first seaside resort; it began hosting guests shortly after the end of the War of 1812. But Coastal Virginia wasn't far behind: the HYGEIA HOTEL at Old Point Comfort in Hampton, next to Fort Monroe, was built in 1822, offering plush accommodations and amenities.

But the golden era of seaside resorts in Virginia would come three-quarters of a century later, give or take, with the opening of palatial hotels, all featuring opulent dining options. This would include a second Hygeia Hotel after the first was demolished during the Civil War; the CHAMBERLIN, built next to the Hygeia; hotels after the development of the town of Virginia Beach in Princess Anne County; and other venues. Around these hotels grew other places to enjoy lunch or dinner or treats like ice cream cones, salt water taffy or handcrafted soft drinks. Communities, such as Norfolk's Ocean View and the city of Virginia Beach, also grew up around these hotels.

HAMPTON

As the colonists left Cape Henry following their historic first landing in April 1607, they crossed the mouth of the Chesapeake Bay and saw a small point of land extending from the end of the Virginia Peninsula into Hampton Roads. It's been called several names: Cape Comfort, Point Comfort and now Old Point Comfort. It's a strategic point, with Fort Monroe being built here in 1822, after lessons learned from the War of 1812. A structure was built to house the engineers and workers constructing the fortress; that building became the Hygeia Hotel, which set the stage for this area of Hampton to become a seaside resort. Later, the Hygeia was joined by the Chamberlin Hotel, and to the north, Buckroe Beach became a haven for folks seeking cool breezes, refreshing salt air, luxurious accommodations and fine dining.

Buckroe Beach

Just north of Old Point Comfort in Hampton is Buckroe Beach, with a history stretching to the establishment of Buck Roe Plantation in 1619. A sleepy community and fishing camp, the area grew, like so many others, when the railroad arrived. For Buckroe Beach, it was the extension of Collis Huntington's Chesapeake and Ohio Railway that began bringing visitors here in 1882; electric trolley service began in 1897, connecting Buckroe Beach with service every fifteen minutes to Fort Monroe, Hampton and Newport News. The rail service coincided with the opening of an amusement park and hotel with a large pavilion that offered food and ice cream vendors. The next year, 1898, the adjacent Bay Shore Beach and Resort opened for African Americans to use in a time when it would be more than a half century before segregation ended.

As Coastal Virginia began to heat up in the summer, folks traveled to Buckroe Beach to take in the cool breezes of the Atlantic Ocean. The BUCKROE BEACH HOTEL offered that. Manager Charles Hewins promised, "Bathing is unexcelled. Fishing and boating unrivaled" and, importantly, "No malaria." Management also promised an outstanding lunch and dinner menu. "Join the Happy Throng Today and Take Your Dinner or Luncheon at the Buckroe Beach Hotel," invited an ad in 1913. "Just the tempting menu, which you have been waiting for, and a delightfully cool breeze to make the meal all the more enjoyable."

The lunch menu offered seafood selections, including littleneck clams, oysters on the half shell, clam chowder, fried pan fish and soft-shell crabs; the only meat offering was "Smithfield Ham, Champagne Sauce." Hot biscuits were the sole bread choice. Relishes of sliced tomatoes and sliced cucumbers augmented vegetable sides such as buttered beets, potatoes in cream and french fried potatoes. Fruit such as iced watermelon and iced cantaloupe provided a light dessert, as did Green Apple Sauce and Lemon Ice. American, Roquefort and Swiss cheeses were served with saltine crackers. A more extensive and elegant menu was offered at dinner, with starters including crab cocktail, oyster cocktail, Mobjack Bay oysters and littleneck clams. Note the name of the oysters' source: Mobjack Bay is just up the Chesapeake Bay from Old Point Comfort, between the York and Rappahannock Rivers. Although many restaurants at the time called out the source of oysters if they were from the Lynnhaven Bay, many times this wasn't the case. It is a common practice today.

"Tomatoes with Spaghetti" was listed as a relish, indicating that this was not a traditional spaghetti entrée or even a side but rather tomatoes that had spaghetti noodles as a lesser element, or even a garnish. Other relishes included queen olives and pin money pickles. Meals on the menu include, "Chesapeake Bay Spanish Mackerel, Montpelier Butter, Straw Potatoes," "Soft Shell Crabs, Tartar Sauce, Pineapple Crust" and "Tide Mill Duck, Currant Jelly, Corn on Cob, Candied Sweets." For dinner, "Home Made Rolls" were offered. Vanilla ice cream, strawberry sundae, peach sundae and lemon meringue pie were among the desserts. The meal rounded out with a selection of cheeses and crackers, similar to those at lunch, with one interesting substitution: instead of Swiss cheese, pimento cheese was offered, a definite nod to the favored flavors of the region. Also of note: Roman Punch was on the menu as an offering about halfway through the meal. This item shows up quite frequently on fine-dining menus of the nineteenth century. It is not a true punch but rather a (most likely lemon-forward) semi-frozen palate cleanser, much like a sorbet is served mid-meal at many restaurants. Think of it as a (probably spiked) frozen lemonade.

Various vendors set up around the beach, such as P.K. NICLOPOOLOS, who advertised in the July 1, 1906 *Daily Press* offering drinks and ice cream "just across from the main entrance of [Buckroe Beach]. We serve you the same drinks at Buckroe that you get from our store in Hampton. Nothing but the best syrups used. Fruit on hand at all times at the stand." Nicolopoolos's brick-and-mortar store was at 40 West Queen Street. For something more substantial, F.W. Moore noted in 1913 that his Buckroe Beach Restaurant

offered a special fifty-cent dinner that included options of clam chowder, baked blue fish, fried oysters or soft-shell crabs, with sides of "cold slaw"; mixed pickled, french fried or boiled potatoes; and sliced tomatoes "every day in the week."

Over the years, the numbers began to decline at Buckroe Beach, and many of the hotels and restaurants closed, some due to the rise in popularity of other area attractions. The fishing pier was destroyed in 2003 by Hurricane Isabel, but it was rebuilt in 2009.

Old Point Comfort

Shortly after the War of 1812, the U.S. government realized that coastal defenses needed to be strengthened, and Old Point Comfort's location was the place to do it. Construction began on Fort Monroe—named for James Monroe, president at the time building started—in March 1819. J. Arnold Dalby's *A History of Old Point Comfort and Fortress Monroe, Virginia* noted that the Hygeia Hotel was built in 1821, "situated near the entrance of the Fort, and consisted of one large room used both as a parlor and dining-room, with four chambers on either side, and kitchen in outbuilding in the rear, as in olden time." The structure was not at first intended as a hotel, but rather "accommodations for the engineers and construction workers outside the perimeters of the new moated fort," according to an edict by superintending engineer Colonel Charles Gratiot. By 1822, it had become the HYGEIA HOTEL, named after the Greek goddess of health, and soon it was enlarged as a resort to accommodate up to four hundred guests. Plenty of guests came to the Hygeia, according to Dalby: "Old Point, as a watering place, was now attracting people from every section. The English, French, and Spanish war vessels would rendezvous in Hampton Roads each year to escape the hurricane months of the West Indies, and their stay would be a season of joyous hilarity for the young people." It also drew distinguished guests, such as Presidents Andrew Jackson, Ulysses S. Grant and John Tyler, Kentucky statesman Henry Clay, showman P.T. Barnum and poet Edgar Allan Poe.

They came for the retreat, for cool breezes, for the healing salt air and for the cuisine. An 1822 hotel ad in the *Norfolk Herald* said, "All of the luxuries of the table, the finest oysters, most delicate fish, choice meats and savory vegetables are procured for repeat and served in many different dress and preparations, as it is hoped will gratify the most fastidious." In 1829, owner

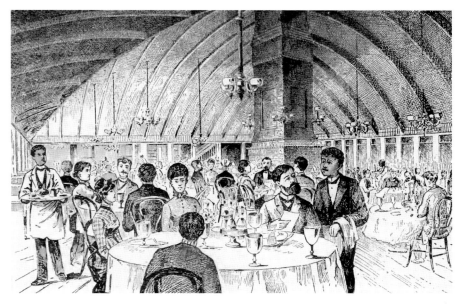

The Hygeia dining room, circa 1880, Hampton. *Author's collection.*

Marshall Park advertised in the *Richmond Enquirer* that the hotel set a "table with the choicest delicacies of the season, market & neighborhood afford." The hotel was razed in 1863 during the Civil War when Union leaders at the federally held Fort Monroe feared it was a haven for Southern spies and sympathizers. To accommodate travelers, however, the Hygeia restaurant was opened on the site in 1863; from this, a second red, palatial, four-story Victorian-style Hygeia Hotel was built in 1868. The property was elevated to one of the most prominent resorts in the nation under ownership of Harrison Phoebus beginning in 1874. Phoebus was a much-respected member of the community around Old Point Comfort; the town adjacent to the point was renamed from Chesapeake City to Phoebus in his honor. Steamships and trains brought guests here by the thousands annually.

Menus of the day reflect the luxury that awaited those guests. The freshness of the cuisine was described in a promotional booklet from the Hygeia: "A bountiful dinner, in which a prominent part is played by a noble sheepshead [a type of fish], who but this morning was swimming tranquilly about, unconscious of his coming doom, restores our flickering energies, and at the same time induces in us that placid, tranquil frame of mind." The bill of fare on February 20, 1881, did not list sheepshead as a dish, but there was "Fillet of Sole, Fried, Sauce Tartare." Among other larger courses: leg

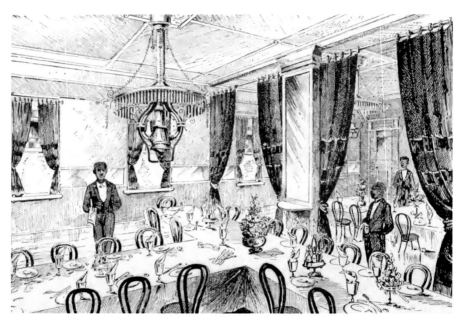

The Hygeia, new banquet hall, circa 1880, Hampton. *Author's collection.*

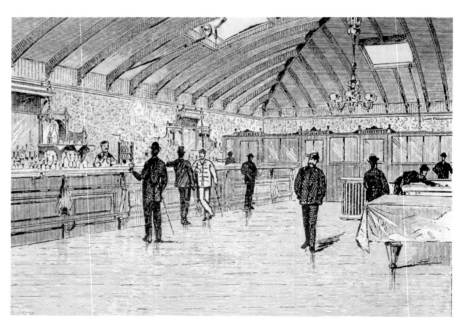

The Hygeia, the bar and the billiard room, circa 1880, Hampton. *Author's collection.*

of mutton with caper sauce and "Stewed Diamond Back Terrapin." There were vegetables, including hominy, and relishes like spiced oysters. Bivalves were offered to start the meal too: "Back River Oyster on Half Shell." Note the name of the oyster source: Back River is an inlet on the Chesapeake Bay between Hampton and Poquoson, just north of the Hygeia.

Local oysters were also on the April 20, 1890 menu: "Cherrystone Oysters on the Shell" with horseradish was listed as a starter; Cherrystone is an inlet just northeast of Old Point Comfort, across the Chesapeake Bay, on the Eastern Shore. Larger courses included spring lamb with mint sauce and coarse hominy, and again, stewed terrapin. Relishes featured spiced oysters, as with the 1881 menu, as well as a crab salad. Much like on the 1913 menu of the Buckroe Beach Hotel was the offering of Roman Punch as a mid-course palate cleanser. A Virginia lemon pie was among a dozen desserts featured.

Not long after Phoebus's death of a heart ailment at age forty-five in 1886, the hotel began to decline and fall into disrepair. Secretary of the Army Elihu Root condemned the Hygeia in 1902 and authorized its demolition for an expansion of Fort Monroe, which never happened.

The Hygeia received company on April 4, 1896, when "[o]ne of the largest, and the handsomest hotel in America was formally opened for the patronage of the public...when the CHAMBERLIN HOTEL at Old Point threw open its doors" (emphasis added), reported the *Virginian-Pilot* the day following the event. The same article noted that among the well-appointed lobby and suites is

> *the dining room, with over a hundred tables, each seating four persons. To the north of the dining-room in the northwest corner of the building, is the pantry and kitchen. Here yesterday over a score of white-aproned cooks were busily engaged in preparing the finest foods which can be set before an individual. Everything is so arranged that guests can be served with the greatest promptness consistent with good service.*

There should be little doubt that good food and good service would be provided at the namesake hotel that John F. Chamberlin built. Chamberlin had a successful boutique hotel with a lavish dining room operating in Washington, D.C. The high-end D.C. eatery had an English bar on the first floor and tables for the public. Upstairs were private dining areas and a banquet hall. The *San Francisco Call-Herald* noted in 1901, "Mr. Chamberlin's wonderful cookery, with his fascinating personality, made Presidents and

statesmen his friends for life....[H]e appealed to the Senators through their stomachs, by exquisitely cooked dishes, his famous terrapin and deviled crabs, rare old wines and liquors, and through his generous personality."

The Chamberlin touted the luxury of the resort. From a period brochure:

> *Your friends have told you of the cuisine of The Chamberlin. They travel the world over and come back to Old Point for their favorite dish—good, wholesome American food "like mother use to cook;" no cold storage stuff, but the real thing—Chesapeake Bay oysters, fresh from the water, absolutely uncontaminated; terrapin, toothsome and tempting; crabs; shad; Smithfield ham; Virginia corn bread.*

It also lauded the dining facilities: "Not only tempting dishes, prepared to one's taste and quickly served, but a delightful Dining-Room, unmatched in all the world for architectural grace and beauty. Afternoon tea in the Palm Room and after-dinner coffee in the Lobby are features especially pleasing."

At dinner on April 19, 1896, one could start with a selection of local oysters and clams: "Lynn Haven, Little Neck Clams, Cherrystone" was on the menu. Entrees included filet of pompano (a butterfish) served au gratin style and "a la Trianon." Trianon sauce was a sauce of the time that, according to *The Fannie Farmer Cookbook*, had a hollandaise base with sherry wine added while cooking. Other options included ribs of prime beef, "Baked Pork and Beans, Boston Style" and "Sweetbreads Glace au Epinards, au Jus," or glazed sweetbreads, fresh spinach with just a hint of cream added and pan juices. Some interesting items include English snipe on toast, pickled lamb's tongue and "Escalope Terrine Fois Gras, Mexicaine." This is pure speculation, but it seems this dish consisted of fatted duck or goose liver compounded with seasonings and spices, packed into a tearing mold and cooked in a water bath at a low temperature to have it set. The slices may have then been scalloped or cut with a zigzag pattern for service. How this classic French dish was made "Mexicaine," or in a Mexican style, is unknown.

An intermezzo of "Punch, A La Cardinal" was offered. This most likely was a granita or sorbet-type palate cleanser, similar to the use of Roman Punch seen at the Buckroe Beach Hotel and Hygeia Hotel, but probably pink or red in color, maybe from red fruit like berries—hence the cardinal reference. Tutti-frutti ice cream, assorted candy and pastries rounded out the meal, in addition to a selection of American, Roquefort and Stilton cheeses.

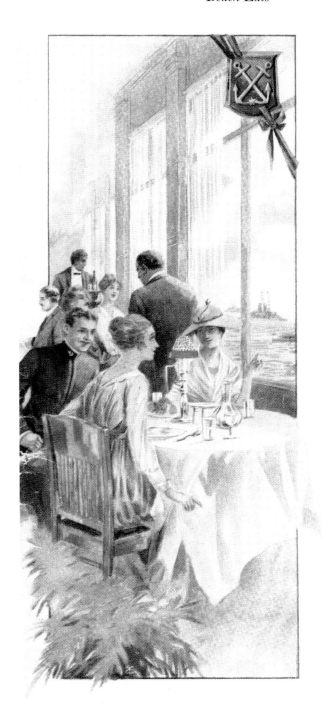

Dining at the
Chamberlin,
Hampton, circa 1900.
Author's collection.

The menu also reminded patrons that "Castalia Spring Water, one of the purest waters known [, is] supplied at table without charge."

Four months after the hotel opened, John Chamberlin died on August 23 from Bright's disease. "He lived to see realized, but not to enjoy, the crowing ambition of his life—the completion of the magnificent hotel at Old Point Comfort that bears his name," said the *Indianapolis Journal* the day following his passing. Fire destroyed the hotel John Chamberlin built on March 7, 1920. The current Chamberlin, built in the classic Beaux-Arts architectural style, opened (the Chamberlin-Vanderbilt, as it was affiliated with the Vanderbilt hotel system) on February 11, 1928. Like many restaurants today, cooks at the Chamberlin-Vanderbilt were utilizing fresh, local ingredients to serve to their very important guests. The *Virginian-Pilot* noted in April that year, "With the probably exception of the far-famed Smithfield ham, Virginia waters have furnished more delicacies for the table of the nation than any other productive source in the Old Dominion, with their contribution of luscious seafoods." Among fish bound for the hotel restaurant were "flounders, rock, Spanish mackerel and others in varied assortment." It also noted the blue crab: "hardshell crab meat is available year around and the softshelled crustaceans are found in local waters in season." Also called out were oysters: "Then, too, there is the oyster propagated on Virginia's great natural rock beds and by Tidewater planters. The Lynnhaven, Cherrystone, Hampton Bar, Seatag and others are taken from local waters." It wasn't just seafood, however, that would be utilized. The article stated, "Truck products vie with seafood delicacies in their contribution to the table. Trained culinary artists, under Nicholas Mores, Chamberlin-Vanderbilt chef, who has catered to the taste of patrons in White Mountain resorts for years, have been instructed with the responsibility of concocting tasty dishes for patrons." Among those: strawberries, lettuce, new potatoes, tomatoes, snap peas and more. "Thus has nature designed to make the exacting task of cooking for Chamberlin-Vanderbilt patrons a little easier for the cooks."

By the end of the twentieth century, the building was becoming worn, and the appeal as a seaside resort waned. Major renovations were undertaken, and in 2008, it reopened as a luxury retirement community. Despite that, the dining room of the Chamberlin is open to the public for certain meals, affording delightful cuisine and sweeping views of the Chesapeake Bay.

NORFOLK

Norfolk became a settlement in the English colony in 1636, but its scope was small and limited to the area of what is today downtown along the Elizabeth River. North of that, colonial settler Thomas Willoughby was granted five hundred acres by King James I in 1622 where Ocean View is today, along the Chesapeake Bay. Despite this, Ocean View would not emerge as a seaside resort for another 250-some years. The community was platted as Ocean View City in 1854, and folks would take the oyster shell road or boat to take in the salt air. Although increasingly popular as a summer resort within the next decade or so, it wasn't until the arrival of a railway that the area would truly bloom. In September 1879, the Norfolk and Ocean View Railroad began a nine-mile-long, thirty-minute steam line linking the town of Norfolk (at Church and Henry Streets) and community of Ocean View. Electric trolley cars would be added in 1902. Soon thereafter, amusements and hotels opened, offering distractions on many levels, including culinary. Ocean View would wane by the 1970s, but in the early twenty-first century, the community began to reemerge.

Ocean View Hotels

In June 1869, an announcement was made for the OCEAN VIEW HOTEL, not only promising the resort trappings of "surf bathing [and] sea air" but dining pleasures, too, including "Fish, Crabs, Oysters, etc. to be enjoyed at Ocean View…unstrapped by any other Sea-Side Watering place in the country." More eats and drinks were mentioned: "A large Vegetable Garden is attached, and the Table will be supplied with the very best Edibles to be obtained in this section. The bar is stocked with the very best Segars and Liquors," said manager Thomas Bradford. Just in time for the Jamestown Exposition, C.A. Baker and his wife opened their Ocean View home to house visitors, an experience they enjoyed so much they added additional rooms, eventually opening the HOTEL NANSEMOND. After the hotel burned in 1920, it was rebuilt in 1928 in a grand Mediterranean Rival design with generous use of Spanish baroque accents. A 1940s brochure said Hotel Nansemond was "Norfolk's most modern resort hotel, open all-year and fireproof…situated on beautiful Chesapeake Bay overlooking the ocean." In addition to sports, such as golf and swimming, fishing and sailing, the cuisine was highlighted: "Tidewater Virginia has long been famous for its

delicious foods. You will find that Hotel Nansemond upholds this tradition with a menu that features Virginia's famous sea foods, Smithfield hams, fried chicken and other Southern dishes. Meals are served in the spacious dining room or in the picturesque indoor and outdoor patios." The hotel was taken over by the federal government for training exercises in World War II, including the planning of Operation Torch, the invasion of North Africa. The Hotel Nansemond fell into disrepair in the 1970s and was destroyed in a fire in 1980.

Around 1946, HOLIDAY INN—not affiliated with the well-known chain—opened in Ocean View, near what is today the East Beach community. An advertisement that year promised "Dining—Dancing… On Beautiful Chesapeake Bay. We specialize in Seafood Dinners." Another notice that year promised "'Food' Chesapeake Bay Style." By 1948, the property was purchased by LESLIE "LES" COLMAN HOGGARD, who catered to only "the best class of people," according to his manager, R.L. Horn. Hoggard continued the hotel's tradition of fine dining and hosting banquets and other special events, but by 1953, an ad appeared wanting help for a snack bar. By the 1960s, that hot dog–and–burger stand began a transformation into what would become SHIP'S CABIN. The restaurant, under son JOE HOGGARD's watch, was Coastal Virginia's first modern celebrity restaurant and an early recipient of the coveted AAA Four Diamond Award in the region. The Holiday Inn would go, but Ship's Cabin had a long run. Joe Hoggard sold the restaurant in 2000. It changed hands a few times before finally shuttering about half a decade later.

Ocean View Amusement Park and Doumar's

By the turn of the twentieth century, rides, games of chance, displays of curiosities and cooling treats like iced drinks and ice cream were offered at the end of the Norfolk and Ocean View Railroad. These would grow into a full-fledged amusement park that would include thrill rides such as the Rocket rollercoaster. A casino opened, as did a bandstand. A picnic pavilion was built for groups, such as Sunday school classes, lodges and clubs, to have outings. For the celebration of Independence Day in 1926, trolleys ran an all-night schedule to accommodate the crowds. Dances at midnight, large firework displays and food were among the many offerings reported: "The Ocean View hotel dining room and the pavilion restaurant have prepared special menus and the best of sea food may be had at

city prices. The 15 refreshment stands serving cold drinks and ice cream are prepared to quench the thirst of the expected throng." The season that year, according to an announcement, featured all sorts of culinary offerings, including,

> [A]*n ideal* Japanese Tea Garden *which has proven a great rendezvous for the ladies....The magnificent Confectionery and Soft Drink Fountain, a provided by* Boogades Bros., *insure patrons the best in hot weather beverages so refreshing when the sun beams from overhead and inspires parched throats....The* Pavilion Restaurant, *under the able management of S.K. Rubaiz, provides a versatile menu, including a delightful light lunch or a full course or sea-food dinner....There is no uncertainty about the* "Doumar" Ice Cream Cone—*they are conceded to be the best the market affords and are shipped all over the country. They are made here "while you wait" before your very eyes by A. Doumar & Bro.* [emphasis added]

The "A." in "A. Doumar & Bro." was Abe, an immigrant from Syria, who is credited, while at the 1904 St. Louis World's Fair, of crafting thin, sweet wafer-thin waffles from a waffle iron in a cone shape and adding ice cream, combining the two treats. Although ice cream cones were not unknown at the time, this is believed to be the point where they became mainstream. Before, ice cream was typically served in small glasses or metal containers or offered in paper bowls for the customer to lick clean. In 1907, the nineteen-year-old Doumar and his brother George brought a self-designed cone machine to the Jamestown Exposition. In just one day at the expo, the Doumars sold 22,600 cones. That was enough to convince the family to move from their home in New Jersey and set up shop permanently in Norfolk, opening a stand at Ocean View Amusement Park. The park closed on Labor Day 1978.

Jamestown Exposition

With the approach of the 300th anniversary of the settlement of Jamestown, Virginia decided to throw a party. The answer: the Jamestown Tercentennial Exposition of 1907, more commonly called the Jamestown Expo, a six-month-long extravaganza from April 26 to November 30 with gates opening at 8:00 a.m. and closing at 11:00 p.m. The cost of admission was fifty cents

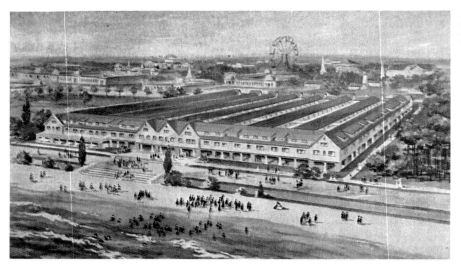

The Inside Inn at the Jamestown Exposition, Norfolk, 1907. *Author's collection.*

for adults and twenty-five cents for children; almost three million people, including paying customers and those who attended for free, visited the expo. Although celebrating Jamestown, the exposition was held in Norfolk due to that's city's accessibility and infrastructure, and a mile-long stretch of relatively undeveloped waterfront land at Sewell's Point was selected for the host site. Although not the same turning point for food seen three years earlier at the 1904 St. Louis Fair, which propelled the popularity of—not the introduction of—many items still enjoyed today: hamburgers and hot dogs (with French's mustard), iced tea, cotton candy (then called fairy floss) and the ice cream cone. There was plenty for Virginia visitors to eat and drink and legacies left all the same.

Perhaps the planners at the Jamestown expo had learned some lessons from the St. Louis event. In 1907, the *Virginian-Pilot* reported on the selection of concessions: "The directors of the Exposition early decided that they would do away as much as possible with the disagreeableness of the presence of the usual Coney Island 'dog' or frankfurter stand, with their hoarse-voiced barkers and unpleasant odors." The Warpath was the name of the midway, where the majority of amusements and concessions where held. Among them: Fair Japan, which Laird & Lee's *Guide to Historic Virginia and the Jamestown Centennial* described as "a typical street scene, as would be found in Tokio [*sic*].…[A] native theater and restaurant will show [them] in their historic and gastronomic life." A tea

garden was featured. Also of note was the OLD VIRGINIA CORN CRACKER, a mill for grinding corn that was cooked into "hoe cake, batter bread, and corn bread with syrup and all-you-can-eat country sausages and the real Smithfield ham." At Old Jamestown, a reproduction of the former colonial capital, "one may rest and also eat modern cooking on a roof garden overlooking the ancient settlement." There were also vendors such as the EL DORADO CAFE in the Streets of Seville exhibit and hawkers of candy and chocolates, peanuts, popcorn, apple cider and grape juice, drinking water, soft drinks, beer from Consumers Brewing Co. and, of course, ABE DOUMAR and his brother selling their already famous ice cream cones. The HE-NO TEA exhibit featured what it billed as the "biggest tea-pot on earth" (said to hold a million cups) and a tea bar, and FERMIN MICHEL served hot roast beef sandwiches. At the Swiss Village, consisting of a replica of a chalet built into the side of a miniature manmade Matterhorn, the restaurant was "one of the most popular eating places in the grounds. Its capacity alone is enough to recommend it, as 3,500 people can be served at a time," reported the *Virginian-Pilot* in April 1907. At the center of the dining hall was a lighted fountain constructed from stones from the shores of Lake Geneva.

The Food Products building on Pocahontas Street at Commonwealth Avenue had "elaborate displays of food stuffs" and "machinery used in the preparation of food stuffs...shown in actual operation," according to the Laird & Lee guide. The *Jamestown Exposition and Historic Hampton Roads* booklet called it an "ornate building devoted to the display of all kinds of food products...because of the great agitation of the subject of pure foods at the present time it is a place of unusual interest." That line is in reference to the Pure Food and Drug Act, enacted a year earlier after a public outcry over reported widespread unsanitary conditions in the food industry, fed by the popularity of Upton Sinclair's book *The Jungle*. Items displayed and demonstrated included baking ingredients, cereals, coffee, condiments, tea and other such items.

Eats and drinks could also be enjoyed at the only hotel located within the fairgrounds, the INSIDE INN. The large, two-storied Colonial-style structure had accommodations for six thousand and dining halls to feed three thousand folks at the same time. The newspaper said it was a great getaway from the hustle-and-bustle of the expo:

> *Enjoy one of the finest views in the world as you walk the wide verandas and board walk of this hotel...no noisy amusements, gambling or*

rowdyism. Everything first-class and service the best. The table is supplied with everything the market affords at reasonable prices. Excellent luncheons 50 cents and unexcelled dinner $1.00, accompanied by sweet strains of music from a high-class orchestra.

On Sunday, a private entrance allowed guests to the restaurant with no fair admission charges to "enjoy a good meal in the Pergola Cafe overlooking the ocean…A la carte restaurant at popular prices" (emphasis added).

Nearby was the Pine Beach Hotel, opened in 1902, which accommodated thousands of visitors during the expo. But before the fair, folks came to this sparsely populated area of Norfolk County for the same reasons they patronized other seaside resorts: cool breezes, salt air and luxuriating. It was initially operated by George F. Adams, formerly of the Hotel Warwick, but Charles H. Consolvo, owner of the Monticello Hotel, took over three years later. Consolvo also owned the Ocean View Hotel. A 1905 newspaper article said of the Pine Beach Hotel eating area, "The dining-room, which commands considerable space, faces the exposition grounds and also affords a beautiful water view." Another article, also from 1905, commented, "Its cuisine and service is first class. Located on Hampton Roads, adjoining the site of the Jamestown Exposition it commands an unequaled panoramic view." A menu from October 1905 shows impressive local culinary offerings. Among the dishes: Little Bay oysters, fried or broiled Pine Beach spots (a type of fish) with bacon, boiled stripe bass (rockfish) with anchovy sauce and broiled soft-shell crabs with tartar sauce. Dinner cost one dollar. Another 1905 article asserted that the dining room here "is on a par with…the Monticello."

Some of the Jamestown festivities were private affairs, such as a dinner for Italian adventurer and cousin to Italy's king Prince Luigi Amedio, Duke of the Abruzzi. The duke sailed into harbor in command of three of his country's warships for demonstration and exhibition and was feted with a special dinner at the Chamberlin on June 8, 1907. The meal was hosted by expo president H. (Henry) St. George Tucker and started with appetizers of caviar canapé, littleneck clams, clear green turtle soup, salted almonds, olives and bonbons. Main courses included soft-shell crabs with sauce tartare, braised sweetbreads with fresh mushrooms and roast spring lamb with mint jelly and "New Peas En Caisse." A side dish was "Tomatoes En Surprise," the particulars of which is not known, but a found recipe called Tomato Surprise showed that dish as thick-sliced tomatoes, with skin on, topped with a mixture of ricotta, grated mozzarella and parmesan cheeses

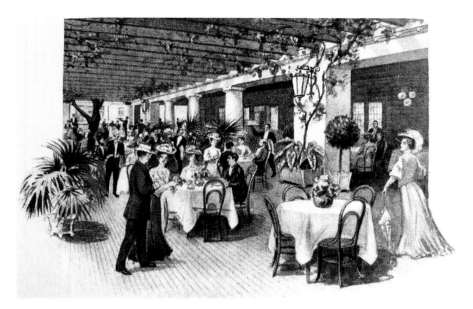

Outdoor pergola, European dining room, the Inside Inn at the Jamestown Exposition, Norfolk, 1907. *Author's collection.*

and mayonnaise, seasoned and broiled. For dessert: ice cream with fresh strawberries, petit fours, lad fingers and macaroons. Alcohol flowed freely that evening with sherry, Mumm's Selected Brut (sparkling wine), rye and scotch whiskeys with soda, cognac and yellow chartreuse, a liqueur.

The fest also gave the region an opportunity to showcase itself like never before, including its hotels and restaurants. *The Jamestown Exposition Edition of the Illustrated Standard Guide to Norfolk and Portsmouth* says of the ATLANTIC HOTEL, "This is a modern hotel, and one of the features is a rathskeller for ladies and gentlemen." Rathskeller is a German term for a restaurant or beer hall, typically below street level; it is also a feature mentioned at the LYNNHAVEN, along with "elegant cafes." Of the HOTEL LORRAINE, it notes, "The principal features of this hotel are an elegant cafe for ladies and gentlemen, and a very attractive stag grill room." Stag is a term referring to a male-only venue. The Atlantic, Lynnhaven and Lorraine hotels were all in downtown Norfolk. A list of "the most prominent restaurants and cafes" included forty-seven establishments in Norfolk and Portsmouth. In Norfolk, these included the MONTICELLO HOTEL CAFE, HOTEL NEDDO CAFE and McDONALD'S LUNCH ROOM, which operated as a dairy lunch. In Portsmouth, there were the HOTEL LAFAYETTE CAFE, MOONEY'S LUNCH

ROOM and PEARSON'S CAFE, noted as a stag establishment. A special callout was given to these establishments as "among the most popular places in Norfolk: STEVE SEELINGER'S, HENRY SEELINGER'S and ST. DENIS HOTEL." Cafe St. Denis, located on Main Street at Roanoke Avenue, purchased a full-page ad in the guide, promoting "High-Class Service at Moderate Prices…Our Steamed Oysters are Unsurpassed" (emphasis added). It showcased a menu of "Sea foods and game in season" with "Cuisine unexcelled" and "Special food dishes for after-theatre parties." The café promised "[h]andsome dining rooms, light and bright, for clubs or private parties" and "Main Street's 'Passing Show' ever in view from our dining room windows."

Although the Jamestown Exhibition was financially unsuccessful, it left a long legacy. The expo helped put the region on the map and showcased the wealth of eats and drinks, as well as hospitality, to be found in Coastal Virginia. It also boosted businesses, including hotels and restaurants. It also laid the ground work for the establishment of the world's largest naval base—a legacy that Coastal Virginia still reaps the benefit from; following World War I, Norfolk sold the 450-acre expo site to the federal government, which, in turn, created Naval Operating Base Norfolk, now Naval Station Norfolk.

Ocean View Chefs and Restaurants

The scrappy lifestyle often associated with Ocean View manifested itself in eateries, too, by the mid-twentieth century. MAMA'S ITALIAN KITCHEN offered no-nonsense Old-World cuisine, while American good-but-not-fancy fare was served up at Greenies and the Thirsty Camel. Mama was GIUSEPPINA LOIERCIO, who opened the restaurant with her husband, ALBERTO LOIERCIO, who had previously cooked at VENEZIANO in Norfolk's Riverview neighborhood. All the hits were there, including linguini with red or white clam sauce, baked stuffed lasagna with meat sauce, Veal Scaloppini Marinara, minestrone soup, pizza and Calzoni Imbottito (with salami, provolone, mozzarella, parmesan and ricotta cheeses, ham and pepperoni). *Virginian-Pilot* restaurant critic Sam Martinette said, "Mama's is as comfortable and cozy as an old sweater, one of the last of a kind—a family-run Italian restaurant with more than a touch of the Old Country." The restaurant closed in 1998 after Alberto's death; Giuseppina ran the eatery for a year until she became ill.

GREENIES BAR dates to 1898 according to court documents issued when the eatery was sold in 2018; the current building was constructed in 1948. Dishes include comfort food favorites like burgers, meatloaf with mashed potatoes and a surf-and-turf platter that showcases an eight-ounce New York strip steak and shrimp. Martinette noted in 1999, "It's not fancy, more down home and comfortable. Like Ocean View." Greenies has been closed and was razed for more public beach access in 2018. The THIRSTY CAMEL is a squat stucco building near the fishing pier and has been in business since the mid-1950s. It is noted for, among other items, shrimp, often steamed and seasoned with Old Bay and served with melted butter and cocktail sauce for dipping, as well as steak prepared in a straightforward manner. Pub grub is also popular. Martinette said in 2000, "The fabled Thirsty Camel was nothing more or less than an Ocean View version of Cheers....with watermen and house painters mixed in with lawyers, nurses and, well you get the picture." The Thirsty Camel is still open.

Well-known modern chefs who have had a strong affinity with Ocean View include MONROE DUNCAN. "Le Chef," as he liked to be called, opened SUDDENLY LAST SUMMER, a cutting-edge eatery, in 1979 with partner TONY KLEMENTZOS. An open kitchen—one of the first in the region—and creative "big city" dishes like fettuccini alfredo with crabmeat, walnuts and snow pea pods set the cuisine scene on fire. Duncan would also open in Ocean View PIRANHA'S—A FEEDING FRENZY, which later changed its name to MONROE'S—A RESTAURANT. Duncan had a proclivity to not only create new dishes but also keep classics on the menu too, such as the Shrimp Savoy Sean, made famous a decade-plus earlier at the NATION'S ROOM in Norfolk's Golden Triangle hotel. Duncan also helmed the Blue Crab and did recipe development for JOE HOGGARD'S SHIP'S CABIN. BOBBY HUBER, a longtime friend who did much mentoring under Duncan, was chef at Ship's Cabin before opening his own eatery, SWEET BIRD OF YOUTH, located in the then-closed Suddenly Last Summer. Huber had also worked at CRUSOE'S CELLAR and the BLUE CRAB in Ocean View. There is more about Joe Hoggard, Monroe Duncan and Bobby Huber later in the book.

Not exactly in Ocean View, and definitely not brick-and-mortar restaurants, the dining rooms on the SS *Princess Anne* and the SS *Del-Mar-Va*, both part of the Cape Charles–Little Creek Ferry Service, offered extensive menus on the twenty-six-mile journey between the two points. The ferry was a vital service linking the Norfolk/Virginia Beach area and the Eastern Shore from 1933 to 1964, with the opening of the Chesapeake Bay Bridge-Tunnel. In a mid-1940s menu, special dinners included local favorites like clam chowder,

Monroe Duncan at Simply Divine Dahlings, Norfolk, 1977. *Author's collection.*

crabmeat cocktail, baked shad with lemon butter or shad roe with bacon and deviled crab. Virginia beef stew was a non-seafood option. Other offerings included "Three Fried Oysters, Pepper Hash, French Fries, Cole Slaw, Roll and Butter, 40 cents" and "Oyster Stew, prepared plain, with milk, with half-and-half, with cream, or special," with prices ranging from thirty cents to sixty cents. Under the "Famous Specials" section is an interesting item: "Hot Buttered Crabflake," which is most likely the ferry service's version of Crab Norfolk, made famous by Doc Twiford decades before.

VIRGINIA BEACH

Although colonists had landed here in 1607, the area—then known as Princess Anne County—was sparsely populated even into the early twentieth century. There was a larger community in Kempsville (formerly Kemps Landing), but the region was largely agricultural, with a few hamlets here and there; by the 1880s, there were fewer than ten thousand citizens. But as seaside resorts were entering their golden age, an eye turned toward a nice area of land just south of Cape Henry for possible development.

The Seaside Hotel and Land Company, headed by Colonel Marshall Parks (whose father had managed the Hygeia Hotel at Old Point Comfort), formed in 1880 and purchased property along the oceanfront. A clubhouse for sportsmen was built the following year in the yet-to-be-named town of Virginia Beach. In 1882, with the name then secure—tradition says through a contest—a railroad was organized and an eighteen-mile-long route broken ground to connect the new area with Norfolk. The line opened on July 16, 1883, and "between July and September, several thousand visitors danced on the (newly constructed) pavilion floor, waded into the ocean, and dined at tables which only weeks before had been part of the pine forest crowding the shoreline," according to Stephen S. Mansfield's book *Princess Anne County and Virginia Beach*.

The VIRGINIA BEACH HOTEL opened in 1884, and the likes of President Benjamin Harrison, politician Williams Jennings Bryan, capitalist Cornelius Vanderbilt and luminary Alexander Graham Bell came to call, noted Mansfield. By 1888, the hotel was significantly altered and expanded and re-christened as the PRINCESS ANNE. Virginia Beach would continue to develop as a seaside resort, with other hotels opening, as well as a number of cottages. It became not just a resort but a true community and incorporated as a town in 1906; the county then had a population of around 11,000. Four years prior, an electric rail line linked Norfolk along the Chesapeake Bay to Cape Henry, and soon Cape Henry and the resort area were linked by rail too. Virginia Beach continued to grow, and the grande dame CAVALIER HOTEL opened in 1926. Over the next few decades, scores more hotels and restaurants opened. The Town of Virginia Beach and Princess Anne County would consolidate in 1963 to form what is today the city of Virginia Beach, the most populated city in the state, with approximately 450,000 residents. More than 6 million people visit here annually according to the Virginia Beach Convention and Visitors Bureau, and *Guinness Book of Records* says it is the largest pleasure beach in the world.

Cape Henry Casino

By the first decade into the twentieth century, two distinct resort areas were emerging on the shore of the Atlantic Ocean: Virginia Beach and Cape Henry. The latter started on July 4, 1903, when WILLIAM O'KEEFE opened the CAPE HENRY CASINO with much fanfare just under the shadow of the two lighthouses on that curve of land where settlers had first landed almost

three hundred years prior. The remote area, north of the resort area of Virginia Beach, was accessible by rail line on either Chesapeake Transit or Norfolk and Southern cars. The casino promised the "Grandest sea view on the Atlantic coast. Continuous panorama of the ships passing in and out of the Capes" as well as "Surf Bathing on a Beach unexcelled by any modern bath rooms." Professor Borjes' Orchestra was the backdrop for dancing until 10:30 at night. For eats and drinks, O'Keefe offered an "Up-To-Date Cafe and Buffet, Dairy Lunch, Soda and Ice Cream Parlors. And all the comforts to be had at a select pleasure pavilion....Plenty [of] free tables and chairs. Good cistern water." But the casino, which many soon started simply calling "O'Keefe's," wasn't just for sun and surf. A newspaper announced on December 9, 1904, "Cape Henry Oyster Roast Today! Delicious Lynnhaven Served." The roasts became a regular occurrence at O'Keefe's.

It was one of those oyster roasts that fed President William Howard Taft in November 1919; the president was in Norfolk to address the Atlantic Deeper Waterways Commission's annual conference. Taft and 400 convention delegates and 150 others, including reporters and the U.S. Marine Band, made their way via rail to O'Keefe's, where they dined at the newly glassed-in pavilion on a menu of Lynnhaven oysters on the half shell, Lynnhaven oysters roasted, Smithfield ham, Princess Anne turkey

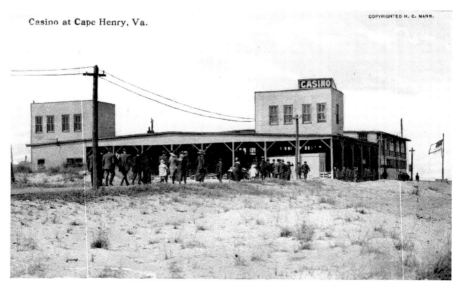

Casino at Cape Henry run by William O'Keefe, serving Lynnhaven oysters, circa 1900. *Author's collection.*

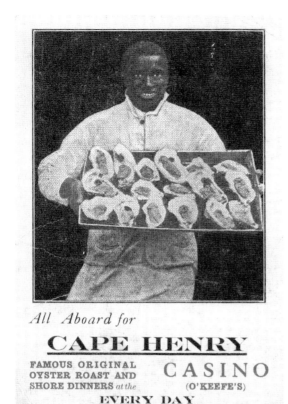

All Aboard for

CAPE HENRY

FAMOUS ORIGINAL
OYSTER ROAST AND C A S I N O
SHORE DINNERS *at the* (O'KEEFE'S)

EVERY DAY

Call O'Keefe, Cape Henry, on Long Distance Phone
Take N.-S. Cars

Cape Henry Casino, famous
original oyster roast and shore
dinners, Virginia Beach, circa
1900. *Author's collection.*

with cranberry sauce, relishes of celery and olives, musty ale and cheese and crackers as a finish. "I am glad to be here by the ocean side. I am glad to taste the best oysters, with the finest flavor, I have ever tasted before," said the president. According to columnist and historian George Tucker, Taft is to have eaten—conservatively—between 10 and 12 dozen raw oysters. For a while, O'Keefe also operated O'Keefe's Inn, later named Courtney Terrace, in the resort area, and operated W.J. O'Keefe & Co. Caterers. A newspaper ad on June 30, 1907, noted the catering was "For Large and Small Conventions" and offered "Sea Food Specialities [including] Shore Dinners, Fish Frys, Crab Feasts, Clam Bakes, Oyster Roasts." O'Keefe noted that Cape Henry Casino and the Virginia Beach Pavilion, in the resort area, were available for parties. The casino burned in 1931. In 1933, plans were announced to build a new casino, called O'Keefe's Inn, but they did not materialize. William O'Keefe died on July 1, 1937.

Princess Anne Hotel

Started in 1884 as the Virginia Beach Hotel, the facility expanded and renovated and the name changed to the Princess Anne four years later. The hotel owners, the Norfolk & Virginia Beach Railroad Company, lured visitors to the new resort with a brochure lavishly illustrated, the cover showing an ideal seaside setting with the imposing Victorian-style structure in the background. It notes that the Princess Anne was "in the midst of pines, its beach unequalled for bathing and driving, the diversity in its many other ways for enjoyment, place it in the foremost rank of Summer or Winter resorts either in this country or abroad." The pitch worked, and the Princess Anne became a premier destination, just a forty-minute rail journey from Norfolk. The first-class hotel featured a "baronial" dining room, according to a newspaper account. Massive wood beams arched over the space, which had detail work throughout, and a massive fireplace took center stage, capped off with the head of an elk over the impressive mantel.

A menu dated April 12, 1897, showcases an upscale menu with several local treats, including Lynnhaven oysters and "Boiled Virginia Beach Drum Fish, Sauce Cubaine." It is unclear what the sauce incorporated, but the concoction most likely had spice and/or tropical notes as a nod to the Cuban inspiration. Also on the menu, "Roast Mallard Duck, Currant Jelly," was served with a lettuce salad. It is highly likely that the duck was sourced from

Dining room, Princess Anne Hotel, Virginia Beach, circa 1900. *Author's collection.*

the hunt clubs at nearby Back Bay. Other entrées featured ribs of prime beef, new spring lamb and chicken croquettes with green peas. A starch-heavy list of sides, including "Maccaroni Italienne," potatoes and rice, also offered new asparagus. The mid-course palate cleanser was Punch Au Kirsch, most likely a semi-frozen offering crafted with kirschwasser, a cherry brandy. "Crushed Strawberry Ice Cream" was one of the desserts, perhaps crafted from some early Virginia Beach strawberries. Cheese and water crackers rounded out the meal.

Lynnhaven oysters also started out the menu on July 29, 1900, accompanied by local dishes such as Smithfield ham and cabbage with Virginia cornbread and "Native Spring Lamb. Mint or Brown Sauce." Another dish, Poulette of Oysters, most certainly made use of local bivalves in this rich offering of oysters scalded in their own liquor and the juice used to make a rich cream sauce before the oysters are returned and served with toast points. There is no intermezzo mentioned. Iced watermelon is listed as one of the desserts.

A fire thought to have originated in the kitchen burned the Princess Anne to the ground on June 10, 1907. Announcements were made periodically about rebuilding the Princess Anne, but these plans did not come to fruition. Although there were many fine hotels and restaurants in Virginia Beach over the next two decades, it would not be until the Cavalier opened in 1927 that the town saw such opulence again.

The Cavalier

The Cavalier sits high on a terraced hill, overlooking the ocean, a regal queen awaiting her subjects. The hotel's beauty and splendor today—after extensive renovations—is as impressive as it was when it welcomed its first guests on April 7, 1927. The Cavalier was born from the ashes of the Princess Anne Hotel—which burned in 1907—when civic leaders realized the need for a new luxury hotel. Guests arrived by train just a few steps away from its grand entrance. Others arrived by chauffeured Rolls-Royces. Celebrities, Hollywood royalty and American presidents came here. Among the visitors were F. Scott Fitzgerald and wife Zelda, Judy Garland, Will Rogers, Herbert Hoover, Harry S Truman and John F. Kennedy. Richard Nixon loved the Hunt Room and would sit by a roaring fire, regardless of the season, according to interviews with longtime employee Carlos Wilson. Hushed traditions say staff saw him burning papers in the fireplace late one night during the Watergate investigation.

The seven-story brick hotel, sometimes referred to as Cavalier on the Hill, was constructed in a Y-shape floor plan for optimum viewing of the ocean from guest rooms and common spaces. It is a Classical Revival–style building, with some architectural features inspired by Thomas Jefferson's Monticello and buildings at the University of Virginia. Rich amenities and features set it apart from other hotels not just in Coastal Virginia but across the country. Among the opulent offerings were several places for eats and drinks, among them the POCAHONTAS ROOM, the formal dining area, and the clubby HUNT ROOM. There also was a dining room for chauffeurs only. C.I. Siler, who was head waiter during the Cavalier's heyday (and had previously worked at Norfolk's Monticello), discussed the level of service given: "They [the servers] would pour your coffee, put cream and sugar in it and stir it for you. They would put syrup on your hot cakes or waffles. They would carve your steak, they would carve your chicken or your turkey. You didn't have to do anything but sit there with your fork and eat." Carlos Wilson remembered in a separate interview that "on Sunday mornings at breakfast, all the waiters wore tails, Hickory-striped pants and white gloves. You couldn't get in here unless you had a reservation. It was beautiful and that's the God's truth."

A menu from the Pocahontas Room dated October 21, 1934, suggested the meal start with either a Cavalier Champagne Cocktail, a martini, a Manhattan or Dubonnet cocktail. An interesting aspect of the menu shows that, despite this being a very high-end hotel, the kitchen was committed

The Cavalier, Virginia Beach, 2018. *Robert Benson Photography for The Cavalier.*

to a local, southern cuisine. Rather than offering a French or otherwise Continental bill of fare, the Cavalier embraced its Virginia roots through its victuals. The meal could begin with a "Lynnhaven Oyster Cocktail," or perhaps a bowl of "Lynnhaven Clam Chowder" or "Cream of Peanuts Souffle." Broiled sea bass or baked blue fish was offered, as well as "Smithfield Ham Glace au Sherry" and "Roast Princess Anne Turkey" with cranberry sauce. The vegetable selection in particular shows the menu's regional style: "Fresh String Beans Southern Style" (most likely seasoned with fatback and/ or ham), "Stewed Tomatoes," "Buttered Sugar Beets" and "Candied Yams." Cakes, pies and ice cream were the main desserts, and a number of cheeses were served with toasted saltines. Gentlemen who went waterfowl hunting at Back Bay returned with their catch and retired in the Hunt Room while the chef prepared the duck to their taste.

The CAVALIER BEACH CLUB opened on the beach, just down the hill from the grande dame, on Memorial Day 1929 and would host the best bands and singers of the era, Glenn Miller, Harry James, Guy Lombardo, Frank Sinatra and Lawrence Welk, to swoon guests. It offered outdoor swimming, an open-air dance floor, cabanas and tables for dining and imbibing. A Sunday tea dance menu shows light bites, including sandwiches such as a Cavalier Club, olive and nut and Smithfield Virginia ham.

During World War II, the hotel was confiscated by the military and occupied for use as a radar training school. Over time, some of the Cavalier's

The Hunt Room and Tarnished Truth Distilling Company inside the Cavalier, Virginia Beach, 2018. *Robert Benson Photography for The Cavalier.*

luster faded. It became a private club, then shuttered in 1973, reopening in 1976. A modern "New Cavalier" tower was built on the beach across the street, diverting guests and funds. The Cavalier began to fall into disrepair. In 2013, developer Bruce Thompson purchased the hotel for $35.1 million to create a five-star resort. After three years and more than $80 million in renovations, the Cavalier reopened in 2018. The hotel, which is in the Virginia Landmarks Register and the National Register of Historic Places, features the fine-dining room BECCA, where the Pocahontas Room once was. The Hunt Club has returned, too. The RALEIGH ROOM, a bar, and TARNISHED TRUST DISTILLING COMPANY have been added, crafting signature spirits.

Other Virginia Beach Bites

For more than a century, there have been plenty of places for good eats and drinks along the Virginia Beach oceanfront. Among them, SEASIDE PARK, opened in the early twentieth century; the park would grow to include concessions, a picnic pavilion, the Peacock Ballroom and a casino, which, according to a July 1934 ad, was "open all day for a la carte service and special lunches and dinners, featuring $1.00 Shore Dinners prepared by the noted chef and caterer Bob Noble." It added, "Each meal [is] a banquet." At the casino, a nightclub featured "high-class New York artists, peppy music and delicious refreshments." Later that year, a fire destroyed the concessions building, burning out several attractions, including a barbecue restaurant; the structure was not rebuilt. By the mid-1950s, the park was past its heyday when another devastating fire hit in 1956. The final section of what remained of Seaside Park was demolished in 1986. Today, the HILTON VIRGINIA BEACH OCEANFRONT hotel stands on part of the site (which has two restaurants, CATCH 31 and SALACIA), as well as the 31st Street Park.

Many independent restaurants popped up throughout the twentieth century at the Oceanfront, including NEPTUNE'S CORNER, a diner directly across the street from Seaside Park on Atlantic Avenue at Thirty-First Street. Just north on Atlantic Avenue at the corner of Thirty-Third Street was MARTY'S LOBSTER HOUSE, a seafood eatery. A 1960s menu from Marty's shows a wide assortment of dishes, including an Old Virginia Dinner of fried chicken, Smithfield ham, black-eyed peas and french fries, and a roasted Lynnhaven oyster plate with a dozen oysters baked in the shells and served with drawn butter, french fries and coleslaw. A notation on the bill of fare

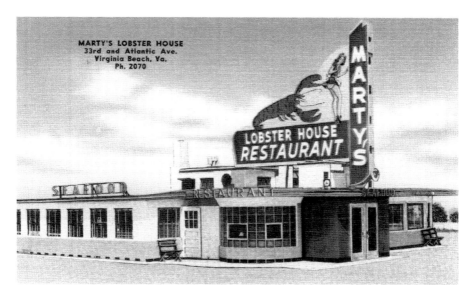

Marty's Lobster House, Virginia Beach, circa 1950. *Author's collection.*

says, "Out of this world." The JEWISH MOTHER threw off fun and funky vibes, as well as a fun and funky menu mostly composed of New York deli-style sandwiches. The restaurant opened on Pacific Avenue at Thirty-Fist Street in 1975 with matzo ball soup, milkshakes and creatively named dishes like Brother Bernie and Sister Adele. The Jewish Mother moved several times after the original building was redeveloped in 2010; the Jew Mom, as it was lovingly called, closed for good in 2014. In 1963, Robert Herman opened the LIGHTHOUSE, serving mostly fried seafood, hamburgers and hot dogs. Expansion in the 1970s added capacity, and the menu evolved to being largely seafood-driven. It was destroyed by Hurricane Isabel in 2003 and was not rebuilt. The land sits undeveloped. Other closed vintage restaurants include: the IRON GATE, an early restaurant owned by iconic Chef TODD JURICH, who is discussed in another chapter; LA CARAVELLE, a French Vietnamese restaurant; SIR RICHARD'S HOUSE OF BEEF, noted for its musical acts, which included Natalie Cole, and its mouthwatering prime rib; WESLEY'S, an early destination dining restaurant; and YORGY'S, which is discussed in another chapter.

Other notable Oceanfront restaurants with longevity that are still open: the BELVEDERE COFFEE SHOP & DINER, inside the Belvedere Hotel, is a step back in time to 1969. A counter and a handful of booths serve customers, with views of the ocean and classic diner dishes. A must-try,

Forbes Candies, featuring salt water taffy, Virginia Beach, circa 1970. *Author's collection.*

long-ago popularized by former Chef RAY RAY LABUEN, is the Eye Opener breakfast sandwich: fried egg, melting cheese, grilled ham and parmesan-encrusted tomato on a toasted onion roll. Others include: ABBEY ROAD PUB & RESTAURANT, BLACK ANGUS (a steakhouse that has been in various locations since opening in 1953), CROC'S 19TH STREET BISTRO, DOC TAYLOR'S, GIOVANNI'S, IL GIARDINO, the RAVEN and TAUTOG'S RESTAURANT. Elsewhere in Virginia Beach, legacy restaurants on the water that are still open include BLUE PETES on Muddy Creek in Pungo, ONE FISH TWO FISH on Wolfsnare Creek, ROCKAFELLER'S RESTAURANT and RUDEE'S INLET, both on Rudee Inlet.

Also of note: FORBES CANDIES was started in the early 1930s by CHARLIE and MARION FORBES, selling homemade peanut brittle and salt water taffy door-to-door. Not long after, they opened their first retail store in Virginia Beach. They added other candies to their lineup, including fudge, jellies, pecan logs and sea foam. During World War II, with sugar and corn syrup rationing, the line was cut back to popcorn, but after the conflict, Forbes returned to the full line of confections. Today, there are five Forbes Candies in Coastal Virginia, including three along the oceanfront.

Halfway between Norfolk and Virginia Beach, C. Cullen Davis opened the PINE TREE INN in 1927 on land acquired by his grandfather. The area

Pine Tree Inn, Virginia Beach, circa 1960. *Author's collection.*

between the two municipalities was connected by the narrow Virginia Beach Boulevard, the only paved road for years; along the way, there was not much more than fields and forests and a handful of communities. The small eatery, shaded by towering pines, gained a big reputation over the seventy-three years it was open; it was the popular place to stop while traveling to or from the beach and the go-to for date nights, holidays and other special occasions. In addition to countless locals, patrons included Lady Bird Johnson and Frank Sinatra. The menu was a rich assortment of fine foods, but Pine Tree Inn was perhaps known best for its oysters. Davis's grandfather J.E. Causey Davis had run an oyster house known as the Lynnhaven Inn on the location for five years before the restaurant opened, and Pine Tree Inn continued offering the freshly shucked bivalves. A mid-1940s menu lists raw Lynnhaven oysters at fifty-five cents for a half dozen. Other menu offerings included fried Lynnhaven oysters, fried spring chicken, broiled or fried filet of flounder, chicken livers and fresh mushrooms sautéed in butter and a seafood plate, a combination platter of "seafoods in season." Also available was an Old Virginia Dinner with fried chicken, Virginia ham, black-eyed peas and candied yams. Eventually, suburbs developed around the restaurant, which bolstered its following. It was named one of the nation's top restaurants in 1972 by *Ford Times*, a

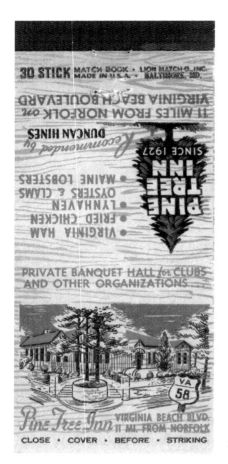

Pine Tree Inn, recommended by Duncan Hines, Virginia Beach, circa 1960. *Author's collection.*

guide published by the automaker. The Davis family sold the restaurant in the 1970s, and various owners ran the eatery. It later changed its name to Tandom's Pine Tree Inn. The last meal was served on July 7, 2000, and the building was sold, razed and replaced by a Wawa convenience store that is shaded by towering pines.

Shore Drive

The stretch of U.S. Route 60 that hugs the Chesapeake Bay from Ocean View in Norfolk and across Virginia Beach to Cape Henry, known as Shore Drive, opened in 1928, augmenting rail service. About halfway, at Lynnhaven Inlet (which is spanned by the Lesner Bridge), was OCEAN PARK CASINO.

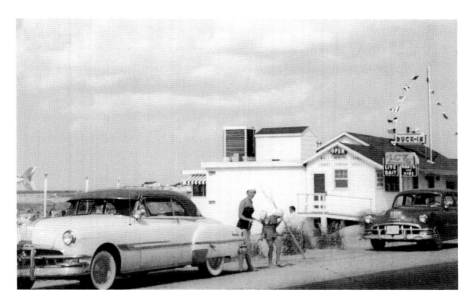

Duck Inn, Virginia Beach, circa 1950. *Al Chewning.*

In addition to offering a variety of amusements, the casino also had good eats. An advertisement on October 17, 1920, declared Ocean Park had an oyster roast dinner "that does credit to the famous Lynnhaven oyster" in "a cafe of refinement…right at the edge of the ocean," with a seating capacity of five hundred that was "modern in every respect." A fire on October 9, 1929, destroyed half the resort; it was rebuilt and opened again in 1931. The new Ocean Park didn't last long; a hurricane in August 1933 destroyed it completely.

Other restaurants of note along this route that are now closed: ALEXANDER'S ON THE BAY, tucked away in the Chic's Beach neighborhood, was an upscale seafood-centric eatery overlooking the Chesapeake Bay. The site was originally a popular hot dog stand in the 1950s, run by Luther "Chic" Ledington—hence the community name. The building expanded, changed hands and changed names until the last name given by owner Angie Alexander. It closed at the end of 2013. The site now houses BUOY 44. CHARLIE'S SEAFOOD served award-winning she-crab soup and other dishes for seventy years. Opened in 1946 by Charlie and Mary Ellen Rehpelz, it closed in 2016. BOBO'S FINE CHICKEN operates in the spot today. Opened in 1953, the DUCK-IN, located on the Chesapeake Bay at the foot of the Lesner Bridge, was known for straightforward seafood and legendary after-work parties on

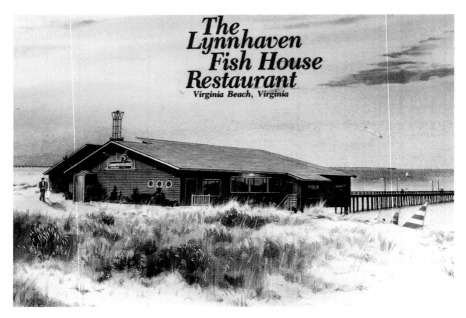

The Lynnhaven Fish House Restaurant, Virginia Beach. *Author's collection.*

Fridays. The restaurant shut down in 2005; condos were built on the site. HENRY'S SEAFOOD was located right on the Lynnhaven Bay next to the Lesner Bridge. Opened in 1962 by Henry S. Braithwaite as an oyster and clam bar, it went through numerous changes and additions to expand to a full-service, seafood-centric eatery. Today, Lesner Inn, an event venue, is on the site. Located next to the Lynnhaven Fishing Pier jutting out into the Chesapeake Bay, LYNNHAVEN FISH HOUSE was opened in 1979 by THOMAS KYRUS and his son, CHRIS. The eatery offered approachable, seafood-forward cuisine with stunning views. The pier and restaurant closed and were demolished in 2018 for other development plans. Notable restaurants with longevity along Shore Drive that are still open today include HOT TUNA and the REEF.

OTHER WATERSIDE EATS

In the tiny village of Irvington on the Northern Neck, the TIDES INN has been welcoming guests since 1947. The quaint, rambling luxury hotel has sweeping views of an idyllic creek leading into the Rappahannock River.

Fresh seafood has been a focus of the menu at the inn's restaurants. In the 1965 guide *Great Resorts of North America*, author Andrew Hepburn includes legacy dish the Hangtown Fry. The breakfast item is still on the menu at The Tides Inn, showcasing scrambled eggs, fried local oysters (the Rappahannock River is noted for the bivalve), a buttermilk biscuit and sausage gravy. The Chesapeake Restaurant is noted for its "tide to table" bill of fare.

Greek immigrants NICK and MARY MATHEWS opened a tiny diner in 1944 that would expand to become the 450-seat NICK'S SEAFOOD PAVILION in Yorktown. The landmark eatery overlooked the York River and the Coleman Bridge stretching across the water to Gloucester Point. It was noted for its seafood-centric menu that also included American dishes, many with Asian and Greek touches. It was also noted for its elaborately decorated dining rooms. Crystal chandeliers hung over coral and teal-hued banquettes; countless statues, oversized gilt-framed oil paintings, urns filled with greenery and bubbling fountains dotted the eatery; and tables were covered with crisp white linens. Extensive damage during Hurricane Isabel in 2003 closed the restaurant.

6

From Hot Dogs to Haute Cuisine

There's an old saying in Coastal Virginia that folks here learn the three Rs early in life: reading, 'riting and the road to Norfolk. As the twentieth century started gaining steam, the region emerged as one with several large economic generators that drew workers from across the area. One was the military presence, firmly established in 1917 when the City of Norfolk sold the former 450-acre site of the Jamestown Exposition to the federal government, establishing Naval Operating Base (NOB) Norfolk, now Naval Station Norfolk. By 1918, there were thirty-four thousand enlisted men at the base, according to the navy. The nation began heading toward another war in the 1930s as the United States watched the military aggression of Germany and Japan. By 1938, land was purchased to expand the naval base, part of a $4 million construction plan. By the time of the Japanese attack on December 7, 1941, Coastal Virginia was in a full-fledged defense boom. There were thousands of new jobs added both on the military and civilian sides. Part of the buildup, during both wars, was at the Norfolk Naval Shipyard, formerly Gosport Shipyard, and sometimes called the Norfolk Navy Yard. In World War I, the shipyard expanded significantly, and again in World War II, when it doubled in size. From the years 1940 to 1945, forty-three thousand were employed there; by the summer of 1940, the yard added on average one thousand new workers each month. The region's population swelled with all the newcomers.

On the Peninsula, activities were swarming at Collis P. Huntington's Chesapeake Dry Dock and Construction Company; later, Newport News Shipbuilding and Drydock Company (NNS) opened in 1886. With the

buildup of naval operations at the turn of the twentieth century, the shipyard had built three warships by 1897. Seven of the sixteen battleships sent on the Great White Fleet's around-the-world cruise in 1907 were built there; the city's fortunes were tied to the company. During World War II, hundreds of ships were launched from the facility. Later, ocean liners, submarines and aircraft carriers would be built at NNS. Today, it is the largest industrial employer in the state.

Back on the Southside, another large economic generator was Ford Motor Company's Norfolk Assembly plant. The plant opened on April 20, 1925, near the Norfolk community of Berkeley, with a workforce of more than seven hundred. It began manufacturing the Model T and would re-gear for other vehicles during its eighty-two-year run, ending with the F-150 pickup truck. The plant, which closed on June 28, 2007, employed thousands—generations of families—and provided many opportunities for advancement for workers. When the Ford plant opened, it was "the biggest non-seafaring manufacturing enterprise Norfolk had ever seen" according to the *Virginian-Pilot*.

And while these workers often made good wages, most were blue-collar laborers. They enjoyed a good hot dog or Dagwood sandwich at lunch, perhaps from one of the carts outside the base and factory gates or at one of the diners or greasy spoons close by. While the nuclear family father worked, mom ran errands and shopped, sometimes treating herself for an elegant—but affordable—lunch at one of the tearooms in an area department store. For the most part, a simple approach to food crossed over to dinner as well. On the nights mom didn't cook, the whole family would pile in the car and perhaps go to a drive-in or a steakhouse, where a simple cut of meat was served with potatoes, a green salad and a roll. Dad might splurge on a whiskey sour cocktail. Seafood was always popular, too, but it was usually served in a straightforward, nothing fancy, often fried fashion. The extent of international cuisine was often spaghetti and meatballs, perhaps at REGINO'S ITALIAN RESTAURANT, opened in 1948. Regino's, formerly in Ward's Corner in Norfolk, is now at Little Creek. Or perhaps dinner was a bowl of chop suey or maybe a Polynesian pu pu platter. For a diversion, the family might grab a pizza or barbecue at the GIANT OPEN AIR MARKET. Of course, there were some restaurants that served finer meals, often prepared with French techniques. And as the century progressed and prosperity grew, folks looked to go out to a "nice restaurant" on special occasions, where light music played, meals were prepared by a chef and not a cook and Champagne was spelled with a capital *C*. A renewed interest in refinement came with the Kennedys in the White House.

DOGS, DRIVE-INS AND OTHER DELICIOUSNESS

America embraced the elements of fast food during the industrialization of the country, when the luxury of time to enjoy lunch became a premium; the midday meal had to be quick and affordable, grabbing a hot dog or two. The country loved its cars, too, and with the popularity of drive-ins coming about in the mid-1940s, folks could motor to an eatery, sit in their vehicles and get a meal delivered right to them, whether a hot dog or burger, almost always with fries and a shake.

Norfolk Dogs

There were hawkers of hot dogs in Coastal Virginia before NICK BACALIS, a native of Greece, began dishing up his version in a hole-in-the-wall joint at 227 City Hall Avenue in 1934. But none created a style that today is still known as the Norfolk Dog. These dogs are to Coastal Virginia what the Chicago Dog is to Chicago, the Coney Dog is to Detroit and the Papaya Dog is to New York City. BACALIS HOT DOG PLACE was catty-corner to the Monticello Hotel. A neon sign pulsated in the window, and inside nine stools lined the counter, filled with flesh pressing flesh during lunch hour. Son GEORGE, while a student at Maury High School, began helping out and started work there full-time when he graduated in 1937. He reigned over the small place, which barely had room for the grill, a sink, an icebox and a coffee urn and the throngs of loyal customers. Until 1974, the routine was the same every Monday through Saturday: arrive at 6:00 a.m. and start a big pot of chili for the dogs during breakfast service. The chili and dogs were usually ready by 10:00 a.m.

The gospel according to dog was spread with two others: ANTHONY "TONY" MIRABILE SR. and JIMMY RELLOS, who worked side by side at Bacalis's stand before Tony ventured out to open TONY'S HOT DOGS. Jimmy worked with Tony there a while before he too opened his own place, JIMMY'S HOT DOGS. All three men, since passed, felt strongly about serving the dogs their way—the Norfolk way—a tough-skinned hot dog slathered with a light and spicy beef chili and topped with onions. Mustard was optional, Tony conceded, but other add-ons weren't. In a newspaper interview, he said, "This is the only place where the customer is wrong. You want it your way, go to Burger King." Today there is a Tony's Hot Dogs in Virginia Beach run by Tony's son Phillip and Joey's Hot Dogs in Richmond run by Tony's son Joey.

Above: Bacalis Hot Dog Place, Norfolk, circa 1970. *Isabella and Carroll Walker Photograph Collection, Sargeant Memorial Collection, Norfolk Public Library.*

Opposite: Tony's Hot Dogs served with homemade chili, Norfolk, circa 1960. *Author's collection.*

Hot dogs have been a staple of DOUMAR'S for generations according to THAD DOUMAR, who runs the restaurant today. "Hot dogs are popular because they are inexpensive and can be eaten on the go," he said. The dogs here are a bit different: called a square dog, they are cut and positioned on a hamburger bun. "The square dog originated during World War II when the War Department decreed that no hot dog buns were to be made for the duration," said Thad. "Only loaf bread and hamburger rolls were available. After the war the family tried to go back to hot dog buns but due to customer demand they gave up the attempt." The dogs here are a slight variation of the Norfolk Dog Tony and others served but a fine representation all the same. "Tony [Mirabile] was very particular about how he served his hot dogs," said Thad. "My grandad always considered mustard relish and onions as a Norfolk Dog, but the customer could always get it how he wanted it."

A beef dog is slathered with mustard, onions and chili, with the chili comprising ground beef, tomato, celery, onions and red kidney beans. At CHARLIE'S AMERICAN CAFE in Norfolk's River View section, owner TED WARREN said it's all about the dog itself. "For us it is a tough skin with a combo of beef and pork; usually a bright red color. It reminds us of childhood." Charlie's Swanky Franks have the mustard, chili and onion, but if you want to get crazy you can get the Maury Dog, which is rolled in bacon and deep-fried. We think Bacalis would approve of the tasty nod to his alma mater, Maury High School.

Doumar's

Like many, ABE DOUMAR arrived in this country in New York City as an immigrant at the turn of the twentieth century. The sixteen-year-old from Damascus, Syria, was ready for the American dream and traveled to the

biggest thing happening in the country in 1904—the St. Louis World's Fair. There, dressed as an Arab in the Jerusalem concessions area, he sold glass paperweights, reportedly filled with water from the River Jordan. Around him were other concessions, including an ice cream man selling his wares on paper dishes and a man selling thin, Persian-style waffles. Details of the story vary, but tradition has Abe rolling one of the waffles into a cornucopia—hence the name *cone*—and adding a scoop of ice cream from the neighboring vendor. The concept was a hit, and the word spread about the fair. At the close of the fair, one of the waffle irons was given to Abe, who took it home with him to North Bergen, New Jersey. There he designed a four-iron machine and commissioned a foundry to make it for him. In 1905, he brought his three brothers to America to help make and sell ice cream cones at Coney Island, New York.

Hearing of the Jamestown Exposition in 1907, Abe made plans to come to Norfolk with his cone machine, establishing a stand at Ocean View Amusement Park. The treats were successful; in one day alone, around 23,000 cones were sold. Other Doumar's stands opened along the coast as far south as Miami Beach, but Abe settled in Norfolk, with his brother George taking over the day-to-day operation of the stand. Over time, Doumar's would close all its locations except for the one here. Doumar's began to sell wholesale ice cream cones in the 1920s. Things were going well until a hurricane in 1933 destroyed the stand along with much of Ocean View. The next year, in 1934, Doumar's would reopen, but this time closer to downtown Norfolk on Monticello Avenue, where it is still located today. In order to be a year-round business, and not seasonally dependent, sandwiches were added to the menu, with waitresses delivering dishes via curb service. The menu is still similar: hamburgers, hot dogs and barbecue sandwiches wrapped in wax paper and secured with a toothpick, french fries nested in paper trays, fresh-squeezed limeades and hand-dipped milkshakes. A Taylor pork roll sandwich pays homage to the family's New Jersey roots.

George's sons, ALBERT and VICTOR, began working in the family business after serving during World War II. Al would become synonymous with the eatery throughout the rest of his life, often greeting customers as he sat by the cone machine, making batch after batch, just outside the doors of the restaurant. On September 26, 1972, he appeared as a guest on the popular television gameshow *To Tell the Truth*, telling the celebrity panelists,

> *I, Albert Doumar, come from a royal family in the world of ice cream. We Doumars proudly claim the title of creator of the ice cream cone. While*

Doumar's, Ocean View Park, Norfolk, circa 1915. *Isabella and Carroll Walker Photograph Collection, Sargeant Memorial Collection, Norfolk Public Library.*

there are others who claim that they were first, there is little doubt that great American treat actually began back in 1904 at the St. Louis Exposition when my relative, Abe Doumar, had the brilliant idea of rolling a waffle into a scoop and filling it with ice cream.

The Smithsonian Institution agrees, recognizing the family's contribution to the culinary world. "After some research, there was no way I could…refute Mr. Albert Doumar's statement that his uncle invested the ice cream cone," said Alixa Naff of the Smithsonian in a newspaper interview in 1994. "It is such a simple technique that it may have occurred to other people at other places at about the same time. I have accepted Mr. Doumar's statement with that caveat," she added. Doumar's also received a nod from the James Beard Foundation for its contributions and was named America's best cones by *Gourmet* magazine. Al died at age ninety-two on May 14, 2014.

Al's son Thad Doumar began working at the restaurant full-time in 1987, and today he runs the business. Most days you'll find Thad at the

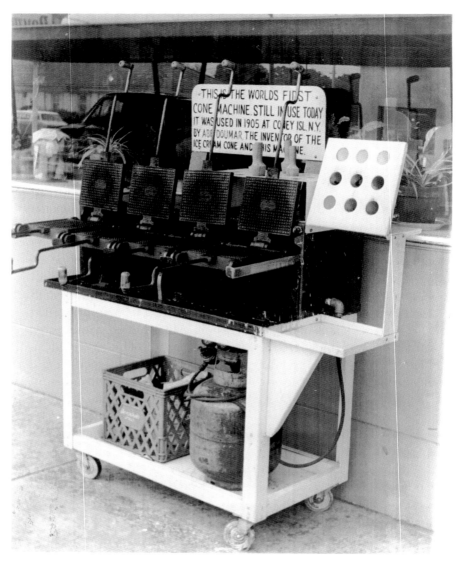

Doumar's ice cream cone machine, 1905, still used daily at the Norfolk restaurant. *Isabella and Carroll Walker Photograph Collection, Sargeant Memorial Collection, Norfolk Public Library.*

same machine that his father ran for years. Making the cones is quick work: batter is poured on the iron and the lid closed; it doesn't take long for the thin wafer to cook. The lid is opened and the warm, pliable waffle peeled away and wrapped around a wooden, cone-shaped mandrel, where

it cools quickly and hardens. The cone is then removed from the mandrel and nested with others in a tray, and the process is repeated. Cones are made on the original machine Monday through Saturday from 10:00 a.m. until 11:30 a.m.

Other Eats

Burger-centric eateries in Coastal Virginia include MONK'S PLACE, which has operated since the 1940s out of a squat, red cinderblock building (augmented with picnic tables) at the elbow of a sharp corner of Princess Anne and Buzzard Neck Roads in Creeds, a rural community in Virginia Beach. Cold beer and, as a bumper sticker says, the "best burger in town, no possum added," are served in a delightful no-frills sort of way. In Hampton, curbside service at SMITTY'S BETTER BURGER has offered, well, the Better Burger (a quarter-pound of fresh ground beef), since 1956. There's also the Super Burger with a half pound of beef. With a nod to the region, seafood plates with fries, slaw and hushpuppies are also offered, including a clam strip dinner, flounder filet dinner and shrimp dinner. Walk up and dine at the picnic tables or in your car at WHAT-A-BURGER in Newport News (not affiliated with the notable Texas fast-food chain) on the same burger-centric menu since 1958. Since 1972, it's been in a location convenient to the shipyard, offering burgers, cheeseburgers, double burgers and triple burgers served in small wax paper bags with sides of crinkle-cut french fries.

Fried chicken has also been a go-to for quick and affordable eats, as well as being a favored dish in Virginia for centuries; Mary Randolph penned a recipe for it in her book, *The Virginia House-Wife*, in 1824. Although fried chicken can be found on menus at restaurants across the region, the bird's been the word at two eateries. MOSEBERTH'S FRIED CHICKEN—opened on May 1, 1940, by JOHN AND DELLA MOSEBERTH—is under third-generation ownership. Above the eatery at the corner of Airline Boulevard and Rodman Avenue, a huge red-and-white chicken perches atop the sign; inside, it's more chicken, with a menu offering it in family packs, as dinners, snacks, by-the-piece, as chicken salad, on sandwiches and in soups. And there is every part of the chicken, too: breasts, gizzards, legs, livers, thighs and wings. Chicken is mildly spiced with a crispy crust holding in the juicy meat. Sides include collards, potato salad, slaw and succotash. Chicken can even be ordered in bulk: six hundred pieces, including tax, will set you back about $900.

POLLARD'S CHICKEN was opened in 1967 by Clyde W. Pollard and his sons Johnny and Robert, and the eatery is still a family business. Like Moseberth's—but with nine locations in Chesapeake, Norfolk, Portsmouth and Virginia Beach—the focus is on one thing. "Our specialty is chicken—dark meat, white meat, livers, gizzards, tenders, boneless chicken breasts, and more," said Johnny Pollard. The crust is light and flaky and the meat tender. Also like Moseberth's, the restaurant is active in catering for large groups as well. One of the signature sides are Pollard's puffs, a buttery, doughy, roll-like bread that is served with honey for dipping. Also noted for its fried chicken, GOLDEN SKILLET was opened in 1964 in the Thalhimer's department store in Richmond, opening the first brick-and-mortar store in 1968 and growing to a chain of more than two hundred locations across the state. The recipe came from Clifton W. Gutherie, who called it Virginia Fried Chicken. A pitched, bright-yellow roof and a large, distinctive pan-shaped sign out front were store hallmarks. Advertisements promised, "Tender as Quail! Tasty as Pheasant!" A mild, flaky crust covering juicy meat. Gutherie died in 1981, and many assets were sold off. Some franchise owners kept a handful of stores open; today there is one Coastal Virginia location in Portsmouth. And in the Eastern Shore town of Melfa, Ronnie Edwards and his wife, Shirley, opened TAMMY & JOHNNY'S, named for their two children, in 1967. The restaurant was first a walk-up burgers stand selling nineteen-cent hamburgers along with fries and milkshakes. A dining room and the famous fried chicken were added in the mid-1970s. The chicken had a light, thin, crispy skin barely covering juicy, tender meat. Tammy & Johnny's closed in 2018.

Another cheap eat: barbecue. JULIUS C. "DOC" PIERCE and his wife, VERDIE, moved from Tennessee to Virginia with his mother's seventy-year-old secret sauce and the desire to serve up some good barbecue. With a bank loan of $2,500, he opened PIERCE'S PITT BAR-B-QUE on October 15, 1971, in a Williamsburg horse pasture. The now iconic misspelling of the word *pit* goes back to the first days when a sign painter penned it out as *pitt*. When advised of the mistake, the painter said, "If you don't like it you can paint it yourself or it will cost you another twenty dollars." The sign stayed. In what was originally a small walk-up stand, the barbecue is slow-cooked over a nearby hand-dug pit. The menu items included a barbecue sandwich, sausage in a bun, fries, slaw, cobbler and pies, milkshakes and soft-serve ice cream and Pepsi. Today, folks can sit in a quaint dining room and enjoy many of the items from the original bill of fare, plus smoked chicken and ribs, burgers and hot dogs, salads and sides such as Brunswick

stew, baked beans, southern-style collards, cornbread and hushpuppies. Four barbecue sandwiches are offered in pulled pork or pulled barbecue chicken, slathered in the original sauce and topped with slaw. Pierce's has been named by both *National Geographic* and *USA Today* as among the top-ten best southern barbecue spots and one of only two recommended barbecue restaurants in Virginia on *Garden and Gun* magazine's Barbecue Bucket List. One interesting note on the sauce: because of its origins, it is a thicker, sweeter sauce than is often associated with the thinner, piquant sauce in Coastal Virginia.

FOOD FOR THE NUCLEAR FAMILY

During the mid-twentieth century, dining rooms began opening in earnest to accommodate the booming family scene. Casual and relaxed, but a bit more formal than a typical diner, these restaurants provided good food at reasonable prices. Their menus were often diverse to please a number of palates: comfort foods like meatloaf, seafood and steak could be found all on one single bill of fare. All members of the nuclear family were considered, too, with the emergence of fun, often fanciful, children's menus, of which many included faux cocktails like a Roy Rogers and a Shirley Temple. Many diners dressed up nicely for a fancy evening out, with the kids left at home with babysitters.

The now-closed BURROUGH'S BEL AIRE RESTAURANT, adjacent to the Bel Aire Motel on North Military Highway in Norfolk, had its origins as a drive-in on Granby Street. The ranch-style brick eatery pitched meals at breakfast, lunch and dinner, especially filet mignon (with a circa 1960 price of $2.15), other "char-broiled steaks" and seafood.

Named after its Moderne-style circular curved façade, the CIRCLE opened in 1947 on High Street at Douglas Avenue in midtown Portsmouth. The restaurant was in both state and national historic registers. An Al Hirschfeld–style mural caricature of Hollywood celebrities featuring the likes of Lucille Ball, Bette Davis, Clark Gable and Groucho Marx graced the walls. Owned by the Mathews family, the restaurant began life as a drive-in, with waitresses on roller skates taking orders through the late 1960s. Some members of the Mathews family were later involved in another iconic Portsmouth eatery, RODMAN'S, a popular barbecue place founded in 1929 by Howard Rodman. For a while, the Circle was a

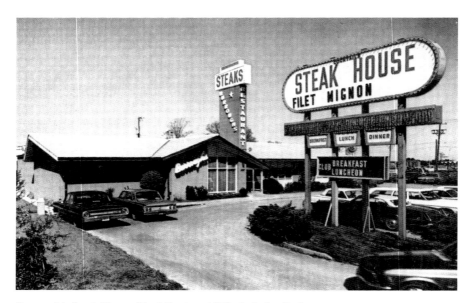

Burrough's Steak House, Norfolk, circa 1970. *Author's collection.*

Chicken in the Rough franchise, popularized in the mid-twentieth century, with a signature dish consisting of fried chicken pieces served atop a bed of shoestring potatoes with biscuits and honey. It was open for breakfast, lunch and dinner, and noted dishes included hot crab dip, beef cuts like New York strip and prime rib as well as seafood such as crab imperial and fresh fish, calves' liver, chicken and dumplings, Smithfield ham, collards and tomato pudding. Dinner entries came with golden-brown hushpuppies on the side. Chocolate fudge cake was a favorite dessert. The Circle served its last meal on New Year's Eve 2008, and the historic building was demolished in August 2013.

Off the beaten path, down a winding road through the Little Neck area of Virginia Beach, HURD'S SEAFOOD RESTAURANT was opened in 1936 by GRACE HURD. As it was located on a dirt road for years, sometimes wreckers had to be called for guests whose cars were stuck in the mud during heavy rains; customers would take off their shoes and wade inside, where Hurd would provide a tub to wash off their feet. Starting in a small building on the Lynnhaven River, Hurd did all the cooking for a menu that mostly included fried chicken or fried oysters. The first eatery seated 40; by 1941, an addition increased the number to 250 and husband Richard quit his job as a milkman for Birtchard's Dairy to work at the restaurant full-time. Later remodeling resulted in

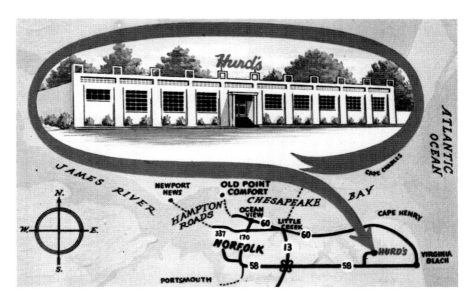

Hurd's Seafood, Virginia Beach, circa 1960. *Author's collection.*

an unusual-looking stark-white boxy building with large round windows, much like portholes on a ship. A nautical theme was carried throughout the restaurant's interior. No traces of the long-closed eatery remain, and the neighborhood is today all residential.

On a circa 1960 menu, specialties listed are raw, roasted or barbecue oysters; raw or steamed clams; and variations of Crab Norfolk: hot shrimp in butter, hot crabmeat in butter and combination hot crabmeat and shrimp. Deviled crabs were also offered. In the Deluxe Dinners section of the menu, Delmonico steak, Italian ravioli with cheese, fried chicken, ham steak with candied yams and native frog legs round out the bill of fare and were served with hot rolls and coffee or tea. A slice of Mrs. Hurd's Famous Pie is the sole dessert mentioned. Children had six offerings in the Kiddie Korner, such as french-fried shrimp, fish filet and a small Swiss steak. An interesting wine selection featured mostly sweet wines, including Georgia scuppernong wine, sweet blackberry wine, sweet red wine and sauterne, augmenting a Burgundy. Special wines were an imported chianti and a kosher Manischewitz sacramental grape wine, both served ice cold. Champagne and pink champagne rounded out the list.

One of the region's oldest, continually operating restaurants, STEINHILBER'S, was opened in 1939 by ROBERT STEINHILBER. Much like Hurd's, it is tucked away in a residential community, in this case the

Above: Steinhilber's Restaurant, established 1939, Virginia Beach, signature fried shrimp. *Author's collection.*

Opposite: Virginia Diner, Wakefield, circa 1945. *Author's collection.*

Virginia Beach neighborhood of Thalia. The restaurant is still in the family, run by Robert's daughter JEANNE STEINHILBER and grandson BRADY VICCELLIO. The eatery is a large, low-lying, rambling building (formerly a golf course clubhouse) located in front of an expansive, manicured lawn leading down to the western branch of the Lynnhaven River. Under a forest-green canopy, one walks inside, where the eatery is still much like it was when it first opened. A casual stateliness prevails, from oversized seating on walnut floors to glowing teak walls accented with mahogany beams. Large, blinded windows look out to the bucolic

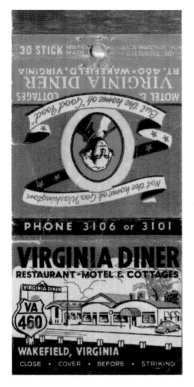

scene. Crab cakes and seasonal seafood selections augment steaks. For a romantic, later dinner, the classic Chateaubriand for Two is offered, featuring a twenty-ounce aged certified Hereford beef tenderloin served with fingerling potatoes, turned mushrooms and a house-made bordelaise sauce. But perhaps the best known—and best loved—dish, which has been on the menu for generations, is the Original Jumbo Fantail Fried Shrimp, served with a signature pink remoulade-style sauce. The fried, golden-brown shrimp, extra-large and lightly battered, are available as an appetizer or as an entrée. Local favorite Bobby Huber was chef here from 2009 to 2013.

Along the long, straight Route 460 highway, about halfway between Suffolk and Petersburg, is Wakefield. Here, in 1842, Dr. Matthew Harris planted the first commercial crop of peanuts in America. It's appropriate then that Virginia Diner, known worldwide for snacks that showcase the legume, is located here. But beyond the peanuts is an actual diner with roots back to 1929. It was then that Mrs. D'Earcy Davis began her restaurant in a refurbished Sussex, Surry and Southampton Railroad car. Motorists along the road would stop for vegetable soup and hot biscuits, among other home-style fare. Today, the eatery, owned by the Galloway family, is open for breakfast, lunch and dinner. Dishes include Brunswick soup, buttermilk biscuits piled high with thinly shaved Virginia ham, southern fried chicken and pulled pork barbecue in the classic piquant, vinegar-based sauce noted in this area. Sides include black-eyed peas, candied yams, collards, spoonbread and stewed tomatoes. And those peanuts? They became a hallmark of the Virginia Diner decades ago when they were put out after dinner instead of mints.

MEALS OF MAGNIFICENCE

In the middle part of the twentieth century, there were three restaurants that put Coastal Virginia on the map beyond the region as far as unparalleled food and service went. From the 1930s to the 1960s, eateries in the Williamsburg Inn and the Golden Triangle, as well as Ship's Cabin, set the standard in fine dining.

The Williamsburg Inn

On April 3, 1937, the Williamsburg Inn opened, regal in a classic Colonial Revival–style, whitewashed brick building inspired by popular hot springs resorts of the era, such as the Greenbrier at White Sulphur Springs, West Virginia, once part of Virginia. Richly appointed, the Williamsburg Inn is in the National Register of Historic Places, and the restaurant is a recipient of the prestigious AAA five-diamond rating. A menu dated October 23, 1940, from just three years after the inn opened, reveals an elegant and local-centric bill of fare with appetizers including fresh crab cocktail and York River Virginia oysters on the shell. Four entrées were offered, among them Broiled Fresh Chesapeake Bay Rockfish with Duchess Potato and Grilled Sugar Cubed Ham Steak in an orange glace and served with sweet potato. Also on the menu were soups, a salad, relishes and vegetables like creamed lima beans, seven desserts and a cheese tray. Noted food critic Duncan Hines praised the inn in several of his annual reviews of restaurants across the nation, *Adventures in Good Eating*.

In 1997, Mark R. Wenger, architectural historian for the Colonial Williamsburg Foundation, described the inn as "one of the nation's finest resort hotels, internationally acclaimed for its accommodations, service and cuisine. Conceived as the social pivot of a huge philanthropic enterprise, it represents John D. Rockefeller, Jr.'s commitment to bring the message of Williamsburg to a larger audience of influential Americans….In more than half a century of continuous service, the Inn has hosted numerous celebrities and heads of state—kings, queens, princes, presidents and prime ministers. Among them: British Prime Minister Winston Churchill; presidents Harry S. Truman, Dwight D. Eisenhower, and Gerald Ford; and England's Queen Elizabeth and Prince Philip, who would visit twice to commemorate the Jamestown settlement." During the first visit in October 1957, for the 350th anniversary, Queen Elizabeth wore a white satin gown embroidered with

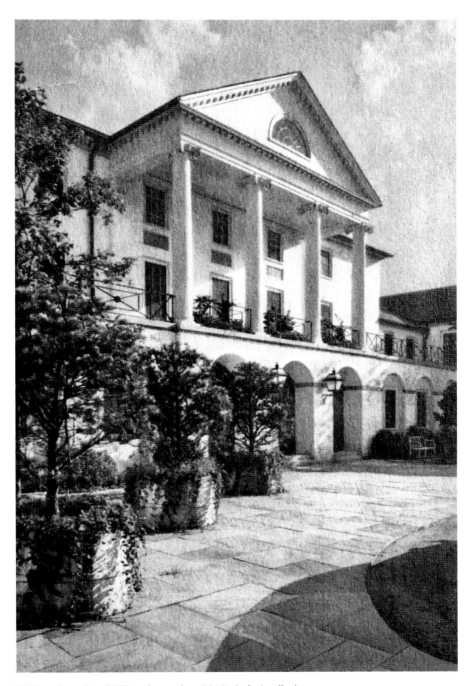

Williamsburg Inn, Williamsburg, circa 1940. *Author's collection.*

precious and semi-precious stones and a diamond tiara to an elegant dinner in her honor at the Inn. The meal showcased Clear Green Turtle Soup, Amontillado with cheese straws and Mushrooms Bordelaise served with Williams and Humbert Dry Sack; an entrée of Boneless Breast of Chicken with Virginia Ham and Baby Green Beans, Amandine, paired with Batard Montrachet 1953; avocado slices in French dressing; and Fresh Strawberry Mousse served with Veuve Clicquot Yellow Label. Demitasse and liqueurs rounded out the evening.

Two chefs in the modern era who have made an indelible mark on the inn's cuisine scene are HANS SCHADLER and TRAVIS BRUST. Schadler, a German native, spent nearly a quarter century at Colonial Williamsburg, retiring in December 2008. While there, he oversaw ten restaurants, including those in the Williamsburg Inn and four colonial dining taverns. Schadler has devoted his life to cooking and has been recognized by winning the Virginia Governor's Cup and Seafood Challenge twice and twice receiving both the Chefs Professionalism Award and the Presidential Achievement Medal from the American Culinary Federation. He was named Chef of the Year three times by the Virginia Chefs Association and has cooked at the James Beard House in New York City twice. During Queen Elizabeth's return to Williamsburg in 2007 for the 400th anniversary of Jamestown's settling, Schadler coordinated all meal functions during her visit. The queen enjoyed the experience so much that the chef was granted a personal audience with her. Buckingham Palace noted to Schadler beforehand that the royal disliked big portions, shellfish and spicy food; a light meal was planned. Under an outdoor tent, with Virginia governor Tim Kaine hosting, the meal began with organic greens and local asparagus, Virginia ham and tomatoes in a light citrus vinaigrette served on china in a blue, gold and pink floral pattern. Local rockfish, provided by Sam Rust Seafood of Hampton, was lightly battered and seared and served with seasonal vegetables as the entrée. A dessert of lemon cloud tart with fresh berries and rhubarb was offered. Today, Schadler owns WAYPOINT SEAFOOD & GRILL in Williamsburg, which reflects the chef's relaxed approach to fine dining using local ingredients. He describes the menu as "a celebration of Chesapeake ingredients and includes items grown at local farms and caught in regional waters. The pure flavors and rich ingredients presented in the seasonally changing entrées represent modern American cuisine with classical culinary roots."

Travis Brust landed his first restaurant job at age thirteen, training as an apprentice under top chefs across the country. One of his mentors was

Hans Schadler at Colonial Williamsburg. Brust became chef de cuisine for the Williamsburg Inn in 2009, overseeing all culinary operations. In 2012, the Williamsburg Inn turned seventy-five, and Brust prepared a special menu of items from the past. The reception included tastes of Carolina rice–dusted local oysters, spring pea soup, Crabmeat Randolph, Virginia cheeses and artisanal bread. At dinner, the menu featured lobster bisque, a palate cleanser of mint julep sorbet, Beef Wellington with truffle-whipped potatoes and spring vegetables and a dessert sampler. Also in 2012, Brust joined other Coastal Virginia chefs MIKE FARRELL of STILL WORLDLY ECLECTIC TAPAS in Portsmouth and JERRY WEIHBRECHT of ZOE'S STEAKS & SEAFOOD in Virginia Beach in Las Vegas for the World Food Championships. Brust took top prize in the Chefs Challenge with his dish Fennel-Dusted Rockfish with Sautéed Bitter Greens, Oyster Mushrooms and Fresh Oyster Ragout, Roasted Pearl Potatoes, Orange-Scented Beurre Blanc and Carrot-Cardamom Gel.

After an extensive $8 million renovation of the Williamsburg Inn in 2017, the REGENCY ROOM (which opened in 1972) was reimagined as the ROCKEFELLER ROOM, which the Colonial Williamsburg Foundation described as "The Inn's signature dining experience [that] celebrates contemporary fine dining and pays homage to the evolution of American cuisine, while maintaining its Regency style." Some items on Brust's current menu include Virginia Crab Cake with English Cucumber Remoulade; Oysters Abby, consisting of Tanglier Island Oysters with Caramelized Lemon and Champagne Sabayon; Coastal Seared Rockfish with Sautéed Pearl Potatoes, Shaved Radish, Brown Butter and Carrot Puree; Turmeric Ginger Shrimp with Coconut Curry Crème, Rice Grit Galette and Piperade; and desserts that include Pecan Financier with Bowman Brothers Bourbon (a Virginia spirit) Chantilly, Maple Syrup and Candied Pecans. The inn also features the Social Terrace, offering al fresco dining and sharable plates and the Terrace and Goodwin Rooms for more casual fare at breakfast and lunch. Brunch dishes include Croque Mary with seared Virginia mam, Swiss cheese, poached eggs, Grana Padano cream and tomato conserve. Brust commented, "I think that the cuisine of Virginia has a tendency to be thought of as historic and maybe a little boring from the outside, yet when guests and foodies dive into our food culture and see that we do push the envelope with creativity, local produce and goods, excellent techniques…they quickly realize that Virginia is a culinary destination that is not to be missed."

Nation's Room at the Golden Triangle

When the GOLDEN TRIANGLE opened on May 17, 1961, it was the first major hotel to greet guests in Norfolk since the time of the Jamestown Exposition more than a half century before. The $7 million, eight-story tower was built as part of the city's downtown redevelopment program, hoping to attract conventions and guests from all over. Owners Herbert Glassman and Robert Futterman offered varying dining options in the hotel, including the casual SATELLITE RESTAURANT, which a period brochure said "features a wide choice of foods for breakfast, lunch and dinner. Rocket service and out-of-this-world meals at down-to-earth prices make this restaurant a family favorite." The Key Club, a private gathering spot, was located upstairs for members only.

But the center of the Golden Triangle's culinary universe was the NATION'S ROOM. This fine-dining restaurant was hailed for its "haute cuisine and elegance in dining" by *Esquire* magazine, marking it as one of the twenty best eating establishments in the country. A unique feature of the restaurant was its chameleon approach in dining. As the hotel advertising described it, "The fabulous Nation's dining room miraculously changes its nationality every night. Authentic dishes of the Nationals of the evening are served

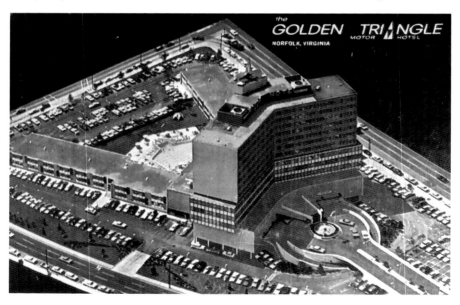

The Golden Triangle, home of the Nation's Room, Norfolk, circa 1965. *Author's collection.*

in the atmosphere of their origin…decor, costumes, even wall fixtures and place settings are magically transformed each evening.…[Y]ou'll enjoy the world's most exciting and whimsical foods at surprisingly reasonable prices."

Famed local chef MONROE DUNCAN worked at the Nation's Room as a server during the restaurant's early years. He said Monday was Italian night, with "red checkered table cloths, white tri-fold napkins, red table lanterns, brass lantern sconces, and waiters clad in long-sleeved shirts, black string bowties, black vests, black trousers, and ankle-length bistro aprons." The menu featured "Minestrone soup, Clams Casino, antipasto, Shrimp Fra Diavolo, Lobster Tetrazzini over linguini, Veal Scallopini Marsala" and "the best Chicken Cacciatore I have ever eaten." Bavarian Tuesday brought lederhosen-clad waiters serving Sauerbraten, Veal Paprika, Roast Duckling in Gingersnap Sauce, Wiener Schnitzel, Hasenpfeffer (rabbit stew), lamb chops stuffed with chicken livers and potato pancakes. Other evenings, there was a formal English presentation and a Polynesian night that Monroe remembered: "We were dressed in white trousers, Hawaiian flowered shirts, white sneakers, and paper leis. The food, from the South Pacific islands, was luscious, especially the seafood curry on rice with fruit chutney, and fried duckling in plum sauce on shredded lettuce [Monroe's very favorite entrée]. Chef (Godfrey) Williams, from Jamaica, created the consummate South Sea's cuisine. We even offered a Pu-Pu Platter served over a charcoal hibachi pot."

American Waters night showcased seafood dishes—many local. With wait staff dressed in white waistcoats with tuxedo trousers, shellfish included oysters or clams on the half shell, jumbo shrimp cocktails, Oysters Rockefeller, oyster stew and Crab Norfolk. Maître d' GARLAND THOMAS "TOMMY" SEAY did a table-side presentation of Shrimp Savoy, which Monroe would repeat later in some of his restaurants over the following decades. Monroe recalled, "Among the most popular dishes were crab cakes, pan-fried soft shell crabs, boiled or steamed whole live lobsters with drawn butter (often removed from the shell table side), and Seafood Newberg served on steaming white rice." For the French evening, dishes popular during America's fascination with international jet-setting during the Kennedy years included Tournedos Rossini, Chateaubriand Bouquetière, Sauce Béarnaise, Sole Fillet à la Bonne Femme, Roast Duckling Bigarade (flambéed table side by Seay, another theatrical act Monroe would adopt), Breast of Chicken Carême and others. On Sunday, favorite dishes from the other cuisines were served at tables diversely dressed from each of the other nights, with servers in varying costumes.

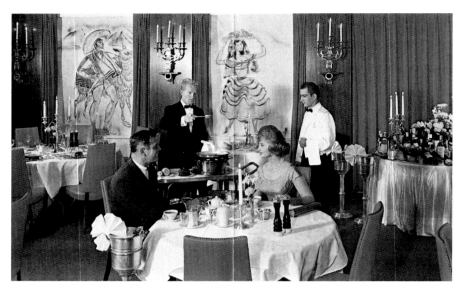

The Nation's Room inside the Golden Triangle, maître d' Tommy Seay serving, Norfolk, circa 1965. *Author's collection.*

The Nation's Room closed in January 1980, and newspaper columnist Sam Martinette recalled the grand send-off: "Former maitre d' Tommy Seay came rolling out of the prep area on roller skates, whizzing among the tables, wearing a fur coat and a cowboy hat. Bobby Gordon was maitre d' that night, and among others who cut their culinary teeth in the Nations Room [were] local legends Monroe Duncan and Earl Branch." The hotel is now a Wyndham Garden property with an on-site casual-dining restaurant.

Ship's Cabin

Growing from a snack bar serving beach-goers at a local hotel, Ship's Cabin quickly gained a national reputation as an amazing seafood-centric restaurant beginning in 1966. Located in the east end of Ocean View, the Norfolk neighborhood was already in decline when JOE HOGGARD elevated the eatery, which had been just outside of the HOLIDAY INN (not related to the national chain) that his father, LES HOGGARD, owned. But the younger Hoggard, a globetrotting gourmet, had a vision. The book *Dining In—Hampton Roads Cookbook* described the neighborhood as "a randy, wild, and largely run down section of town—not the kind of place one would expect to find anything

remotely Continental." Hoggard explained to the authors, John Gounaris and Robert Stanton, "I went to just about every famous seafood restaurant in the country, from New York to San Francisco, and the best ones are always in the most questionable neighborhoods. I came home to OceanView and thought, 'Hell, this is great! I'm already here.'" By December 1972, Ship's Cabin gained kudos in *Metro Hampton Roads Magazine*'s first Top Ten Percent Restaurant Awards, naming it one of the best thirteen eateries from Virginia Beach to Williamsburg. The restaurant would garner the first four-diamond rating from AAA in the region.

Hoggard was not only a visionary in the location of his eatery but also in sourcing foods locally, something that was not as common four decades ago. "Fresh, fresh," noted the *Dining In—Hampton Roads Cookbook*. "Everything has to be straight from the deep blue and used immediately….His philosophy is homespun and simple: make the most of what you have, for you have more than you think….The Chesapeake Bay-front location is an obvious advantage [for] fine, fresh Virginia seafood." When vegetables weren't in season, he used those grown hydroponically, locally grown and delivered daily with roots still intact. Hoggard loved to travel and bring back notes from his adventures to share with his kitchen staff to create experiences for his loyal patrons. He recalled an event in 1984 with Julia Child:

> *I was able to spend a week with her, at the Robert Mondavi Winery. She was doing the cooking and Mr. Mondavi was pairing the wines. A couple of years later, we were together at the* IACP [International Association of Culinary Professionals] *conference in Paris, and Julia, Patricia Wells and Anne Willan were the principal speakers. After the event there was a three-day trip to Burgundy.…*[W]*e dined only at starred restaurants. Julia was my seat mate on the bus for the excursion.…*[S]*he was quite the gal.*

But in the end, there was no place like home. "The wanderer, however, always return to bring the spoils back home: to Norfolk, to OceanView," the *Dining In—Hampton Roads Cookbook* said.

Inside, the Ship's Cabin was divided into several dining rooms, decorated in simple, tasteful nautical themes. One featured a circular fireplace, a replica of one from a sugar plantation in St. Croix. *Daily Press* food writer David Nicholson described it in 1989: "Dining at Ship's Cabin is like descending to the ocean floor. In the restaurant's low-ceilinged dining room, a wall of windows looks out on sea oats bent by Ocean View's breezes. Beyond, faintly visible in the twilight, one can make out the dark waters of the Chesapeake

Bay." One of the signature dishes, created for Joe by Chef Monroe Duncan, was Oysters Bingo, named after Ship's Cabin patron, state politico Frederick T. "Bingo" Stant Jr. Although Duncan was never formally in the kitchen at Ship's Cabin, he often worked with Hoggard in fleshing out dishes. Hoggard reminisced:

> *In the late 60s I met Monroe and a number of his friends, all of whom worked at a place that I had never heard of, the Nation's Room. These guys would sit outside at the concrete tables at my father's bar* [the predecessor to Ship's Cabin] *and eat crabs, shrimp and iced tea. I can't recall ever having a more lively group.* [Later] *we became friends and would often visit each other's restaurants. I was always amazed at his food preparations. I would ask him how to prepare a dish, he would teach me. When I decided to introduce sautéed dishes to my menu, I sent my cooks to Monroe, he would sometimes show up in my kitchen to coach. Without him, I don't know where I would have gone for inspiration and direction. The most memorable occasion was when we were creating a new oyster dish which eventually became Oysters Bingo, we tasted many versions and when we got it right, I wrote him a check and ask that he not mention that it was his recipe, he never said a word.*

A *Daily Press* reviewer described the plate in 1987: "Six freshly shucked oysters are lightly battered and sautéed in butter, wine, and shallots. They're then placed back on the half-shell, and the sautéing sauce is spooned over them. A true delight." The article also made note of a blackened mahi mahi; salmon stuffed with artichoke hearts, tomatoes and mushrooms wrapped in pastry; back fin crab cake served with a five-ounce filet mignon; mesquite-broiled swordfish; and Seafood Melange, consisting of sautéed seasonal seafood tossed in a white wine sauce. Ship's Cabin was also noted for its bread service; a basket of multiple choices—including cinnamon raisin, honey wheat and blueberry, baked daily—and sent out warm to greet diners. This special service was later adopted by Bobby Huber.

The restaurant had several chefs over the years, including BOBBY HUBER, TERRY MARRIOTT, CHUCK SASS and MICHAEL TOEPPER. In 1988, Sass represented Ship's Cabin with a seafood seminar in conjunction with the Virginia Institute of Marine Science (VIMS) of the College of William & Mary. On the menu: Shrimp and Lobster Ravioli with Red Pepper and Broiled Garlic Vinaigrette; Mussel and Scallop Chowder with Andouille Sausage and Zinfandel Marinated Black Beans; and Sautéed Backfin

Crabmeat over Grilled Smithfield Ham and Chardonnay-Smoked Tomatoes. Dessert was Chocolate Decadence with Raspberry Coulis and Candied Napa Valley Walnuts. The dishes were paired with wine from Virginia's Naked Mountain Vineyards. Sass would go on to cook and operate at other notable Coastal Virginia restaurants. Hoggard would also open Cafe Rosso in Norfolk's Ghent. Ship's Cabin, under Joe Hoggard, closed in 2000. It operated with other owners for several years under the same name, but the magic was gone. The building sits empty today, silently looking out across the Chesapeake Bay, ghosts of unforgettable dinners past during its glorious glory days rattling about inside.

SHOP AND SUP

Not all of the region's beloved eateries have been standalone restaurants. Several have been tucked away within retail businesses, including a groundbreaking supermarket and first-class department stores.

Giant Open Air Market

Not since DAVID PENDER founded his namesake grocery at the turn of the twentieth century had the region had such a diverse food store than when Giant Open Air Market opened in 1939. Founded by Wendell P. Rosso and Vincent J. Mastracco Sr., Giant Open Air opened with a small store at 330 Campostella Road in Norfolk's Berkley neighborhood and near the Ford plant. By 1948, a new building had opened with a soda fountain and luncheonette and multiple departments within, such as a floral area— unique to the day but common in modern supermarkets. The store would expand across the region, and gain a reputation not just in Coastal Virginia but nationally with the opening of a true supermarket in 1961 in Norfolk's Wards Corner. There, the 150,000-square-foot building was one of the largest retail stores in the country. The twenty-four-hour store, which would become the brand's flagship, closed only on Christmas Day. It had a "front door" air curtain that greeted customers, keeping insects out and property temperatures in. The seafood department had a 20-foot cascade of ice leading down to fresh catch, a "banana tree" built into the produce department, an exotic "House of Flowers" floral department and more.

Lunch counter, Pender's Department Grocery, Washington Street, Norfolk, circa 1920. *Author's collection.*

The "Finest Foods of the World" department included such delicacies as English teas, French cheeses, Russian caviar and chocolate-covered ants. A large portico covered shoppers from the weather as they drove up to load their groceries. A twenty-three-hour Laundromat was also on site.

But one of the more unusual things about Giant Open Air was that several restaurants—not just a snack bar—were inside, set up like a food court at a shopping mall. There was a rotisserie, where folks went crazy for the chicken with its spicy, smoky paprika-based rub. There was a barbecue stand; a pizza parlor where folks swore the best pie in town could be had (with twenty thousand sold weekly); the Southern Manor Pancakes House, offering breakfast around the clock; and a general eatery with a wide assortment of dishes. In 1966, a second store on this scale opened in Mercury Plaza Shopping Center in Hampton.

The main restaurant there featured breakfast specials, including a ham and cheese omelet with biscuits, butter, jelly and grits for seventy cents or a stack of three "delicious, light, fluffy" buttermilk hot cakes with maple syrup and butter for forty cents. Around two dozen lunch specials were on the menu, priced at seventy cents. There was a roast beef dinner that included a "generous serving [of] charcoal-broiled beef, delicious celery dressing, hot savory beef gravy, choice of two vegetables, hot rolls and butter." There was

fried chicken, chicken chow mein, spaghetti and meatballs and baked fish, also. Dinners priced at eighty-five cents included the Baked Smithfield Ham Dinner, with a "generous portion of genuine Smithfield ham, choice of two vegetables, spiced apple rings, hot rolls and butter."

One of the unique features was a steakhouse where customers selected their own cuts of meat and had them "charcoal broiled" to order. The bill of fare included T-bone, porterhouse, club, rib, filet mignon, Delmonico and sirloin steaks; center-cut sugar-cured ham slices; center-cut lean pork chops; milk-fed tender veal cutlets; beef kabobs; and jumbo lobster tails. Cooking "on our gigantic open pit before your very eyes—served with french fried potatoes, onion rings, fresh baked special rolls, and whipped butter" cost an additional $0.60 on top of the price of the meat. Roast beef au jus was also sold with sides in a small portion for $0.60, a large portion for $0.85 or a giant portion for $1.25. The bakery sated the sweet tooth with blueberry, peach or strawberry shortcake, a jumbo chocolate whipped cream eclair or a jumbo slice of pie. Pie options were coconut, peach, lemon, cherry, sweet potato, French apple or apple in addition to coconut, lemon or chocolate meringue. Desserts ranged from $0.15 to $0.29 and were all made in-house. "Giant Markets are tops as tourist attractions," the *Daily Press* newspaper proclaimed.

The grocer merged with its largest rival, Farm Fresh stores, in 1986; the latter incorporated Giant's signature arch in the logo as a rainbow. Farm Fresh had its start in the mid-1950s, founded by brothers David Furman and

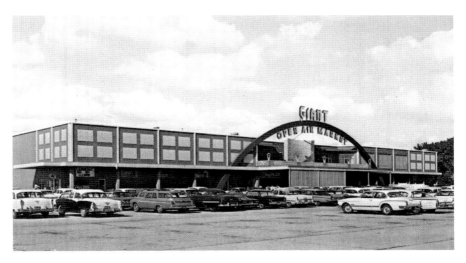

Giant Open Air Market, Ward's Corner, Norfolk, circa 1960. *Author's collection.*

Morris Furman as an extension of a farm stand. The chain would grow to be one of Coastal Virginia's most prominent throughout the 1990s and into the new century but, with increased competition, filed for bankruptcy and closed shop in 2018. The majority of the stores were sold to Kroger and Harris Teeter. A handful of Farm Fresh stores were sold to an independent grocer, keeping the Farm Fresh name and the legendary fried chicken in the deli department. Restaurants can be found today in Whole Foods Markets in Virginia Beach, which features a beer-centric pub; and Newport News, which includes an oyster bar with half-shell and char-grilled bivalve offerings. Wegman's, noted for its diverse stores, which include themed restaurants, opened in Virginia Beach in 2019.

Tearooms

By the turn of the twentieth century, a different kind of retailer was emerging in America: the department store. Long before the shopping mall of the mid-century, a department store was primarily one large location, often in a downtown setting. Just about anything could be found in these stores, from clothing to cosmetics and everything in between. Many also had restaurants, in particular, tearooms, which offered dainty dishes designed for women shoppers. These typically differed from lunch counters with a quieter, more formal—yet still casual—setting, more refined dining options beyond BLTs such as frozen fruit salads and the occasion of a fashion show at the noontime hour. Two of the most cherished tearooms in Coastal Virginia were W.G. SWARTZ CO., which later became MILLER & RHOADS, and SMITH & WELTON.

Miller & Rhoads was an established, thriving department store in Richmond, first opened in 1885, when partners Linton O. Miller and Webster S. Rhoads asked a colleague to come and assist in the operation of the store. Instead, William Grant Swartz went into a partnership of his own, opening Miller & Rhoads and Swartz on Main Street at the head of Commercial Place in downtown Norfolk in 1896. Newspaper accounts at the time declared it to be "a new kind of store." By 1907, the retailer great had opened a 130,000-square-foot building at the corner of Plume and Bank Streets. "The opening of this store was a magnificent and brilliant affair," a period advertisement proclaimed. By 1927, Swartz acquired full interest, and the retailer was named W.G. Swartz. Historian and columnist George Tucker remembered the tearoom:

Occupying a bird's eye elevation on an upper floor of the store's Plume Street annex, it was a dignified, white linen-bedecked rendezvous for those who enjoyed leisurely lunches. It specialized in Southern fried chicken, batter bread [spoon bread], *homemade rolls and fresh vegetables in season, the high windowed dining room was also famous for three-layered Lady Baltimore cakes served with hefty dollops of peach or vanilla ice cream.*

Swartz died on December 31, 1935.

In 1965, Miller and Rhoads purchased back their interest in W.G. Swartz, taking that name until the store was bought out in 1988, changing hands to Hecht's and now Macy's. As Miller & Rhoads, the tearoom developed quite the following. Favorites ranged from Brunswick stew to chocolate silk pie, but perhaps the most noted was the Missouri Club sandwich, where ladies wielded fork and knife to cut through the Dagwood offering of Virginia ham and turkey between bread that was covered in melted cheese, topped with bacon and served with mustard pickles. The mustard pickles were made in house, sweet pickle marinated overnight in a heady mix of yellow mustard, sugar and ground cloves.

In 1898, Tom Lawrence and R. Frank Welton opened a small men's furnishings store on Portsmouth's High Street that would grow into another of Coastal Virginia's beloved retailers, Smith & Welton. The Fountain Room offered a number of dishes, noted by George Tucker as "the town's most popular gathering place for lunch....I fondly recall the chicken salad, a specialty, accompanied by a slice of tomato aspic....Then there were the heavenly desserts—lemon chess pie, apple pie with whipped cream and a sinfully rich coconut cake. There was also a simpler item on the menu—toasted cheese sandwiches made with the restaurant's special spread." The spread, called Piquant Cheese, was special to many. Tucker gives the recipe as "Take one pound of sharp cheddar cheese, one half of an onion, four strips of green pepper, four tablespoons of mayonnaise and four

Smith & Welton's Fountain Room was the department store's tearoom in downtown Norfolk, circa 1945. *Author's collection.*

teaspoons of catsup. Grate the cheese, onion and green pepper together. Add the other ingredients and mix well. Chill—then enjoy on crackers or toast in memory of one of Norfolk's most memorable eating places of the past." Another sandwich popular at tearooms was on the Fountain Room menu too: chopped olive sandwich, which consisted of chopped green olives folded into rich cream cheese and piled high between slices of toast. A Monday special was a cup of hot soup, an olive sandwich and coffee or tea priced at fifty cents. In spring 1991, Smith & Welton shuttered.

AMES & BROWNLEY, a Norfolk retailer first opened in 1898, also offered a tearoom. An April 28, 1940 advertisement for the sixth-floor eatery encouraged shoppers to "Bring your Cards, Meet Your Friends, Spend a Cozy Afternoon" and offered a special of fruit salad, sandwich and a choice of coffee, milk or tea for a quarter. For a bite of something sweet, an order of Chinese Chews—an old-timey southern bar cookie traditionally made with chopped dates and walnuts and sprinkled on top with powdered sugar—and a pot of tea cost fifteen cents. A piece of pie à la mode with a choice of coffee, milk or tea was priced at twenty cents.

In downtown Newport News, Sol Nachmans opened his namesake store, NACHMANS, in 1894. The business expanded and moved several times, settling into a three-story building on Thirty-Second Street and Washington Avenue. Within the sixty-thousand-square-foot store was a first-floor tearoom, at times referred to as the Fountain Room. It was noted for its Slice-O-Lemon Pie. A period ad noted "Our Own Delicious Deviled Crabs" with fries, a tossed green salad, "Hot Home Made Breads" and iced tea cost one dollar. It would become Virginia's third-largest department store before merging with Norfolk-based RICE's in 1970 to form RICES NACHMANS, which went out of business in 1985 following a buyout by Hess's. After a succession of buyouts and trades, some of the Coastal Virginia stores are now Dillards.

THALHIMERS was opened in Richmond in 1842 and entered the Coastal Virginia market in 1976 after moving into a former J.B. Hunter store at Military Circle Mall in Norfolk. The Sword & Kilt restaurants were noted for a number of dishes, from chicken salad to deviled crabs, but none was as revered as much as the hot-from-the oven popovers. In her book *Finding Thalhimers*, Elizabeth Thalhimer Smartt, whose family ran the Virginia institution for five generations, made special mention of them: "They were served piping hot just as you sat down to the table. I would split the popover open with my knife to butter it, and a puff of steam would arise. Then I pulled the light and airy layers out with my fingers, enjoying every decadent

bite." The store would close in 1990, purchased by Hecht's, which later became part of Macy's.

Although not a department store, and now a restaurant and not a tearoom, the CARRIAGE HOUSE in Norfolk's Freemason neighborhood began as one in 1947. It was built in the early 1840s as a garage to house the carriage, horses and riding equipment behind the stately home (which was demolished in the 1930s) of nineteenth-century timber tycoon Captain John L. Roper. A relative of Roper's, Virginia Bruce Whitney, decided the quaint building would make a fine tearoom. Today, it is owned by Omar Boukhriss, who offers a contemporary menu with many seafood offerings as well as dishes from his native Morocco. As of this writing, the only department store in Coastal Virginia with a tearoom is NORDSTROM'S (a third-floor café) at MacArthur Center mall, which opened on March 12, 1999, in downtown Norfolk. The furniture and home accessories retailer IKEA, noted for its Swedish-themed restaurants located within its stores, opened in Norfolk in 2019. The eatery serves a breakfast that includes Swedish pancakes and features a Swedish meatball plate served with vegetables and lingonberry jam at lunch and dinner.

Coastal Virginia Comes into Its Own

As Coastal Virginia entered the late 1960s, restaurants in the area began to reflect America's desire for finer dining. There were still plenty of family eateries, but chefs here began to explore and enhance offerings to the dining public. Ritzy restaurants had already existed in hotels through the twentieth century, including the CAVALIER in Virginia Beach, the MONTICELLO in Norfolk and WILLIAMSBURG INN in the former colonial capital, but this movement was different. America itself was exploring what it meant to dine out, fueled by the elegant days of the Kennedy administration's Camelot era and the advent of the jet age, when suddenly travel to Europe was increasingly more available, and more affordable.

About this time, two restaurants emerged that set the stage for many more eateries to come and, some would rightfully argue, still have lingering influence. One was the NATION'S ROOM inside the Golden Triangle Hotel on the northern edge of Norfolk's downtown. Here, tucked away in the back of the main lobby of the groundbreaking hotel, was a dining room that would be lauded in national press, including being named one of the twenty best restaurants in the nation for "haute cuisine and elegance in dining" by *Esquire* magazine. The hotel and restaurant opened on May 17, 1961. The other restaurant was SHIPS CABIN, emerging a few years later in Norfolk's Ocean View, opening in 1966. Ship's Cabin would garner the first four-diamond rating from AAA in the region.

Both were incubators for talent that would spread to a next generation of chefs and their restaurants and emerge in yet another generation,

too, leading up to the current day. Nation's Room would foster MONROE DUNCAN, the region's first true celebrity chef, while Ship's Cabin would have such talent as BOBBY HUBER, TERRY MARRIOTT, CHUCK SASS and MICHAEL TOEPPER passing through its doors. These chefs, in turn, would move on to open their own places and mentor other chefs, who would also go on to establish other eateries. Especially in the case of Ship's Cabin, a true respect for the concept today called farm-to-table or fish-to-table was fostered by owner JOE HOGGARD, who looked in his own backyard—the Chesapeake Bay—for fresh Virginia seafood selections.

Chefs arriving on the scene in the 1980s and 1990s had not worked in the kitchens with Monroe Duncan (like Bobby Huber) or in the kitchens of Joe Hoggard (like Chuck Sass) or their protégés still benefitted as a result of an evolving, progressive approach to cooking and kitchen management. The scene begun by the initial group that emerged in the 1960s and 1970s set a stage for Coastal Virginia diners to be receptive for open kitchens and more open-minded about new tastes. This next wave would include MICHAEL CAVISH, SYDNEY MEERS and ALVIN WILLIAMS among them. In the front of the house, bartenders kept pace, and sommeliers such as MARC SAUTER began educating and entertaining the palates of diners with fine wines.

There was also a surge on the Peninsula, including Williamsburg. The influence of HANS SCHADLER at Colonial Williamsburg and MARCEL DESAULNIERS (who opened the TRELLIS and invented the dessert Death by Chocolate) in the town proper still resonates. Some daring restaurants such as FIRE AND ICE (under Chef Michael Toepper) teased palates in the last decade of the twentieth century. But it wasn't just restaurants that moved to bring Coastal Virginia into its own: in Virginia Beach, PETER COE opened the groundbreaking Taste Unlimited (now TASTE), offering fine cheeses, pâtés, handcrafted sandwiches with premium ingredients and wines from around the world. GEORGE ACKERMAN, along with the POWER FAMILY, opened the now-closed WARWICK CHEESE SHOPPE in Newport News, and later the Power family opened the CHEESE SHOP (they also operate Fat Canary) in Williamsburg, still thriving today.

As the twenty-first century was ushered in, yet another wave of chefs and other culinary professionals seem comfortable in the collective skin of Coastal Virginia.

CURRENT MENUS THAT DEFINE COASTAL VIRGINIA CUISINE

Many times folks will ask how to define the cuisine of the region, but you don't have to look far to figure that out. It's the evolution of the Old Guard modernizing their local-centric menus to the contemporary palate at eateries in the Cavalier Hotel (BECCA and HUNT ROOM, under Chef KEVIN DUBEL) and Williamsburg Inn (including the ROCKEFELLER ROOM under Chef Travis Brust) or at STEINHILBER'S RESTAURANT (under Chef PAUL SYMS). It is about using foodways—including cooking methods—that are either native to the area, or something that is done particularly well here. It's also the carefully sourced regional ingredients used in the dishes. You'll find these celebrated at many eateries across Coastal Virginia. Examples of current restaurants—some open a short time, others for decades—chefs and restaurateurs that subscribe to this approach include:

Charles Thain of Blue Seafood & Spirits, Virginia Beach. *Author's collection.*

Chef/owner CHARLES THAIN of BLUE SEAFOOD + SPIRITS, a seafood-centric restaurant in Virginia Beach.

Chef BARRY SMITH of COMMUNE, a farmer-owned sustainable eatery, café and bakery with locations in Norfolk and Virginia Beach. Commune owner Kevin Jamison also owns New Earth Farm in Virginia Beach.

Chef/owner ERICK HEILIG of EAT: AN AMERICAN BISTRO, a New American restaurant in Virginia Beach.

Chef DAVE BRUE of THE ATLANTIC ON PACIFIC, a New American restaurant in Virginia Beach.

Chef/owner KENNY SLOANE of FIN SEAFOOD RESTAURANT, a seafood-centric eatery in Newport News.

Chef/owner HARPER BRADSHAW of HARPER'S TABLE, a New American restaurant with a focus on southern cuisine in Suffolk.

Chef/owner CLINT COMPTON'S HEARTH WOOD FIRED CUISINE & CRAFT BEER, a New American restaurant in Virginia Beach.

Chef FABIO CAPPARELLI of HILTON NORFOLK THE MAIN with the eateries the GRAIN ROOF GARDEN & LOUNGE, a beer garden offering casual dining; SALTINE, a seafood-centric restaurant; and VARIA, offering trattoria-inspired Italian cuisine and an extensive wine bar.

Chef KYLE WOODRUFF of HILTON VIRGINIA BEACH OCEANFRONT with the restaurants CATCH 31, a casual contemporary restaurant with a focus on seafood; and SALACIA, an upscale steakhouse with many seafood selections as well.

Chef TODD RAMSEY of HOT TUNA BAR & GRILL, a seafood-centric restaurant in Virginia Beach.

Chef/owner STEPHEN MARSH of LEGRAND KITCHEN, which bills itself as a "finer diner"; and HOYT'S LUNCHEONETTE, a family-friendly lunch spot, both in Norfolk.

Chef KEVIN DIEHL of PASSION THE RESTAURANT, a contemporary fine-dining restaurant in Chesapeake.

Owners Karl Dornemann and Eric Stevens of GOSPORT TAVERN, PUBLIC HOUSE, STILL WORLDLY ECLECTIC TAPAS and SOUTHERN SUPPER MORSELS in Norfolk and Portsmouth, focusing on fresh ingredients and fresh tastes.

Chef MACKENZIE HESS's SONOMA WINE BAR, a New American restaurant in Virginia Beach.

Owner BILL GAMBRELL's TAUTOG'S RESTAURANT, a seafood-centric restaurant located in a 1920s cottage in Virginia Beach.

Chef/owner RODNEY EINHORN of TERRAPIN RESTAURANT, a New American fine-dining restaurant with a focus on seafood in Virginia Beach.

Chef MICHAEL KOCH of ZOE'S RESTAURANT, a fine-dining steak and seafood restaurant in Virginia Beach.

Several of these chefs have prestigious honors, including cooking at the legendary James Beard House in New York City and other regional and national accolades.

OTHER RESTAURANTS THAT CHANGED THE LANDSCAPE

Many other restaurants have also made an impact on Coastal Virginia's cuisine scene through their chef-driven menus, quality offerings, commitment to the community and providing a unique element all their own. That includes these current eateries, which have been in operation for several decades:

One of the region's oldest restaurants is the FRENCH BAKERY AND DELICATESSEN, opened in 1912 in Norfolk by Elias Habib. It is still operated by the family, offering sandwiches, such as pastrami, breads and pastries.

Owners Tony and Lina Saady's AZAR'S, a Mediterranean eatery, introduced much of the region to hummus and other classic Lebanese dishes when it opened in 1988. It has two locations in Virginia Beach.

Owners John Stein and French master baker Phillipe Bulan's BAKER'S CRUST, a New American casual-dining restaurant, was noted for bringing groundbreaking artisan breads and other baked goods to the region when it opened in 1993. Today, a full menu is offered at the three Coastal Virginia and three Richmond-area locations.

CAFE EUROPA owners chef/owner MICHAEL SIMKO (who is Czech) and his wife, Veronique (who is French), have offered fine dining at their Continental restaurant in Portsmouth for around thirty years.

CRACKER'S was groundbreaking in showcasing tapas to the region when Karl Dornemann and Peter Pittman opened the eatery in Norfolk in 1998. Today, it is owned by Chris Glover, who also operates the similar-themed PACIFICA in Virginia Beach.

Authentic German dishes were welcomed with the opening of DAS WALDCAFE in Newport News in 1976, but it closed in 2015. Similarly, the GERMAN PANTRY opened in Norfolk and also closed in 2015. In Portsmouth, brother and sister Kevin and Stefanie Osfolk opened the BIER GARDEN, which is still open. The team has also opened a second location in Virginia Beach.

Fine Italian dining was introduced to the region when IL GIARDINO

Crab cakes at Le Yaca, Virginia Beach and Williamsburg. *Author's collection.*

RISTORANTE opened in 1983 and emphasized with the opening of another white-linen eatery, ALDO'S RISTORANTE, in 1988. Il Giardino operates two Virginia Beach locations, and Aldo's has one, also in Virginia Beach.

LE YACA FRENCH RESTAURANT was opened in Williamsburg in 1980 by Daniele Bourderau, bringing fine French dining to Coastal Virginia, having started in an old farmhouse in a small village in the French Alps in 1964. One of the first chefs in the United States for Le Yaca was Daniel Abid, who purchased the restaurant in 2001. In 2016, a second Le Yaca location opened in Virginia Beach.

GONE BUT NOT FORGOTTEN

Other restaurants that made a footprint in Coastal Virginia and that are no longer in business include:

99 MAIN, opened in 1999 in Hilton Village, the planned community built in 1918 to house employees of Newport News Shipbuilding & Drydock Company. Contemporary fine dining with French- and Mediterranean-inspired accents in a small and sophisticated space were offered by Chef JIMMY FERGUSON and his wife, Christine. The two seemingly had restauranting in their DNA. Ferguson's family owned the now-closed STRAWBERRY BANKS INN AND RESORT, which included a restaurant. It was across from Old Point Comfort, noted in 1607 by settlers for the wild strawberries growing there. Christine's father operated Sanitary Restaurant, a diner, from 1951 until 1990 in downtown Newport News, catering to the shipyard and business community. 99 Main closed in 2015 when the couple decided to retire.

ANTIQUITIES at the Norfolk Airport Hilton (which opened in 1985) was a fine-dining, glitzy restaurant with elegant presentations of beef, duck and seafood. Rack of lamb and saddle of venison were carved table side. It was noted for its table-side preparations of Caesar salad and flaming desserts from maître d' EARL BRANCHE, who had once waited tables alongside Monroe Duncan at the Nation's Room. In Branche's obituary in the *Virginian-Pilot* in 2012, Duncan recalled, "He [Branche] would arrive at the table and open his arms and say, 'I'm going to do this for you.' Afterwards he would back away from the table bowing and lifting his arms like an eagle's wings and say, 'bon appetit.'" The restaurant operated for around twenty years, closing when the hotel was renovated.

Opened in 1976 and named after a Saigon restaurant, LA CARAVELLE offered Vietnamese-French cuisine from owners Loi and Tam Nguyen, who had been Parisian restaurateurs. The menu blended the cultures, with offerings like Trout in Sweet and Sour Sauce, Curried Lamb, Le Veau au Roquefort and crispy roast duck in a Grand Marnier sauce. The restaurant closed in 2001.

LE CHARLIEU served classic French cuisine in a former private home built in 1885 in downtown Norfolk. Opened by Richard (a Paris native) and Carole Tranchard in 1978, it featured dishes such as French Onion Soup, Brie en Croute, Escalope de Veau Charlieu and Coquille St. Jacques Gratinee. Le Charlieu closed in 1993.

LUCKY STAR was a groundbreaking Virginia Beach casual-comfort restaurant featuring seasonally fresh ingredients with a seafood focus, such

as deviled crabs, goat cheese-filled portobello with pasta, pepper-seared tuna with baby greens and sesame-wasabi horseradish dressing. AMY BRANDT opened the eatery with partner Herman L. "Butch" Butt III in 1989. Brandt and Butt sold Lucky Star in 2004, with Chef SCOTT BERNHEISEL and his wife, Julie, taking over. Butt died in 2006 and Brandt now owns Amy B Catering on the Eastern Shore. The restaurant later closed and is now home to chef/owner KEVIN SHARKEY's 1608 CRAFTHOUSE.

Open in 1991 by David and Tracey Holmes, MAGNOLIA STEAK & SEAFOOD CO. in Norfolk's Ghent offered a casual bill of fare showcasing surf and turf. Southwestern-style dishes were also offered. The eatery garnered many accolades, including praise from *Southern Living* magazine, for its steaks. Magnolia Steak closed in 2009. Today, Public House occupies the spot.

FOUR AND TWENTY CULINARY PROFESSIONALS TO KNOW

(In addition to other chefs and restaurateurs profiled throughout the book)

George Ackerman

With the exception of gourmet offerings at Giant Open Air Market, there weren't many places to get brie, pâté, fine wine or other gourmet goodies when the WARWICK CHEESE SHOPPE first opened in Newport News in 1971. Though the shop was initially owned by Tom and Mary Ellen Power (of the Cheese Shop, the Trellis, and Fat Canary in Williamsburg), George Ackerman, previously in wine sales, and his wife, Marguerite Hargreaves, took over the business in 1978. Ackerman's father, L.C. "Bud" Ackerman, was president of Newport News Shipbuilding from 1969 to 1973 and bought the store for the couple. More than just the namesake cheese—although between eighty and one hundred different kinds were stocked—the shop carried a variety of items; fresh-baked breads, deli meats, made-from-scratch desserts and other sweets, specialty foods like country hams from Edwards Virginia Smokehouse, gift baskets, some one hundred different wines from across the United States and the world. The shop was also noted for its sandwiches, served on fresh bread slathered in

a signature—and secret—house dressing and piled high with meat and cheese. "Sandwiches are the heart of the business," Hargreaves told *Daily Press* writer David Nicholson. George Ackerman died in January 2014, and the shop closed that October after thirty-six years in business. In his obituary, Ackerman was noted as "one of a list of people responsible for elevating the palate of the Peninsula."

Frank Baumann

Frank Baumann, a Brooklyn native, came to Virginia Beach in the late 1960s as a representative of Fotomat and ended up leaving an indelible mark on the cuisine scene of the resort city, rather than photos. He was an active civic leader. Baumann began venturing into the hospitality industry by opening several after-hours clubs and, in 1977, purchased the legendary SIR RICHARD'S. Sir Richard's was a popular nightspot known for steak and singers; acts to grace the stage included Natalie Cole. Baumann opened FRANKIE'S PLACE FOR RIBS in 1982 at the Virginia Beach Oceanfront, offering no-nonsense slabs of ribs slathered in tangy sauce and other meat-centric items. Long before an onion bloomed, Frankie's offered a much-loved Onion Loaf, in which large, sweet onions were sliced thin, lightly battered, shaped into a loaf and fried. Baumann's brother, Jay, later opened a second Frankie's in the Kempsville area of Virginia Beach; both locations are now closed.

MR. YEE'S opened in 1992; the Chinese restaurant focused on Cantonese cuisine, along with some American, Hunan and Szechuan dishes. It was opened as a tribute to Steve Yee, who operated the popular Virginia Beach restaurant Golden Dragon for about forty years, beginning in the late 1950s. In 1993, with the closure of Mr. Yee's, Baumann opened a steakhouse, BEEFEATERS (now closed) in the same location. Other ventures: SEASIDE RAW BAR and a deal to purchase HENRY'S PLANET SEAFOOD on Shore Drive, which did not materialize, as Baumann became ill and passed away in 1999. His legacy lives on with ROCKAFELLER'S, open since 1989 and run by his wife, Elizabeth "B.J." Baumann. The restaurant offers spectacular views of Rudee Inlet in Virginia Beach from its large, two-story beach cottage-esque building. Fresh seafood is the focus on a varied menu that also includes ribs prepared with the recipe from the former Frankie's Place for Ribs and prime rib with the recipe from Sir Richard's.

Travis Brust

Although being a chef wasn't a goal early on, compliments from family and friends on his cooking encouraged Travis Brust. "I seemed to have the knack for this cooking thing, so I pursued it," remarked the chef. Today he is executive chef/food and beverage director at Colonial Williamsburg, including overseeing dining operations at the Williamsburg Inn and its signature restaurant, the ROCKEFELLER ROOM. Brust began his journey with a culinary apprenticeship at age eighteen at the Balsams Grand Resort Hotel in New Hampshire. From there, he worked under master chefs and traveled to other resort properties across the country to do the same, including a stint in Colonial Williamsburg, returning to Williamsburg in 2004 to mentor under Chef Hans Schadler. Brust describes a culinary experience at Williamsburg Inn in six words: "Intimate dining with an unforgettable meal." The chef has written a menu that's rich in Virginia ingredients, with a number of classic dishes crafted for a contemporary palate. Among many awards, Brust placed first in the 2012 World's Chef Challenge in Las Vegas and second place again in 2013, as well as winning Virginia Chefs Association Chef of the Year in 2014.

Jerry Bryan

In a region of excellent restaurants overall, and in an area of outstanding restaurants that focus on seafood, Jerry Bryan's COASTAL GRILL, opened in 1989, is lauded by patrons and peers alike. On the menu, favorite dishes include steamed mussels and a grilled leg of lamb. The restaurant is famous for seasonal seafood like rockfish and soft-shell crabs as well as the ubiquitous acorn squash served alongside entrées. Bryan said the eatery goes through about eight hundred bushels of the squash a year; it is served halved and baked until the orange flesh gives way to your fork with no hesitation and filled with a generous addition of brown sugar floating atop a pool of melted, rich butter. Bryan first earned acclaim cooking at the MAX, an innovative restaurant in Portsmouth in the 1980s (it later moved to Norfolk) and also cooked at CRACKER'S in Norfolk.

Here's how Coastal Grill makes it butternut squash, a recipe from Bryan himself:

Preheat the oven to 400 degrees Fahrenheit. Split the squash from stem to tip and, with a spoon, scoop out the seeds. On a lipped baking sheet or in a pie tin, place the squash hollow side down. Add a half-inch of water and place in the oven for 35–45 minutes, or until the skin yields easily to the tip of a knife. (Don't push in too far, or the squash will not hold the butter.) Invert squash and add a pat of sweet butter and a tablespoon of brown sugar. Yields 2 servings.

Michael Cavish

Perhaps as outlandish in his own right as Monroe Duncan was Michael Cavish. Not a chef but rather a restaurateur, Cavish approached living in a life-in-the-fast-lane manner. An attorney, he also had a long career in restaurants, including Sharky's in Virginia Beach from 1973 until 1975 and the Judge's Chambers in Norfolk from 1975 until 1980. Inspired by time on the West Coast, he opened Fellini's in 1988 on Twenty-First Street in Norfolk's Ghent. Fellini's was far more than just another Italian restaurant or pizza parlor; it is credited with introducing the California-style, or gourmet pizza, to Coastal Virginia. At first there were eight pies, but the number expanded as folks got used to something more than pepperoni or sausage on their pizza. The style was relatively new altogether, credited as being developed in the Golden State in 1980 in some small—but well-respected—eateries, including Ed LaDou's Prego Restaurant, and chefs working for Alice Waters at Chez Panisse in Berkeley. The concept took off with Wolfgang Puck's Spago in 1981 in West Hollywood, where LaDou then worked. LaDou later worked on the concept in 1985 for California Pizza Kitchen. Within three years, Cavish was adopting that concept here. A reporter in 1991 noted two favorites of the time, including Thai Chicken, with diced breast of chicken marinated in a peanut-ginger sauce, with green onions, sautéed zucchini, julienned carrots and roasted peanuts. The other was the Cajun, with andouille sausage, sweet bell pepper, red onion and a spicy Cajun sauce topped with smoked gouda and mozzarella cheeses.

Popular Fellini's expanded to a larger space along the same avenue in 1990 and then moved to its present location on Colley Avenue, also in Ghent, in 1995. For a while, there were Fellini's locations in Chesapeake and Virginia Beach. Cavish briefly operated Wilma's Chili Parlor in the mid-1990s along Norfolk's North Colley Avenue. It closed in 1995 when

he decided to move Fellini's there from its (second) location on Twenty-First Street due to lease issues. That space would become Joe Hoggard's CAFE ROSSO. Cavish was murdered during a robbery in 1998. Fellini's is still open, run by family members of Cavish's, including his sister Donna McCullough.

Peter Coe

Peter Coe, founder of Taste. *Taste.*

With the exception of Warwick Cheese Shoppe, there were few gourmet stores in Coastal Virginia in the 1970s. Peter Coe, a Connecticut native and former banker, sought to change that, founding TASTE UNLIMITED (today known as TASTE) with a single store in the Shops at Hilltop in Virginia Beach in 1973. Coe was partners with childhood friend John Curtis, who was a partner in the Trellis in Williamsburg. Other partners in Trellis were Tom and Mary Ellen Power, who had opened Warwick Cheese Shoppe in Newport News two years prior.

Coe embraced the region, and the region embraced him. He imported fine goods but was an endless champion of local purveyors as well; he was an early advocate of Virginia wine, selling it since 1978, when he first brought Meredyth Vineyard's Marechal Foch wine into the stores. Coe led cooking classes and wine tastings. Taste Unlimited grew into an institution, selling a number of specialty products and gourmet sandwiches made in-store. A store in Norfolk's Ghent opened in 1976, and expansion continued to eight stores in the region, one in Richmond, and Borjo Coffeehouse in Norfolk.

In 2006, Coe sold Taste Unlimited to father and son Peter (who had previously worked in the Virginia ham business) and Jon Pruden but stayed on as a consultant. "As Peter often remarked, Taste was to be his legacy, and he continued to work with us each day for those five years (until his passing in 2011) to ensure the business continued to thrive," said Jon Pruden in a tribute article to Coe. Another tribute was the renaming of an original favorite sandwich on the menu to recognize the first location. The Hilltop features roasted turkey and provolone cheese on French bread with the

store's proprietary house dressing. "It's the quintessential TASTE sandwich," said Pruden. "Deliciously simple." In 2009, TASTE was recognized as an Outstanding Retailer by the Specialty Food Association. Coe was posthumously inducted into the Specialty Food Hall of Fame in 2015.

Marcel Desaulniers

Even if you don't know the name Marcel Desaulniers, you know his world-famous dessert, Death by Chocolate. The Rhode Island native graduated from the Culinary Institute of America in 1965 and served in Vietnam in the U.S. Marine Corps. He worked in several restaurants in New York City before moving to Virginia as manager of Food Production and Quality Control for Colonial Williamsburg. It was there he became acquainted with the foods and foodways of Virginia. "I started using blue crabs, which had not been a big thing in New York, and the emphasis on using salt-cured ham, as a seasoning was sort of revolutionary for me," he said. "We strictly used Chincoteague oysters, which were called saltwater oysters because they grew in saltwater marshes. They had a distinctive flavor that you didn't get from oysters that came from New York." With friends TOM POWER SR. and JOHN CURTIS, Desaulniers opened the TRELLIS in Williamsburg in 1980 and operated it for twenty-nine years. In its early years, the iconic restaurant, now owned by DAVID EVERETT, introduced many diners to Virginia cooking and a whole new—albeit centuries-old—regional food style.

"We were shooting to have an American cuisine [that was fresh and local]. Instead of canned soup, we'd have house-made soups garnished with Edwards salt-cured ham, and entrées with quail grown locally and catfish caught out of the James River," said Desaulniers. "We connected with the farmers and growers immediately. It was more difficult, but we were pleased to have something that was different from other places." The Trellis supported Virginia vintages early on; the vines growing around the namesake trellis at the front of the restaurant are cuttings from the long-gone Meredyth Vineyards. Desaulniers has penned ten cookbooks, hosted several television cooking shows and appeared on Julia Child's show *Baking with Julia*. In 1993, he was named Best Chef in the Mid-Atlantic Region by the James Beard Foundation and also won the Baking and Desserts category of the James Beard–Farberware Cookbook Awards for his *Death by Chocolate: The Last Word on a Consuming Passion*. After selling the restaurant, he opened a

chocolate café with wife, artist Connie Desaulniers, for several years. MAD About Chocolate—MAD is an acronym for Marcel Andres Desaulniers— was later sold, and the chef known as the Guru of Ganache has fully retired. The chocolate café has since closed.

Monroe Duncan

Monroe Duncan was a larger-than-life iconic chef, part of the area's cuisine scene off and on (mostly on) for decades. His personal pursuit of pleasure was contagious and excited patrons. There may have been others like him in other cities, but not here, not at the time. His résumé is as long as was his appetite for life: the Nation's Room at the Golden Triangle, the Chamberlin Hotel, Simply Divine Dahlings, Suddenly Last Summer, the Lazy Lobster, Monroe's Mocambo, the Blue Crab, Piranha–An Eating Frenzy, Todd Jurich's Bistro, Smithfield Inn and Uncle Louie's, to name a few. But it was perhaps Suddenly Last Summer, opened in 1979 in his beloved Ocean View neighborhood of Norfolk, where he first became known. The restaurant was opened with partner Tony Klementzos in a former High's Ice Cream shop. The eccentric "Nouvelle Florida" décor included an aquatic motif mural and liberal use of pink flamingos throughout, along with random art. It was one of the first eateries in Coastal Virginia to feature an open kitchen, where Duncan could be the star. When he wasn't cooking, he would go out and schmooze with diners, many of whom became lifelong fans. He defined his style: "We intend our food to make definite statements about cooking as an art. Our approach is always classical—our results always brand new."

Along the way, Duncan not only fed patrons but other chefs' careers, too. In 2014, the chef, or Le Chef, as he liked the moniker, died in his sleep in Chicago, which he had called home for the past few years. He was in his mid-seventies. His personal style and his cooking style were forces to be reckoned with. Monroe wore bright shirts and combat boots. He challenged himself, his staff and the palate of Coastal Virginia. He pushed, and pushed hard. He was a fierce, roaring lion one minute and a sweet, purring kitten the next. His food was creative, utilizing local ingredients with classic techniques. Dishes Duncan was noted for included Flounder Bercy, table-side Caesar salad and his mother's cantaloupe pie. The chef also consulted with other restaurants occasionally and is known for creating Oysters Bingo for Joe Hoggard's Ship's Cabin.

On his passing, many remembered him. "There is so much to say about Monroe and how much of a mentor he was to me," said TIM BROWN, chef/owner of HOOK U UP GOURMET in Cape Charles, in a tribute article the author penned when he was food editor at *Coastal Virginia* magazine.

I first met Monroe in 1986 when he was the food and beverage director at the Chamberlin Hotel and he offered me the sous chef position fresh out of culinary school. [We worked together again later at] Monroe's Mocambo. The things Monroe taught me were to educate my palate and learn the technique and your culinary profession can go any were. There were so many crazy time working for him in the kitchen. He would scream and carry on and call us everything in the book. His passion for food, quality, consistency and creativity were most important to him.

The late BOBBY HUBER, who is profiled later, said, "[Monroe] taught me the bounty of the seasons and the Chesapeake Bay, how to interact with customers and the value of an experienced waitstaff. Monroe was much more than a chef; he was larger-than-life, a mother, father and mentor all rolled into one." PATRICK REED, chef/instructor at the Virginia Beach Technical and Career Educational Center, remembered his first encounter with Duncan: "It was 1985, just graduating Culinary Institute of America, and looking for a gig on the East Coast. [Monroe] flew me down for a weekend interview at the Chamberlin Hotel. It was the beginning of an education that lasted almost 30 years. I soon learned his panache and polish in the dining room mirrored his demand for the highest quality food, exciting menus and hard work. I fell in love with professional food service that weekend, and it's all Monroe's fault."

David Everett

Some chefs own multiple restaurants; not many can stride across a parking lot to go from one to another. Chef David Everett can; his BLUE TALON BISTRO, the TRELLIS RESTAURANT and DOG STREET PUB are all clustered together in the Merchant's Square area of Williamsburg. The chef began working in restaurants at age twelve and, as a young adult, crisscrossed the country working in kitchens from Walt Disney World to Washington, D.C. He came to Williamsburg to work at the exclusive Ford's Colony community, where he worked for fourteen years, including as executive chef and director of food

and beverage. Everett left in 2004 to open the first of his own restaurants, Blue Talon Bistro, offering a blend of New American and French cuisines.

In 2009, he purchased the iconic Trellis restaurant, just yards away from Blue Talon Bistro, and put his own touches on the menu over which Marcel Desaulniers had presided since 1980. The Trellis, open for brunch, lunch and dinner, is still elegant but casual, and the New American cuisine approachable, "with bright and exciting menu selections," according to the eatery's website. DoG Street Pub (DoG is an acronym for Duke of Gloucester Street, the eatery's location) is a gastropub next to the Trellis, offering tavern-style food with upscale preparation and presentation, using top-quality ingredients. Located in a former bank, the open, airy space with hewn wooden tables and chairs is as inviting as the well-thought-out menu.

Joe Hoggard

Joe Hoggard approached each evening at his venerable Ship's Cabin in Norfolk's Ocean View like the conductor of a world-class symphony. "Our customer deserves our best every time," he said in a 1987 newspaper interview. From humble beginnings as a snack bar adjacent to his father's hotel at the East Beach end of the community, Ship's Cabin rose to national prominence in the 1960s. Many of the region's top chefs were associated with the seafood-centric restaurant. More about Ship's Cabin can be found in the "Beach Eats" chapter of this book. Hoggard sold the restaurant in 2000 and took on a few other projects before moving to Mexico.

In 1995, Hoggard opened Cafe Rosso in the former second Fellini's location in Norfolk's Ghent and focused on casual Italian dining. In 1995, noted Meredith Nicholls became owner; he suffered a severe spine injury while mountain bike racing in 2004, leaving him paralyzed from the chest down. The next year, the eatery closed; today 80/20 Burger Bar is in the location. For a while, Hoggard also owned or was partners in Joe's Sea Grille and Zinc Brasserie in Virginia Beach, both now closed.

Bobby Huber

Bobby Huber was his own chef, but the influence his mentor, Monroe Duncan, had on his career was evident throughout his culinary career and personal life. In a 1991 newspaper interview, Huber was asked if he was living

in the shadow of such a larger-than-life figure. "Under Monroe's shadow?'" he responded. "I don't think that's a bad thing at all. He's probably the best and the hardest chef I've ever worked for. I find it complimentary being associated with Monroe. It's more of a spotlight than a shadow." A New York native, Huber spent much of his youth growing up in Florida, where his path in the kitchens began with washing dishes at age thirteen. The navy brought Huber to Coastal Virginia; he served a four-year stint as a culinary specialist on submarines, including the USS *Atlanta*. He honed those skills at the Norfolk campus of Johnson & Wales University. After his time in the military ended in the late 1980s, Huber stayed here, and with each dish he prepared at each restaurant he cooked at and/or owned, his reputation grew. By the time he opened the restaurant that would define his cooking style and elevate Huber to celebrity chef status in the region, he already had an impressive résumé, including CRUSOE'S CELLAR and then BLUE CRAB with Duncan—both in Norfolk.

He had taken over the kitchen at the Blue Crab in Ocean View after Duncan departed for another venture, working on changes to the menu and service at Louis Eisenberg's iconic UNCLE LOUIE'S in the city's Ward's Corner area. Then Huber's first, but short, foray into restaurant ownership came in 1991 with SWEET BIRD OF YOUTH, located in the former ANDY'S PUB and before that the site of Duncan's SUDDENLY LAST SUMMER in Ocean View. Lunch consisted of large, New York–style sandwiches on house-baked breads served with unusual side dishes, and dinner featured table-side Caesar salads, chicken, meat and seafood entrées—such as Onion-Crusted Salmon Filet with Sage Cream and Golden Caviar or Breast of Duck with Angel Hair Pasta and a Sake/Ginger Root Sauce—and nightly specials. By 1992, Huber was cooking with Chef MICHAEL TOEPPER—highlighted later—at FIRE & ICE restaurant in Hampton and VICTORIA'S FIRE in Williamsburg. In 1993, Huber moved again, this time taking over the kitchen of JOE HOGGARD's venerable SHIP'S CABIN for two years. A 1993 newspaper account noted Hoggard at first expressed some concern about hiring Huber for his "reputation for assembling artsy dishes with bizarre ingredients" but said he was "impressed with the 26-year-old's enthusiasm for cooking." Huber toed the Hoggard company line.

The game changed for the chef and Coastal Virginia in 1995 with the opening of BOBBYWOOD. Like Monroe Duncan, Huber sought out the shabby and made it chic. In the once-prestigious but then a bit downtrodden area of Ward's Corner, he converted "JERRY'S, a tavern dating back to 1946, into an upscale establishment, offering wood-oven baked pizza, skillet-seared

sashimi, and creamy risotto tossed with rock shrimp, scallops and Prince Edward Island mussels" (emphasis added), according to a *Virginian-Pilot* article by restaurant reviewer Sam Martinette. Huber took over the space next door, the former NAAS BAKERY, to create an open kitchen. He removed a wall and created a dining room area. There, with a flourish of flamboyance, the chef had "A 50-foot banquet… built under the Bobbywood sign [in the style of the iconic Hollywood sign], where [Huber's nephew] Adam Fell created a mural with [King] Kong at one end [perched atop a corner of the shopping center where the restaurant was located] and Huber riding to the rescue atop a killer whale, a la 'Free Willy,'" whisks waving in the wind. Between the Hollywood icons are caricatures of area chefs, including Duncan (stirring the pot) and SYDNEY MEERS of the DUMBWAITER. Other caricatures included Chef SAM MCGANN and "tuxedoed local stars being interviewed by pesky entertainment press." It was an immediate success, and Huber was in his element. It was at Bobbywood where he would also craft creations that stayed with him throughout his career, including decadent oyster stew served in a bowl over a generous serving of creamy mashed potatoes, Bobbaque (his version of barbecue) and an aptly named dessert, Amaretto Sin Pie. He closed Bobbywood in 2003.

In 1998, Huber opened the short-lived BOBBY'S AMERICANA in downtown Hampton. In a *Daily Press* interview, he said the eatery "reflects the celebration of American chefs getting credit for what we really work hard to do.…It used to be, I guess, that chefs weren't heralded in the United States like they are now. But the whole revolution of it is kind of cool. I'm glad to be part of it." In Virginia Beach, Huber headed up the kitchens of such restaurants as ALEXIS (Continental cuisine in the former LE CHAMBORD), RED MULLET (an upscale diner) and ONE FISH TWO FISH (still open) and, in Norfolk, BLUE HIPPO (closed).

He then opened a second, sleeker Bobbywood in downtown Norfolk in 2006. *Virginian-Pilot* restaurant critic Tammy Jaxtheimer described it as follows: "Rich wood and cool stone decorate the spacious dining rooms and bar area. I felt as if I were

Bobby Huber of, most notably, Bobbywood. *Author's collection.*

inside a West Elm catalog with textures, cocoas and clean lines. Walls are in tasteful colors of pumpkin, butterscotch, Granny Smith apple and eggplant. A 3,000-bottle wine cellar with about 20 by the glass is well matched with the menu." Huber offered some old favorites and introduced "Spoons": a lineup of utensils with one bite of varying temptations, like Leek Fondue with Corn Maque Choux, Tomato Tartare with Fresh Mozzarella and Wild Mushroom Risotto. He revived the stunning, complimentary bread service learned while at Ship's Cabin and crafted seasonal, sublime appetizers and desserts. It closed in 2008.

In summer 2009, he joined the venerable STEINHILBER'S as executive chef before leaving to open BRAISE, offering his signature creative cuisine, in early 2013. Braise's other owners and Bobby had parted ways by early 2014, and shortly after that he announced plans to open a third Bobbywood. That never materialized. Huber, who suffered from many health issues, died later that year, leaving his wife, Heidi, and son, Zach. The last restaurant he had ownership in, Braise, closed in 2018. After Huber's passing, Joe Hoggard told the author, "When Bobby worked with me, I spent endless hours being his father; no regrets. He was just hell-bent on being an outlaw. I loved him like a son."

Todd Jurich

In more than four decades, Pittsburgh native Todd Jurich has worked at some of the region's best-loved restaurants and has operated his own venerable eatery, the namesake Todd Jurich's Bistro, in downtown Norfolk since 1992. His career began in 1976 as a sauté cook and bartender at VICTORIA STATION in Virginia Beach, a popular chain of the day housed in refurbished railroad cars, usually sporting a caboose. There Jurich would cook dishes such as slow-roasted prime rib au jus, dry aged on the bone. Jurich worked at a number of restaurants in a number of positions, including the QUARTER DECK, TRADEWINDS inside the Virginia Beach Resort & Conference Center and the noted WESLEY'S, all in Virginia Beach, preparing him for ownership of the IRON GATE HOUSE in 1985. The now-closed restaurant, which opened in 1977, was at the Virginia Beach Oceanfront and featured seasonally changing menus. Located in a former beach house, it felt warm and inviting, especially with a fireplace in the main dining room. The eatery's five-course dinner might have started with Crabmeat Smithfield, which featured chilled jumbo lump crab and remoulade sauce topped with Smithfield ham. In the book *Dining In—Hampton Roads Cookbook*, Jurich explained his philosophy at

the Iron Gate: "We strive to create a comfortable feeling for our guests. We want each person to feel as if he or she is enjoying a leisurely five-course meal in a good friend's home."

In 1987, Jurich was an owner of the CRAWDAD CAFE and in 1988 an owner of the COYOTE CAFE (known for its Chipotle Bronzed Tuna Taco), both in Virginia Beach. Iconic restaurateur RICK MAGGARD was also part of these restaurants. In 1989, the chef would open MENUS in Pinewood Square, located in the former Wesley's. In a newspaper interview at the time, Jurich said, "Our menu will be handwritten, and changed to match the season. Being at the Beach, we'll have a grilled, fresh catch of the day. And, since Wesley's had such great success with their rack of lamb and steaks, we're going to have a Cowboy Steak, a big 20-ounce bone-end Delmonico that will be served with mile-high red onion rings." Today the space is TEMPT RESTAURANT LOUNGE.

By 1992, Jurich had shifted his culinary career to Norfolk, opening BISTRO 210 (sometimes known as BISTRO!) on York Street, in the former STRIPES. The chef was a pioneer of fine-dining restaurants being established downtown. The name changed to TODD JURICH'S BISTRO in 1997 and moved to bigger digs around the corner on Main Street in 2002. Todd Jurich's Bistro is known for its farm-to-table menus, which are especially strong in Atlantic and Chesapeake Bay fish and shellfish. Many local farms supply produce for the American regional dishes there, too. A signature item is Jurich's Pumpkin Crab Soup, which is best described as autumn in a bowl. A rich, creamy puree of roasted pumpkin and chicken stock is enriched and thickened with milk and then flavored with warm spices like cinnamon, nutmeg and star anise. The soup is studded with generous amounts of jumbo lump crabmeat. Atop that are croutons seasoned with cinnamon and Old Bay® and finished with a sprinkling of chopped parsley and a touch of paprika oil. In 2011, the chef operated the short-lived TODD JURICH'S 21ST CENTURY BURGER BAR in Virginia Beach. It offered upscale hamburgers like the Parisienne, which was topped with frisee, lardons and a sunny-side-up egg.

Rick Maggard

Rick Maggard was a dynamic restaurateur, feeding the belly and brains of diners with a half-dozen eateries—all in Virginia Beach—in the 1980s and 1990s.

These included the BARKING DOG, offering American regional cuisine with such bistro dishes as roasted pork loin served with crispy jicama and sweet

potato cakes and a Caribbean-inspired lime pepper jelly or braised lamb shanks served with garlic mint jam and a side of mashed potatoes garnished with a dab of pesto. Maggard's CAFE SOCIETY offered eclectic American fare with a southwestern flair, such as the signature dish, fish tostadas. The tostadas featured blue corn tortillas stacked with fresh catch, lettuce, black beans and guacamole. They were offered as an appetizer or combined with a crab and lobster cake for an entrée. COYOTE CAFE was full-blown southwestern, from the décor (including a large howling coyote mural) to the twenty-two-ounce margaritas. Popular was the Oysters Santa Fe, where a bowl was filled with freshly shucked oysters, bacon, onion and spinach in a creamy, tamarind-spiked sauce and poured over slices of grilled French bread. Coyote Cafe would change hands over the years, closing for some time and reopening briefly in 2017, only to go dim again in 2018.

CRAWDADDY'S (later expanded to CRAWDAD CAFE) served Cajun- and Creole-style café dishes at breakfast, lunch and dinner. A *Daily Press* review in 1988 highlighted an offering of blackened scallops in a spicy homemade orange marmalade spiked with ginger. It was "typical of the style of cooking here," wrote Prue Salasky. "Local ingredients made with Cajun techniques, lightened by incorporating sauces and condiments in the 'new American' style." Other of Maggard's eateries included ELBOW ROOM and NORTH BEACH SEA GRILL. Notable chefs like TODD JURICH, SAM MCGANN, WILLIE MOATS, CHUCK SASS and JOHN TAYLOR worked with Maggard at various restaurants; all are now closed. Maggard died in 2003. Wife Madelyn is known for her legendary coconut cakes and red, ripe tomatoes.

Chuck Mamoudis

Chuck Mamoudis, a Chesapeake native, attended college at Louisiana State University, where he developed a love of cooking; the Cajun and Creole flavors of that region would make frequent appearances in his restaurants back in Virginia.

Mamoudis made a name for himself not only in Coastal Virginia but nationally with his Virginia Beach restaurant, YORGY'S, which opened in 1981. The restaurant exuded casual elegance, with touches like Italian tile tables, set with elegant china. There was also an open kitchen so guests could watch the action. The book *Dining In—Hampton Roads Cookbook* described the weekly-changing menus as "eclectic, drawing on Mamoudis' Greek heritage, Virginia up-bringing, Creole exposure during college, extensive culinary

reading, and constant experimentation." Yorgy's is a Greek nickname for the chef's middle name, George. The restaurant closed in 1987.

Mamoudis returned to the scene for a while in 1991 by cooking at the venerable Virginia Beach restaurant the RAVEN on Tuesdays with "An American Night Out" menu—a precursor to today's popular pop-up concepts. The bill of fare featured many of Yorgy's favorite dishes, including scallops stuffed with salmon simmered in a black bean sauce or tuna mousse wrapped in roasted red peppers. He would continue to guest chef at other area eateries.

By 1999, Mamoudis had opened the casual and quirky SHADOWLAWN GRILL with partner HEATHER GAINES. The menu too was casual and quirky, with offerings like tempura-fried bits of Smithfield ham rolled with a crabmeat stuffing and served with dijonaise sauce; Salmon Pomodoro consisting of char-grilled salmon with sautéed plum tomatoes; and fried crawfish-stuffed green tomato surrounded with étouffée and drizzled in a Greek-inspired béarnaise, made with grape leaves and not the traditional tarragon. Perhaps the most noted signature dish was summer squash blossoms stuffed with crawfish, andouille sausage, crab and shrimp, lightly battered and fried before being served in a tomato and shrimp étouffée cream sauce.

Shadowlawn Grill closed in 2005, with the chef moving to Key West and saying he was taking an "educational working sabbatical, on a quest to discover how far food can go up a rosemary stem." In a 1991 article, he was lauded as "among the first to introduce New American Cuisine to Hampton Roads when he opened Yorgy's." Mamoudis died in 2008. The space is today home to another casual and quirky eatery, GRINGO'S TAQUERIA.

Chad Martin

Chad Martin began his career bussing tables in 1997, eventually moving up to being a server. "I waited tables for about a year [at the noted FIRE AND ICE, located in Hampton], then moved to the back of the house at lunch as they needed to fill a vacant spot for a cook. I worked for an out-of-the-box thinking chef, and I loved it," he said. That chef was MICHAEL TOEPPER, who is profiled in this section. Martin later landed at the cutting-edge ARIA FIFTY ONE CAFE and at Jimmy and Christine Ferguson's 99 MAIN, both in Newport News.

The chef would venture into restaurant ownership in 2001 at BLUE HIPPO, along downtown Norfolk's Restaurant Row on Granby Street, selling his interest in 2005. BOBBY HUBER would take on the executive position for

Chad Martin of Create Bistro, Hilton Village, Newport News. *Chad Martin.*

a while as the second BOBBYWOOD was under construction. The richly decorated Blue Hippo opened in 1998 offering lavishly presented plates of Continental cuisine; it closed in 2006. Martin would head to the now-closed ISLA in Virginia Beach for a short while as executive chef, crafting "modern island cuisine" before opening his first restaurant from scratch, CREATE BISTRO, with partner Andrew Hyatt.

The forty-five-seat Create Bistro opened in the Hilton Village area of Newport News in the former ROSIE'S CAFE. "I opened Create with a $10,000 gift, and nine credit cards," said Martin. The chef flourished, crafting delicious and innovative dishes like Pan-Roasted Eye of Lamb Loin with Scallion Risotto and Sautéed Mushrooms and Sautéed Tiger Prawns on Chorizo-Brie Cheese Grits with Smoked Shrimp Broth. He explained the latter: "I wanted to have a shrimp and grits on the menu, but I didn't want the same ol' thing. So we made our own blend of chorizo sausage for the dish and added creamy rich brie cheese to the grits, then finish it off with a chipotle-shrimp stock from the shells." In 2009, the restaurant was heavily damaged by fire just as Martin was planning on opening a second eatery a few blocks away.

That restaurant, CIRCA 1918 KITCHEN & BAR, opened in 2010. The quaint eatery is named for the year that the Newport News community of

Hilton Village, where it is located, was established. Martin calls it "Creative America Cuisine." That includes the Original Bison Meatloaf, a rich, meaty offering served with sour cream mashed potatoes, wilted spinach and house-made steak sauce. Another is Za'atar Crusted Ahi Tuna, over fennel quinoa and bok choy with Teriyaki-Furikake Vinaigrette and Ginger Cashew Butter.

Sydney Meers

Sydney Meers began his path in the culinary field first as an observer as a child watching his grandmother Winnie Lee Johnson cook at her Johnson Cafe in Senatobia, Mississippi. She would carve a country ham, cook up a mess of collards and roll out miles of pie dough. In the spring of 1974, as a man in his early twenties, Meers owned a small café of his own with his mother and father where he "cooked at night a little, did waitering, and when needed, dishes." Meers joined the air force, which took him to Coastal Virginia, and he used his GI Bill to attend culinary school at the Norfolk campus of Johnson & Wales University. While still in the military, he cooked at SARAH's in the Phoebus area of Newport News. After graduation, he worked in the kitchen of MARCEL DESAULNIERS's prestigious TRELLIS restaurant in Williamsburg; like many young chefs, he could be found in the kitchen of a number of places: the COACH HOUSE in Norfolk, CAFE ZOES (not affiliated the present-day Zoes) in Virginia Beach and CHAPPELL's in Norfolk, ending up at the LAZY LOBSTER in Norfolk's Ocean View working with MONROE DUNCAN in 1987 and 1988. "I was helping Monroe get it going (at night) while by day working on The Dumbwaiter."

Like Duncan's SUDDENLY LAST SUMMER, the DUMBWAITER was a revolutionary restaurant for Coastal Virginia at the time. The 1989 opening introduced the area to another chef who wasn't satisfied with cooking the way many others at the time were. Also like Suddenly Last Summer, the quirky interior with its open kitchen was as much of a treat to the eyes as Meers's cooking was to the stomach. The Dumbwaiter was in downtown Norfolk next to LE CHARLIEU and LA GALLERIA. At the time, the chef described it as "a mixture of down-home Southern and regional American." Also down home: the liberal use of Meers's own folk art as decoration, mixed with displays of Pee Wee Herman dolls and other pop culture kitsch. The Dumbwaiter was a resounding success, and by 1994, it had moved to a larger space nearby. The Mississippi Delta style of cooking that Meers had grown up with was the inspiration for his dishes, which he executed using

Sydney Meers, noted for the Dumbwaiter and Stove restaurants. *Sydney Meers.*

classic technique learned at culinary school. Meers remembers some of his favorite dishes: "I still cook from my homeland," he said.

> *Smoked Tenderloin Salad with a Catsup Vinaigrette and etouffe. Rockfish all kinds of ways, I love that fish. I would saute it and set it on pan-roasted beets, turnips and collards sitting in a bowl and pour potlikker around it—damn good—and top it with a goat cheese-caper compound butter. And my Sextuple Truffle, a rich and decadent tart that I made so it would become my signature. It did, and I made it often. It's in the second edition of Marcel's* Death by Chocolate *cookbook.*

Meers makes cooking look simple enough, but the attention he puts into every detail is intense. He cures his own version of Tasso ham, which he calls Smoochie Bear; he also cures his own country ham. He bakes his own breads and crackers and desserts. He makes his own sauces. Every burner on the stove is ablaze and the oven blazing hot when he presides over the

kitchen. He is also noted for another southern delicacy, a sharp pimento cheese. Meers has been lauded in national press, such as *Southern Living* magazine, and he was nominated for a prestigious James Beard Foundation Award. In 1998, the Dumbwaiter closed, leaving folks desperate for his "neo-southern" cooking. The sign that hung from the door proclaiming "A Bistro so fabulous it must be illegal" was taken down. Ahead of its time, many said. Occasionally, Meers would guest chef at other restaurants, such as the popular WILD MONKEY in Norfolk's Ghent. Then, four years after closing, the chef announced he would open COWBOY SYD'S in the new Port Warwick development in Newport News; it opened in 2003. The eatery had many of the hallmarks of the Dumbwaiter, but both the menu and décor were not quite as bold. Cowboy Syd's closed in 2006. For a while, Chef MICHAEL TOEPPER operated the restaurant LIGHT in the space; it currently houses Chef KENNY SLOANE's FIN SEAFOOD.

Next on Meers's menu was his final eatery, STOVE THE RESTAURANT, in the Port Norfolk area of Portsmouth, which opened on Halloween 2006. The intimate forty-seat eatery felt like the old Dumbwaiter in many ways, but more sophisticated from the years Meers had been honing his skills. His menu was creative and cutting-edge, and his collection of curiosities and oddities entertained diners. He also began to bottle and sell his own signature Cowboy Syd's D'Lish Sauce, which has a smoked tomato flavor with a bit of spice. Then, on May 7, 2018, the chef made a post on the restaurant's Facebook page in his colorful way of expression:

> *Hello ladies and gentlemen of the world of the stove as you may have heard I'm cleaning my sauté pans after Saturday there will be no more food cooking stove it's been a great 12year Ron* [run] *I'm tired my back hurts my knee aches, lol, but nonetheless a fun time I want to think all you for your support my staff and I will always appreciate you and now I'm going to go smoke a cigar and drink a glass of whiskey,* **THE END.**

The last supper was May 12, and forty-four years after his culinary journey began, it ended. Or, knowing Meers, did it?

Willie Moats

Over a career of more than three decades, Willie Moats has been in the kitchen of some of Coastal Virginia's most well-known restaurants.

Working with RICK MAGGARD, Moats began in 1987 at CRAWDAD CAFE in Virginia Beach, cooking meals in the Cajun/Creole eatery before becoming executive chef at PRINCESS ANNE COUNTY CLUB in Virginia Beach in 1990. Throughout the early 1990s, Moats was in the kitchen in the resort city at MENUS (nouvelle cuisine), BLUE WATER CAFE (Pacific Rim and regional cuisine), then TIMBUKTU in 1995. There, as executive chef and partner, Moats gained widespread recognition for his Mediterranean cuisine. During this time, Moats was highlighted in an episode of the PBS series *A Taste for Travel* with Burt Wolf. He left in 1999.

After Timbuktu, the chef could be found at BLUE MOON CAFE (Mediterranean, Virginia Beach), COYOTE CAFE WEST (Norfolk) and LONGBRANCH STEAKHOUSE (Virginia Beach). For several years, he owned TRAVELING CHEF CATERING COMPANY. In 2004, he started in the kitchen at 456 FISH in Norfolk, rising to corporate chef in 2005 over it and its sister eateries, BYRD & BALDWIN BROTHERS STEAKHOUSE and BODEGA, also in Norfolk. That group was owned by legendary restaurateurs Sture Sigfred and Ron Zoby. Moats is vice president of food operations for HARBORS EDGE RETIREMENT COMMUNITY in Norfolk. In a newspaper interview shortly after moving to Menus in the 1990s, Moats said of his culinary skills, "I don't know how else to describe it, I've got a gift from God. I stay away from cookbooks, never look at them." In the same article, AMY BRANDT, then at the LUCKY STAR in Virginia Beach, agreed. "Willie's right, he does have a gift. I know just how he feels. You can just tell by watching him that he instinctively knows what he's doing. When Willie's cooking there is no hesitation. When he's going to put a plate together he knows just how it's going to look, how everything is going to taste before he starts."

Peter Pittman

Peter Pittman's résumé is like a who's who of beloved eateries across Coastal Virginia: CRACKERS (tapas), BACKSTAGE CAFE AT THE NORVA theater (bistro offerings), BODEGA (tapas), PETER'S TEN TOP (fresh sandwiches and other light fare) and WONDER BAR (eclectic) in Norfolk and the FLAGSHIP (seafood) in Portsmouth among them. The Portsmouth native knows the region and how to feed it. From a kitchen job in the mid-1980s, Pittman would work on designing and developing a number of eateries throughout the next three-plus decades. One of his most legendary restaurants was the WILD MONKEY, opened in 1996, nestled on the bustling Colley Avenue area of

Ghent in the former MIKE'S COLLEY DELI, a time-honored, much-revered Jewish delicatessen owned by Norman Prince. The Mike's Special sandwich, composed of bologna, pastrami, salami, Swiss cheese, coleslaw and mustard stuffed between two slices of rye bread, was the stuff of legends. (Today, Virginia Beach's ROUTE 58 has a similarly amazing bill of fare.) The empty space was also just down the street from the artsy Naro Expanded Cinema, sure to capture moviegoers.

Pittman schemed about the new venture. A *Virginian-Pilot* newspaper article printed a checklist of must dos/must haves: Streamlined, efficient, fun. Nothing pretentious. Quick, so you can catch a show. Approachable food with a special twist. No separate checks. No pink wines. No high chairs. No reservations. An enticing name. Tradition about the latter says friend Gary McIntyre knew of an old sign in a friend's barn on Knotts Island that said "Wild Monkey," and it went from there. McIntyre would be involved with Pittman at Bodega (now closed) and Wonder Bar (Norfolk, now closed). McIntyre himself is an owner at the BARKING DOG (burgers and dogs, in Hampton; not associated with the first in Virginia Beach), DEADRISE (seafood) and KISMET BISTRO AT 99 MAIN (American traditional), also in Hampton. Food writer Sam Martinette said in a *Virginian-Pilot* review that the Wild Monkey was "[t]he freshest restaurant concept I've encountered in years." Pittman described one of the dishes, the Norfolk Lo Mein, as "a low-fat noodle dish using garden vegetables, broccoli, carrots and onions, instead of Asian vegetables, and a shiitake mushroom-infused soy base to mellow and sweeten it out." Pittman sold the Monkey, as it was colloquially called, in 1999; it later closed and is now the site of GREEN ONION.

In 1999, he joined the faculty of Johnson & Wale University's Norfolk campus, there for five years until it closed and consolidated with the Charleston, South Carolina campus to open a location in Charlotte, North Carolina. Pittman opened the NORFOLK TAPHOUSE in 2006, a pub with extensive beer offerings and New American cuisine; in mid-2018, he divested his interest there. For five years, beginning in 2011, he ran Conch and Bucket, a seafood-centric restaurant in Hampton and in 2017 he did consulting work for McIntyre in opening a Barking Dog location in the Poquoson area of Hampton. Pittman still runs the HAMPTON TAPHOUSE on the Peninsula, opened in 2006.

The Power Family

The Power family has been part of the Peninsula's cuisine scene since 1971, when TOM POWER SR. and wife MARY ELLEN opened the WARWICK CHEESE SHOPPE in 1971. Power, who had been working for National Cash Register, saw a similar store during a sales trip to Baltimore, and together they decided to bring the concept to Coastal Virginia. At the time, the only place to find artisan bread, gourmet cheeses and other food products, as well as a wide assortment of wine, was GIANT OPEN AIR MARKET. The couple worked the store, engaging customers. They also became known for their sandwiches, made with the quality products found at the store. GEORGE ACKERMAN would take over the store in 1978.

The Powers expanded in 1973, opening the CHEESE SHOP on Prince George Street in Williamsburg. Their family business grew when the couple partnered with JOHN CURTIS and MARCEL DESAULNIERS in 1980 to open the TRELLIS; they sold their interest in it in 1994. The Cheese Shop would grow and expand, too, eventually ending up on Merchant Square; the previous location now houses BLUE TALON BISTRO.

The Powers entered the restaurant business again in 2003 when they opened FAT CANARY, a fine-dining eatery, adjacent to the latest, and current, location of the Cheese Shop. The restaurant was named for a quote by sixteenth-century English writer John Lyly, "Oh for a bowl of Fat Canary, rich Palermo, sparkling sherry." Canary was a type of wine—named for its source, the Canary Islands—popular during colonial times in Williamsburg. Son TOM POWER JR. worked as a busboy and waiter at the Trellis and developed an interest in cooking. He attended the Culinary Institute of America in Hyde Park, New York, and worked under Emeril LaGasse in an internship at Commander's Palace in New Orleans, at Ritz Carlton hotels in California and in Hawaii under Roy Yamaguchi at Roy's. The bill of fare at Fat Canary changes seasonally and includes many locally sourced items. The restaurant has received the AAA Four Diamond award every year since opening. Today, Tom Power Jr. and sisters CATHY POWER PATTISALL and MARY ELLEN POWER ROGERS run the businesses.

Chuck Sass

Chuck Sass oversees the operation of more than a half dozen of some of the region's most high-profile restaurants. Not bad for someone who started in 1980 as a busboy (and sometimes dishwasher) at Harry Brown's restaurant in downtown Annapolis, Maryland. "After some time, the chef gave me some light prep, and before I knew it I had worked my way to omelet chef at Sunday brunch, then to the dinner line. I had the culinary bug, and I have never looked back," he said.

After attending Culinary Institute of America at Hyde Park, Sass came to Coastal Virginia, working with JOE HOGGARD first at SHIP'S CABIN in Norfolk in 1987, then JOE'S SEA GRILL in Virginia Beach in 1990. Through the early 1990s he was at a number of Virginia Beach restaurants with RICK MAGGARD, including the BARKING DOG, COYOTE CAFÉ and CRAWDADDY'S. Sass opened his own restaurant, BIG TOMATO, in 1992, and was named Chef of the Year by the *Virginian-Pilot* newspaper. A life-changing opportunity came in 1994 when he joined Bruce Thompson's PHR hospitality group, becoming chef at the newly opened MAHI MAHI'S SEAFOOD RESTAURANT AND SUSHI SALOON. He would receive national recognition for his cooking flair there. From there, he opened and oversaw a succession of eateries under the PHR umbrella, all in Virginia Beach: CAFE AMARINO GELATERIA, the GARDEN GRILLE, LAGER HEADS, MAMA'S ITALIAN KITCHEN (not affiliated with the original Norfolk eatery), PI-ZZERIA, ROCKFISH, TORTUGAS, ULTRA CRAFT COCKTAILS. When the Hilton Virginia Beach Oceanfront opened in 2005, along came other eateries under Sass's guidance: CATCH 31, SALACIA and SKY BAR. It was the same when Hilton Norfolk the Main came online in 2017 with GRAIN, SALTINE and VARIA, as well as in 2018 when the Cavalier Hotel reopened in 2018 with the BECCA, the HUNT ROOM and RALEIGH ROOM. Sass is executive vice president of food and beverage operations for PHR.

Marc Sauter

Marc Sauter works his magic not in a pan, but in a glass—a wine glass. The sommelier/owner of ZOES STEAK AND SEAFOOD RESTAURANT in Virginia Beach said,

> *I was bitten by the wine bug when I was very young.…I liked the way it brought people, families and friends together. So after my parents came*

Marc Sauter of Zoes
Restaurant, Virginia Beach.
Author's collection.

home from a wine dinner one night…by chance there was a show on TV about wine that I had watched that evening. Soon after that my father was transferred to California in the heart of Ernest and Julio Gallo's wine country. So that was just the beginning I needed, next to college and working in restaurants to pay for school. My father affectionately says I turned a hobby into a career.

Sauter's career has taken him to the upper echelon as a wine professional: he is at the third of four levels in the Court of Master Sommeliers and is an Advance Master Sommelier candidate.

Sauter became a sommelier when he was twenty-two years old and working at LA GALLERIA RESTAURANT in Norfolk. He has worked at and been part owner in many restaurants in Coastal Virginia, including TODD JURICH'S BISTRO (Norfolk), the now-closed ZINC BRASSERIE (Virginia Beach) and EURASIA (Virginia Beach), and joined Zoes Steak and Seafood in 2009. Zoes first opened in 2003. Part of Sauter's job includes coordinating with Chef MICHAEL KOCH, pairing wine with courses for dinners. "We have wine dinners here at Zoes priced from $59 a person to $2500, so a wide

range of styles," he said. Outside of wine dinners, he still works with pairings, assisting patrons in finding the right bottle to go with their meals. He has been awarded Service Professional of the Year for the southeastern United States by *Sante* magazine and his selections lauded in the Top 34 Wine Lists in Northern America by *Wine Enthusiast* magazine. Sauter has been the recipient of Wine Spectator Awards for his wine lists for more than two decades.

Hans Schadler

Hans Schadler started his fifty-plus-year culinary career as a boy at his mother's restaurant in the countryside town of Hanau, Germany, peeling potatoes and cleaning tables. "We went to school from 7 a.m. to noon, then reported to the restaurant," he told food writer David Nicholson in a *Daily Press* interview. At age fourteen, he headed to nearby Frankfurt and spent two years in an apprenticeship learning the culinary arts for a prestigious hotel/restaurant group that ran the London Savoy Hotel and the Opera Restaurant there. Later he received a doctorate of culinary arts from Johnson & Wales University. Leaving Frankfurt, Schadler cooked at various restaurants and resorts across that area of Europe, ending up at the Hotel Bristol in Oslo, Norway. "It was a first-class hotel that had a very affluent, solid guest foundation and was the official caterer to the Royal Palace," Schadler said. There, at age seventeen, he was recruited to work cooking for the Norwegian Cruise Line, with guests in formal wear enjoying extensive menus that included champagne, caviar and foie gras. After more than five years at sea, including four around-the-world trips, Schadler settled in the Caribbean. He ran a kitchen at Caneel Bay Resort on St. John, U.S. Virgin Islands, then opened the Woodstock Inn in Vermont in 1974.

In 1982, COLONIAL WILLIAMSBURG reached out to the chef, asking for consultation on the prestigious G7 economic summit to be held there the following year. The summit would host such world leaders as President Ronald Reagan, British prime minister Margaret Thatcher, Canadian prime minister Pierre Trudeau, French president François Mitterrand and West German chancellor Helmut Kohl. Schadler loved his visit and moved to the colonial capital in 1983. The two decades he spent in Williamsburg solidified Schadler as one of the nation's great chefs. While there, he oversaw ten diverse restaurants, including the Williamsburg Inn, four

colonial dining taverns, a bistro, a sports club and banquet events there. In 1988, Schadler was offered the executive chef position at the White House, which he declined due to the potentially short-term nature of the position and also to avoid "the glitz and glory." He did, however, leave for several years from 1996 to 2002 to return to the Caneel Bay property in the Caribbean. During his tenure, Schadler cooked for several presidents of the United States and even coordinated all meal functions during Queen Elizabeth's visit to commemorate the 400th anniversary of Jamestown in 2007. Schadler left in 2008.

His time there was also pivotal for many other chefs, too, as he reinstated a culinary apprenticeship program affiliated with the American Culinary Federation. Through this program, Schadler mentored many aspiring chefs, including Travis Brust, executive chef and food and beverage director at Colonial Williamsburg, and Kyle Woodruff, now executive chef at Hilton Virginia Beach Oceanfront, who also worked under Schadler at RIVERS INN restaurant in nearby Gloucester Point (opening in 2009, closing in 2010) and at WAYPOINT SEAFOOD & GRILL in Williamsburg, which opened in 2011. Schadler's daughter, Tina Schadler-Phillips, assists in the running of the restaurant, and noted chef Steve Perkins can be found in the kitchen. Perkins worked with Schadler for decades at the Williamsburg Inn after graduating from the Culinary Institute of America in 1987; he also has cooked at noted establishments like the Jefferson Hotel in Richmond.

Schadler describes Waypoint as "a celebration of Chesapeake ingredients and includes items grown at local farms and caught in regional waters. The pure flavors and rich ingredients presented in the seasonally changing entrée s represent modern regional American cuisine with classical culinary roots," adding that his passion for food keeps him inspired and filled with creative energy. "Much of my enthusiasm comes from local foods grown and cultivated for their pure flavors." Schadler has appeared on numerous television programs, including *The Today Show*, *Good Morning America* and the *Great Chefs of the East* series. Among his accolades, the Virginia Chefs Association elected him Chef of the Year three times. He has cooked twice at the famous Beard House in New York. In 2015, he received the American Culinary Federation's Hermann G. Rusch Chef's Achievement Award.

Michael Toepper

Norfolk native Michael Toepper blazed trails on the Peninsula with creative, innovative restaurants rivaling many of their Southside peers. He worked at the noted ELLIOT'S, POT POURRI and SHIP'S CABIN in Norfolk, but it was FIRE AND ICE, opened in a former pizza parlor in Hampton in 1990, that propelled Toepper's culinary status. The contemporary American eatery offered cuisine "which shows heavy New Southern as well as Asian fusion influences, boasts dishes such as marinated grilled pork tenderloin with a rich ancho chile-dried cherry glaze, crispy grilled grits cakes and a tangy black-eyed pea relish," according to a *Virginian-Pilot* review, noting "few cooks like Toepper and [Sous Chef Gail] Hobbs-Page are willing to take the chance to create more imaginative and adventurous food. So, in an area seemingly dominated by chains, pork barbecue emporiums and all-you-can-eat seafood joints, it's easy to understand why Fire & Ice has distinguished itself as one of the best on the Peninsula." Hobbs-Page now makes artisan cheese at her Caromont Farm near Charlottesville. Bobby Huber would cook briefly for Toepper at both Fire and Ice and his next venture, VICTORIA'S FIRE. Victoria's Fire, offering innovative, nouvelle American cuisine, opened in Williamsburg in 1992. Both restaurants closed.

Toepper next opened ARIA FIFTY ONE in 1999, offering more creative fare. The *Daily Press* noted then, "At the quirky Fire & Ice in Hampton, chef Michael Toepper built a loyal following for his zany food. Now installed at Aria Fifty One in Newport News, he has the surroundings to match his culinary creations," in reference to the futuristic décor. Writer Prue Salasky concluded, "By virtue of its design and Toepper's creativity in the…kitchen, Aria Fifty One effectively transports diners out of its shopping center location in Newport News to a more exotic world." Chad Martin cooked with Toepper here. Following Aria Fifty One, Toepper became corporate chef for Smithfield Foods, including taking over the kitchen at Smithfield Inn in 2001, and reentered restaurant ownership in 2006 with LIGHT RESTAURANT & BAR in Newport News in 2006 serving up American regional cuisine. He would later work at TERRA'S in Suffolk and BLURR BISTRO AND ULTRA LOUNGE in Newport News, both short-lived eateries, and cook at other restaurants, including Chris Savvides's VIRGINIA ORIGINALS, now closed. It was located on the first island of the Chesapeake Bay Bridge Tunnel. Savvides also owns BLACK ANGUS in Virginia Beach. Following a two-year stint at Virginia Originals, it appears Toepper has hung up his apron.

Alvin Williams

Alvin Williams grew up in Leeds, England, and learned to love cooking at an early age. "My parents use to grow vegetables in our back yard and myself and my siblings would gather and pick them and cook them together, so cooking came easy to me after a short while," he said. "I began washing dishes at an American restaurant named Chevy's in his hometown when he was 14 years old, working his way up through the ranks and into the kitchen. I met lots of interesting people working in the industry, culinary misfits like myself; it seemed to be the perfect fit." During culinary school, he did an internship at the Mayfair Hotel in London and, after school, moved to the British capital to work at Grosvenor House Hotel. The chef moved to the United States in 1991 to be with family after getting burnt out cooking in London. He had two sisters living here at the time, with one being married to a man in the navy.

His first job was at the legendary LE CHAMBORD restaurant in the London Bridge area of Virginia Beach in a converted post office building. The 125-seat restaurant was opened in 1989 by FRANK SPAPEN, a Belgian native formerly of LA BROCHE (opened in 1979 in Virginia Beach), who named the French-Continental restaurant for a castle in the Loire Valley in France. *Daily Press* food writer Prue Salasky described the swanky restaurant as having a main dining room with "whitewashed walls and exposed blond beams [that] combine for a spare, Mediterranean look that offsets the formality of the young at the entrance with its accent tables and overstuffed sofas piled high with pillows. A fireplace in one room and a fountain in another give each dining area a distinctive character." The menu was divided by pastas, fish and meats. Many ingredients were local, including vegetables from Bay Breeze Farms in Virginia Beach's Pungo community. Le Chambord was one of the few restaurants in Virginia to earn the distinction of receiving the Mobil four-diamond award for ten consecutive years. Later the more casual BISTRO ROTISSERIE AT LE CHAMBORD opened alongside the eatery, and Williams cooked there. The chef looked to Spapen as a mentor. "He brought me out of my shell and taught me about all aspects of the restaurant business. Most importantly how to speak with, connect with, engage, and listen to the customers." Frank Spapen died in 2001, and the restaurant closed in 2002. The building was a succession of eateries, including ALEXIS, TAVERNA and RUMBA!

Williams opened COBALT GRILLE in Virginia Beach in 2000, BARDO in Norfolk in 2003 (where he was partners with Karl Dornemann and

Alvin Williams
of Cobalt Grille,
Virginia Beach.
Author's collection.

Eric Stevens, restaurateurs currently with the PUBLIC HOUSE and SUPPER SOUTHERN MORSELS in Norfolk) and GOSPORT TAVERN and STILL WORLDLY ECLECTIC TAPAS in Portsmouth. Williams sold his interest in Bardo within a few years to focus on the Virginia Beach eatery. "Cobalt is a restaurant where you can come for a special occasion, family dinner, business meeting, date night, or dinner with friends," he said. "It is quite unique in the way that under one roof there are several atmospheres but all showcasing awesome food and service. The private dining room is obviously for private dinners, meetings, large family dinners, and special occasions. The bar and lounge are a little more casual with couches, bar-height tables, and communal tables. The outdoor patio area with fire pits is always fun. The chef's table for multi-course meals and special occasions, and of course the main dining room." Williams asserted he opened Cobalt to have a place to showcase his own cuisine, which utilizes the skills he learned in Europe and honed in America. "Over the years my cuisine has adapted to use the regional products and suit the needs of my clientele, but not compromising quality or my culinary background." Some signature dishes

include F.L.C., composed of a fresh flounder (or other seasonal whitefish) filet that is pan-roasted and topped with lobster and lump crab and served over mashed potatoes with fresh asparagus in a lemon-beurre blanc sauce. Another is the Beef Wellington, a filet mignon topped with foie gras and wild mushrooms, baked in a puff pastry case and served with sautéed baby spinach and drizzled with a red wine Bordelaise sauce.

A Sampling of Coastal Virginia Cuisine

Sometimes a cuisine defines its region, and sometimes a region defines its cuisine. In Coastal Virginia, it is a little of both. Building on established foods and foodways of natives indigenous to the land, the British settlers, trade with the Caribbean and slaves from Africa gave birth to the first true American cuisine here. It was a combination of methods—among them methods of preparation, methods of preservation and methods of presentation—that helped build the cuisine of Coastal Virginia, as well as native foods combined with foods brought from those who came here. Tastes of the region also play a factor; for, although each individual has his or her own likes and dislikes, a collective palate emerged. Here are a baker's dozen recipes to give you a sampling of Coastal Virginia cuisine. Some of the recipes that follow also appear in my book *Dishing Up Virginia*.

～

Bobby Huber's Ocean View Flounder

Bobby Huber was one of Coastal Virginia's iconic chefs. His larger-than-life personality was reflected in his style of cooking and his generous hospitality. In this recipe, Bobby uses one of the region's favorite fishes, the flounder, in homage to the Norfolk neighborhood of Ocean View he loved so much.

4 (6-ounce) flounder filets
¼ cup all-purpose flour

½ teaspoon salt
½ teaspoon freshly ground black pepper
2 teaspoons extra-virgin olive oil
4 garlic cloves, chopped
2 tablespoons roughly chopped fresh flat-leaf parsley
¼ teaspoon red pepper flakes
1 (28-ounce) can plum tomatoes, drained and coarsely chopped
½ cup clam juice

Lightly dust the flounder with the flour and season with salt and pepper on both sides. Set aside. Heat the olive oil over medium heat in a 10-inch skillet. Add the garlic, parsley and pepper flakes and sauté for 30 seconds; do not let the garlic brown. Add the tomatoes and clam juice. Place the flounder in the skillet and spoon the sauce over it to cover. Reduce the heat to medium-low and simmer until the flounder is just cooked through, about 15 minutes. Plate and spoon sauce on top. Makes 4 servings.

~

Cast-Iron Skillet Cornbread

The importance of corn to Virginian Native Americans cannot be emphasized enough, and upon their arrival, the English, too, valued the grain. Corn was used in many ways, including bread making. Later, when milling became more advanced, light, fluffy cornbread joined the table of good eats and good drinks. You'll find cornbread in many restaurants, served alongside dishes like barbecue, Brunswick stew and fried seafood.

2 tablespoons vegetable oil
2 cups stone-ground white cornmeal
½ cup all-purpose flour
1 teaspoon baking powder
1 teaspoon salt
1 egg
2 cups buttermilk

Preheat the oven to 450 degrees. Pour the vegetable oil into a 10-inch cast-iron skillet and place in the oven to warm. Whisk the cornmeal,

flour, baking powder and salt together in a medium bowl. Beat the egg in a separate medium bowl. Whisk in the buttermilk until combined. Pour the egg-milk mixture over the cornmeal mixture and stir thoroughly to incorporate. Remove the skillet from the oven and pour the hot oil into the batter. Stir to combine. Pour the batter into the skillet and bake for 20 to 25 minutes or until the top of the cornbread is golden and a toothpick inserted in the center of the bread comes out clean. Makes 8 servings.

~

Classic Chesapeake Crab Cake

Understand that there are two types of crab cakes: the classic, sometimes called a boardwalk style, and a modern take, sometimes called a restaurant style. The restaurant style is a lovely thing to behold: big pieces of jumbo lump crab and little, if nothing else, except for a bit of a binder like mayonnaise. But the classic is what has been the staple in the region for centuries. It has a filler, usually of crushed crackers or torn bread, and uses other parts of the crab, typically back fin meat. It's called a classic for a reason; it's absolutely delicious. You will find this style at crab shacks and diners dotting the Chesapeake Bay.

¼ cup mayonnaise
I egg
I ½ teaspoons fresh lemon juice
I teaspoon Worcestershire sauce
I teaspoon dry mustard
½ teaspoon red pepper flakes
¼ teaspoon Chesapeake Bay seasoning
⅛ teaspoon freshly ground black pepper
I pound back fin crabmeat
8 Ritz® or other buttery crackers, crushed
3 scallions, light green and white parts only, finely chopped
2 cups all-purpose flour
½ cup peanut oil

Whisk the mayonnaise, egg, lemon juice, Worcestershire sauce, dry mustard, pepper flakes, Chesapeake Bay seasoning and black pepper

together in a medium bowl. Put the flour in a shallow dish. Combine the crabmeat, crackers and scallions in a separate bowl and lightly toss. Pour the mayonnaise mixture over the crabmeat mixture and gently toss to coat. Cover and refrigerate for about 20 minutes to firm up.

Form the crab mixture into cakes using a 3-ounce ice cream scoop (or about 3 tablespoons) for each and dredge them lightly in flour. Heat the peanut oil in a large skillet over medium-high heat and, working with two or three crab cakes at a time, cook until golden, 4 to 5 minutes. Turn the crab cakes and cook until golden on the other side, about 4 minutes. Place on a paper towel–lined plate to drain. Serve with cocktail sauce, tartar sauce and lemon wedges. Makes 4–6 crab cakes.

~

Colonial Virginia Peanut Soup

Peanuts are one of Coastal Virginia's culinary calling cards. This creamy, rich soup is a favorite in Virginia and is often found in restaurants in the Colonial Williamsburg area. It's best when made with homemade peanut butter. This is my version.

Peanut Butter

4 cups roasted, unsalted Virginia-type peanuts
3 tablespoons peanut oil
Salt, optional

Soup

2 celery stalks, trimmed and finely chopped
1 medium sweet onion, such as a Vidalia, finely chopped
4 tablespoons unsalted butter
3 tablespoons all-purpose flour
2 quarts chicken broth
2 cups smooth peanut butter
1¾ cups light cream
½ teaspoon freshly ground white pepper

Virginia-type peanuts, finely chopped for garnish
Thyme sprigs, for garnish

Make the peanut butter. Place the peanuts in the bowl of a food processor fitted with the steel blade attachment and drizzle the peanut oil over the top. Pulse to break up the peanuts, then blend until very smooth. If the mix is very dry, drizzle in more oil by the teaspoonful. Add salt, if desired.

Make the soup. Cook the celery and onion in a large saucepan over medium heat until sweating. Add the butter, and continue cooking the celery and onions until translucent, about 5 minutes; do not brown the butter. Add the flour and stir until blended. Add the chicken broth and bring to a boil. Return to medium heat, stirring occasionally, and allow the soup to reduce slightly, about 15 minutes.

Pour the soup through a sieve into a large bowl, pressing hard against the solids with the back of a spoon. Discard the solids and return the liquid to the saucepan and heat on medium-low. Add the peanut butter and cream and stir constantly until blended. Add the white pepper. Heat for 5 minutes, stirring constantly. Divide the soup among eight bowls, Garnish with the chopped peanuts and thyme sprigs and serve immediately. Makes 8 servings.

Cream Biscuits with Virginia Country Ham

A simple cream biscuit is the perfect platform for Virginia country ham. Light, airy and delicate in flavor, it envelops itself around the salty, tangy piece of cured meat as both elements work in tandem to create the perfect dichotomy of flavors and textures. You'll find ham biscuits at many diners and down-home eateries in the region, especially offered as an appetizer or a side.

2 cups flour
1 tablespoon baking powder
2 teaspoons sugar
1 teaspoon salt
1 to 1½ cups heavy cream
1 egg, beaten

2 tablespoons water
8 thin slices Virginia country ham

Preheat the oven to 425 degrees. Whisk the flour, baking powder, sugar and salt together in a large bowl. Drizzle in 1 cup of the cream, adding a little at a time and stirring to incorporate; the dough should be firm and smooth. Add the remaining ½ cup cream if needed.

Turn the dough out onto a floured surface and gently knead; do not overwork the dough. Gently roll the dough out until it is about ½ inch thick. Cut the dough into 8 biscuits using a flour-dusted 3-inch biscuit cutter and place on a large baking sheet about 1 inch apart.

Whisk the egg and water together in a small bowl. Brush the egg wash on top of each biscuit. Place the baking sheet in the middle rack of the oven and bake for 15 to 18 minutes or until the biscuits are golden. Split biscuits and fill with Virginia ham slices. Yields 8 biscuits.

~

Deviled Crab à la Thalhimers

Tearooms developed in department stores in the late nineteenth and early twentieth centuries as quiet, refined places for ladies to lunch. More elegant than a typical lunch counter or lunchroom, but not quite full-blown restaurants, they were an inviting place to sit and linger for generations of shoppers. In Coastal Virginia, several department stores offered tearooms, including the now-closed Ames & Brownley, Miller & Rhodes, Smith & Welton and Thalhimers. This recipe is inspired by the famous deviled crabs offered by Thalhimers.

2 pounds crabmeat
½ cup dijon mustard
½ cup horseradish
2 eggs, beaten
¼ cup hot sauce
1 teaspoon freshly ground black pepper
3–4 tablespoons mayonnaise
1 teaspoon paprika

Preheat oven to 350 degrees. Mix the crabmeat, mustard, horseradish, eggs, hot sauce and black pepper together in a large bowl. Add just enough mayonnaise to bind. Divide the crabmeat mixture equally among eight ramekins and sprinkle each serving with ⅛ teaspoon paprika. Bake on the top rack of the oven for 10 to 15 minutes or until heated through and slightly golden on top. Serve immediately. Makes 8 servings.

~

Doc's Crab Norfolk

Norfolk's namesake seafood dish couldn't get much better. Succulent, sweet crab sautéed in rich butter with a bit of piquancy added from vinegar, a soupçon of umami from Worcestershire and a tad bit of heat from hot sauce is just what the doctor ordered. In this case it was Doc Twiford who created this delicious dish in the 1920s at his downtown Norfolk restaurant. This is my version of the classic.

¼ cup white vinegar
2 teaspoons Worcestershire sauce
1 teaspoon hot sauce
½ cup (1 stick) butter
2 cups back fin crabmeat
¼ teaspoon paprika

Whisk the vinegar, Worcestershire and hot sauce together in a small bowl. Melt the butter in a large skillet over medium-high heat. Add the crabmeat, stir, then add the vinegar mixture. Cook, tossing continually, until heated through and the butter and vinegar mixture reduces slightly, 4 to 7 minutes. Transfer equally to two plates and sprinkle each with paprika. Makes 2 servings.

~

Eastern Shore Oyster Stew

This Eastern Shore–inspired stew is a simple, elegant way to showcase one of Coastal Virginia's tastiest culinary calling cards, the oyster. The richness

of the milk and cream, along with the earthiness from the spices used pair perfectly with salty seaside oysters in particular, but the dish is good with bivalves from any of the eight growing regions. You'll find soups like this in seafood shacks throughout the region.

1 ½ cups milk
½ cup heavy cream
½ teaspoon salt
½ teaspoon freshly ground white pepper
⅛ teaspoon freshly ground nutmeg
⅛ teaspoon cayenne pepper
4 tablespoons unsalted butter
1 pint shucked oysters, liquor reserved
4 chives, chopped

Warm the milk, cream, salt, white pepper, nutmeg and cayenne in a large saucepan over medium-low heat, stirring occasionally, until hot, about 10 minutes. Warm the butter over low heat in a medium saucepan until melted. Add the oysters and liquor and cook, stirring occasionally, until the edges of the oysters begin to curl, 2 to 3 minutes. Add the oyster mixture to the milk mixture and cook on medium-low heat for about 2 minutes; do not boil. Divide the soup among four serving bowls and garnish with the chives before serving. Makes 4 servings.

～

Monroe Duncan's Soft-Shell Crabs Bercy

Monroe Duncan was one of the first chefs to propel Coastal Virginia into a more modern era of cooking when he opened his first restaurant, Simply Divine Dahlings, in 1979. Monroe's cooking style was his own, a bit classic, and a bit avant-garde, much like he was. Prior to his passing in 2014, I began work with him on collecting his recipes for a cookbook, Come Flame with Me, *a project that was, sadly, never finished. This is one of his recipes from the manuscript.*

2–3 cups milk
3 soft-shell crabs, dressed
¼ cup all-purpose flour

1 teaspoon salt
1 teaspoon freshly ground black pepper
3 ounces clarified butter
3 ounces whole butter, unsalted
1 teaspoon minced shallots
Juice of one lemon
3 ounces white wine
4 ounces jumbo lump crabmeat
Fresh chopped cilantro

Add milk to a small casserole and place crabs in to marinate. Cover and refrigerate one hour. While crabs are marinating, add flour, salt and pepper in a small bowl and whisk to combine. Remove the crabs from the milk and carefully pat dry; place them on a cutting board and lightly dust both sides with the seasoned flour.

In a medium skillet over high heat, heat the clarified butter just below the smoke point. With tongs, carefully add each crab, one at a time, to the butter. Pan fry the crabs for 3–5 minutes on each side, until golden brown. Remove crabs to a serving plate and set aside; discard butter.

Move the pan back to the heat and reduce to medium; add whole butter; as it melts, add the shallots and sauté shallots for 3–4 minutes or until opaque. Add lemon juice and wine, whisking continually. Add crabmeat and stir for 3–4 minutes until crabmeat is heated. Pour over plated crabs, garnish with cilantro and serve immediately. Yield 1–2 entrées.

～

Oysters Bingo à la Joe Hoggard

Joe Hoggard's Ship's Cabin restaurant, in Norfolk's Ocean View, was legendary for its outstanding seafood and service; it continually won praise, as well as the first AAA four-diamond rating in the region. Hoggard named this rich dish in honor of one of Ship's Cabin's patrons, Virginia politico Frederick T. "Bingo" Stant Jr. This is my version of the classic.

Oysters

12 oysters
1 cup all-purpose flour

½ teaspoon salt
½ teaspoon freshly ground black pepper
¼ teaspoon red pepper flakes
2–3 tablespoons vegetable oil
2–3 tablespoons butter

Sauce

2 tablespoons reserved oyster liquor; can substitute
bottled clam juice or seafood broth
2 tablespoons white wine
2 tablespoons fresh lemon juice
2 medium shallots, minced

Other

Parmigiano-Reggiano cheese for garnish
Lemon zest for garnish

Shuck the oysters and reserve the liquor (liquid). Combine the flour, salt, black pepper and pepper flakes in a medium bowl. Toss the oysters in the flour mixture and shake to remove any excess flour.

Heat the oil and butter in a skillet on high heat. When the skillet is very hot, add the oysters, being careful not to crowd them (cook in batches if necessary). Sauté until the coating is golden brown, about 30 seconds, then turn and sauté for 30 seconds longer. Transfer the oysters to a serving bowl with a slotted spoon, leaving the oil/butter mixture in the skillet.

Make the sauce. Add the oyster liquor, white wine, lemon juice and shallots to the oil/butter mixture and bring to a simmer. Cook until the sauce thickens slightly, stirring occasionally and scraping the bottom of the skillet to incorporate the flavorful bits. Remove the skillet from the heat, stir the sauce blend thoroughly and pour over the oysters. Top immediately with shaved curls of Parmigiano-Reggiano and lemon zest and serve immediately. Makes 1–2 servings.

~

Roasted Oysters

Harkening back to the roasted oysters English settlers first tried—and loved—in April 1607 along the shores of the Lynnhaven Bay, my recipe can be easily done in the backyard. Just heated enough to take away objections from those who may not like raw oysters, the roasting method does not mask as many of the bivalve's distinctive characteristics as with other cooking methods. You'll find oyster roasts, especially in the spring and fall, across Coastal Virginia.

4 dozen oysters

Heat a gas or charcoal grill to medium-high. Place the oysters, flat side up, on the grill and grill for 8 to 10 minutes, or until the shells open at least a quarter-inch. Remove the oysters from the grill with tongs and, with a gloved hand, open the shells with an oyster knife, being careful not to spill any juices. Discard the empty top shell and slide the oyster knife under the meat to release; arrange the oysters on a serving plate. Serve immediately with drawn butter for dipping. Makes 4–8 servings.

~

Sailor's Delight Mimosa

Surrounded by the Atlantic Ocean, Chesapeake Bay and all their tributaries, Coastal Virginia has indelible links to the water. This mimosa uses one of the region's sweetest calling cards—the strawberry, noted early by the first settlers—to create a drink with layers of red and orange, much like a sunset over the sea. Coastal Virginians love their brunch, especially al fresco, and many area eateries serve up special eats and drinks for the occasion. We recommend using Virginia sparkling wine and Virginia vodka.

Strawberry Coulis

1 cup fresh strawberries, caps removed
½ cup sugar
1 tablespoon lemon juice

Mimosa

½ cup fresh orange juice (juice of 2 oranges, approximately)
½ cup vodka
1 bottle (750 milliliters) sparkling wine
Whole fresh strawberries for garnish

Make the coulis. Combine the strawberries, sugar and lemon juice in a medium saucepan and bring to a boil over medium-high heat. Reduce heat and simmer, stirring continually, for about 5 minutes. Purée the strawberries in a blender until smooth and then strain or press contents through a fine sieve. Chill at least 2 hours before use; will keep refrigerated up to one week.

Make the mimosas. Spoon 2 tablespoons of strawberry coulis and 1 tablespoon of orange juice and 1 tablespoon of vodka into each champagne flute. Top off with the sparkling wine. Garnish with the fresh strawberries, either sliced and dropped into the glass, cut and placed on the glass rim or whole on cocktail skewers. Makes 8 cocktails.

~

Tearoom Piquant Cheese

Pausing from shopping and other errands, women would congregate at department store tearooms to have coffee, enjoy a dainty bite and perhaps take in a fashion show. An eternally popular sandwich is pimento cheese; my version is inspired by the much loved, much missed Piquant Cheese at Smith & Welton. The pop of flavor comes from apple cider vinegar rather than ketchup in the store's recipe.

8 ounces sharp cheddar cheese, shredded (1 cup)
8 ounces mild cheddar cheese, shredded (1 cup)
1 roasted red bell pepper, seeded and chopped
½ small sweet onion, such as Vidalia, finely chopped
½ cup mayonnaise
2 tablespoons apple cider vinegar
½ teaspoon salt
½ teaspoon celery seed

¼ teaspoon freshly ground black pepper
¼ teaspoon cayenne pepper

Combine the sharp cheddar, mild cheddar, bell pepper and onion in a large bowl. Whisk the mayonnaise, vinegar, salt, celery seed, black pepper and cayenne together in a medium bowl; pour over the cheese mixture. Mix well and taste, adjusting the mayonnaise and seasonings for texture and flavor. Refrigerate at least 2 hours before serving with desired accompaniments. Store covered in the refrigerator for up to 3 days. Make sandwiches from the spread, top crackers or spoon into hot grits and stir. Makes about 2½ cups.

Selected Bibliography

Barrow, Mary Reid. *The Virginia Beach Harvest Cookbook*. Norfolk, VA: Donning Company Publishers, 1985.

Barrow, Mary Reid, and Robyn Browder. *A Great Taste of Virginia Seafood: A Cookbook and Guide to Virginia Waters*. Atglen, PA: Schiffer Publishing, 1984.

Evans-Hylton, Patrick. *Dishing Up Virginia: 145 Recipes that Celebrate Colonial Traditions and Contemporary Flavors*. North Adams, MA: Storey Publishing, 2013.

———. *Hampton Roads: The World War II Years*. Charleston, SC: Arcadia Publishing, 2005.

———. *Smithfield: Ham Capital of the World*. Charleston, SC: Arcadia Publishing, 2004.

———. *The Suffolk Peanut Festival*. Charleston, SC: Arcadia Publishing, 2004.

Fairfax, Colita Nichols. *Hampton, Virginia*. Black America Series. Charleston, SC: Arcadia Publishing, 2005.

Foster, Mary L. *Colonial Capitals of the Dominion of Virginia*. Lynchburg, VA: J.P. Bell Company, 1906.

Gounaris, John, and Robert Stanton. *Dining In—Hampton Roads Cookbook*. Seattle, WA: Peanut Butter Publishing, 1984.

Jordan, James M., IV, and Frederick S. Jordan. *Virginia Beach: A Pictorial History*. Richmond, VA: Thomas F. Hale Publishing, 1975.

Mansfield, Stephen S. *Princess Anne County and Virginia Beach: A Pictorial History*. Norfolk, VA: Donning Company Publishers, 1989.

Nunley, Debbie, and Karen Jane Elliott. *A Taste of Virginia History: A Guide to Historic Eateries and Their Recipes*. Durham, NC: John F. Blair, 2004.

Owen, Emerson D., ed. *The Official Hotel Red Book and Directory*. 1920 ed. New York: American Hotel Association Directory, 1920.

Parramore, Thomas G., with Peter C. Stewart and Tommy L. Bogger. *Norfolk: The First Four Centuries*. Charlottesville: University of Virginia Press, 2000.

Quarstein, John, and Julia Steere Clevenger. *Old Point Comfort: Hospitality, Health and History on Virginia's Chesapeake Bay*. Charleston, SC: The History Press, 2009.

Randolph, Mary. *The Virginia House-Wife*. With historical notes and commentaries by Karen Hess. Columbia: University of South Carolina Press, 1984.

Rouse Jr., Parke. *The Good Old Days in Hampton and Newport News*. Richmond, VA: Dietz Press, 1990.

Smartt, Elizabeth Thalhimer. *Finding Thalhimers: One Woman's Obsessive Quest for the True Story of Her Family and Their Beloved Department Store*. Manakin-Sabot, VA: Dementi Milestone, 2011.

Smith, John. *The Journals of Capt. John Smith: A Jamestown Biography*. Washington, D.C., National Geographic Society, 2007.

Tazewell, William L. *Norfolk's Waters: An Illustrated Maritime History of Hampton Roads*. Woodland Hills, CA: Windsor Publications, 1982.

Tucker, George Holbert. *More Tidewater Landfalls*. Norfolk, VA: Donning Company Publishers, 1975.

————. *Norfolk Highlights*. Norfolk, VA: Norfolk Historical Society, 1972.

Whitaker, Jan. *Tea at the Blue Lantern Inn: A Social History of the Tea Craze in America*. New York: St. Martin's Press, 2002.

Woodward, Sandra Kyle. *Norfolk Cookery Book: The Culinary Heritage of a Southern Seaport*. Norfolk, VA: Donning Company Publishers, 1981.

Yarsinske, Amy. *Jamestown Exposition*. Vol. 1. Charleston, SC: Arcadia Publishing, 1999.

————. *Jamestown Exposition*. Vol. 2. Charleston, SC: Arcadia Publishing, 1999.

————. *Lost Norfolk*. Charleston, SC: The History Press, 2009.

————. *Lost Virginia Beach*. Charleston, SC: The History Press, 2011.

————. *Norfolk, Virginia: The Sunrise City by the Sea: A Tribute to Photographer Carroll H. Walker Sr.* Norfolk, VA: Donning Company Publishers, 1994.

Author's note: archived and contemporaneous newspaper and magazine articles, as well as internet-based information, were also relied on for research for this book.

About the Author

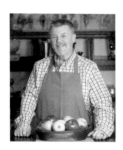

Patrick Evans-Hylton is a Johnson & Wales–trained chef, food historian and an award-winning food writer, covering tasty trends since 1995 in print, broadcast and electronic media. He is publisher of VirginiaEatsAndDrinks.com

He cooks and writes in his Chesapeake Bay kitchen in Virginia Beach.